D1084372

CELLINI

ARTIST, GENIUS
FUGITIVE

For
Simonetta Berbeglia and Maurizio Masetti

CELLINI

ARTIST, GENIUS
FUGITIVE

DEREK PARKER

SUTTON PUBLISHING

First published in the United Kingdom in 2003 by
Sutton Publishing Limited · Phoenix Mill
Thrupp · Stroud · Gloucestershire · GL5 2BU

British Library Cataloguing in Publication Data
A catalogue record for this book is available from the British
Library.

ISBN 0-7509-2957-X

Typeset in 11/14.5pt Sabon.
Typesetting and origination by
Sutton Publishing Limited.
Printed and bound in England by
J.H. Haynes & Co. Ltd, Sparkford.

Contents

Chronology

It is extremely difficult to work out, from the *Life*, the order of events in Cellini's life. The first real attempt was made by Robert H. Hobart Cust as part of the work on his edition, published in London in 1910. While his is by no means the most readable translation, Cust's work on the chronology of events remains the most reliable, and the following is largely based upon it.

1500 3 November – birth of Benvenuto Cellini.

1513 Apprenticed to Michelangelo Brandini.

1515 Employed by Antonio di Sandro.

1516 Cellini banished to Siena with his younger brother; works in Siena, then in Bologna.

1517 Works in Pisa.

1518 Works in Florence, is admitted to the Goldsmiths' Guild.

1527 Besieged in the Castel Sant' Angelo with Pope Clement VII. His brother Cecchino is killed.

1529 Returns to Florence.

1530 Kills his brother's assassin; is pardoned by the Pope. Opens his first goldsmith's shop in Rome.

1534 Murders Pompeo de' Capitaneus, a jeweller. Absolved by Pope Paul III.

1535 Leaves Rome for Florence and Venice. Returns to Rome, accepts commissions from the Pope, but becomes seriously ill and returns to Florence.

1537 Travels to Paris and Fontainebleau, but unwelcomed by King Francis I, stays only for some months. Meets Cardinal Ippolito d'Este. Returns to Rome.

1538 Accused of stealing jewels from the Pope, is imprisoned. Escapes and takes refuge with Cardinal Cornaro.

1539	Re-imprisoned on the Pope's orders; released through the intervention of Ippolito d'Este.
1540	Works for d'Este, returns to France (murdering a man en route); welcomed by Francis I and given ambitious commissions.
1542	Naturalised by the king, commissioned to design a fountain at Fontainebleau and a work for the main entrance of the château.
1544	Has a daughter by one of his models. Suffers from the antagonism of the king's mistress.
1545	Returns to Italy.
1553	Has a son by one of his models.
1554	Recognises his son and provides for the mother.
1555	Death of Cellini's son.
1556	Attacks a fellow goldsmith and is imprisoned, but pardoned by the duke.
1557	Again prosecuted for sodomy, fined, imprisoned but reprieved and put under house arrest on the orders of the duke.
1558	Begins to dictate his *Life*. Takes religious vows.
1561	Birth of an illegitimate son, Giovanni. Plans to leave Florence defeated by Cosimo I.
1562	Illegitimate daughter born; Cellini secretly marries her mother Piera de' Parigi. Invitation to return to France foiled by Cosimo I.
1563	Joins the Accademia delle Arti del Disegno as a founder member. Son Giovanni dies.
1564	Plans the setting for the funeral of Michelangelo; his plans defeated by painter members of the accademia. Daughter Reperata born.
1566	Daughter Maddalena born.
1567	Begins to write his *Treatises* on sculpture and goldsmithing. Officially marries Piera.
1568	*Treatises* published in Florence.
1659	Son Andrea Simone born.
1571	Benvenuto Cellini dies on 13 February. Buried at Sant' Annunziata in Florence.

List of Illustrations

Acknowledgements

While there is no substitute for first-hand examination of Benvenuto Cellini's work, the monograph published by the late James Pope-Hennessy in 1985 contains fine and detailed illustrations of all his major work. Very grateful posthumous thanks are due to this fine critic and scholar, whose enthusiasm for Cellini's work is evident on every page.

I am as usual in debt to the librarians and assistants at the British and London Libraries, to Maurizio Masetti, and in particular to Simonetta Berbeglia for her wholehearted and persistent work in extracting illustrations from the Museo Nazionale at the Bargello in Florence, who informed me that they were unable themselves to send photographic prints to England because of insuperable difficulties with the paperwork. The Victoria and Albert Museum, the Fitzwilliam Museum in Cambridge and the curators of the Palazzo Vecchio in Florence were also helpful.

My wife has once again made intelligent and insightful comments both about Cellini's work and my attempts to comment upon it, and I am extremely grateful to Jaqueline Mitchell and Clare Jackson, my editors at Sutton Publishing, for their usual invariable attention to detail and insistence on clarity and accuracy.

Introduction

When he died, Benvenuto Cellini was regarded by his fellow Italians as one of the great artists of his time. As a goldsmith and jeweller his work was among the finest designed and made by any Renaissance virtuoso, while his statue of Perseus holding the head of Medusa was generally agreed to be worthy of comparison with Michelangelo's *David*, which stood a few yards away from it in the great central square of Florence. His fame was not confined to his native Italy: at Fontainebleau, his work for King Francis I was equally celebrated. And time was to reveal a masterpiece unknown to all but a few of his contemporaries: his autobiography.

This revealed – in fact celebrated, for his confessions were unregenerate – the many and volatile adventures of his private life, for which his banishment from Florence when he was sixteen, for brawling in the streets, set the pattern. At twenty-three he was condemned to death for skirmishing (which did not stop him from continuing to fight anyone who offended him); at twenty-seven he turned soldier, defending a castle against an overwhelming enemy; at thirty he killed a man, and was saved from trial and execution only by the intervention of the Pope; at thirty-four he was once more forced to fly from the law after wounding an enemy, and he spent much of his thirty-eighth and thirty-ninth years in prison (not for the last time: less than twenty years later he was again imprisoned, charged with stealing papal jewels). Meanwhile, he was on several occasions accused both of heterosexual and homosexual sodomy, while at the same time fathering a number of illegitimate children by a succession of mistresses who for much of the time amicably shared his studios with boys who were not only his models and assistants, but his catamites.

Much of this was common knowledge among his contemporaries, and his behaviour made him few friends. But even his enemies had to admit the stature of his work – in Florence, although he had produced no major work for some time, the news of his death brought forth almost as many tributes as those which had been paid, six years earlier, to his idol and friend Michelangelo, and comparable crowds attended his funeral.

His revelation of himself, warts and all, in his *Life* did him no favours, for until relatively recently readers were simply unable to reconcile the violence of his temperament and actions with the fact that he was also a sensitive artist. He was 'capable of malicious mischief, of murder, and of ways of living which are perhaps better left unmentioned' and probably, to boot, 'a rousing good liar'. Modern scholarship has shown that in fact his account of life in Florence, Rome and Paris in the 1500s is remarkably accurate (apart from being the most complete account of the life of the time). We are also, today, capable of understanding and accepting without repugnance his true sexual nature, which he was at pains to disguise in a book meant for publication, and which revealed much about himself, but not everything. A writer in the twenty-first century can allow himself to interpret without undue reticence certain passages which previous commentators have either ignored or purposely obfuscated.

In the sonnet he placed at the beginning of his autobiography, Cellini wrote of his 'cruel fortune's spite' – '*mio crudel destin*'. It is a more significant phrase than many commentators have credited. Because astrology has for the past century or more been considered an intellectually disreputable subject, biographers have failed to take into account the importance it assumed in the lives of a great number of subjects born when it was a widely prevalent belief system. Editors of Benvenuto Cellini's *Life* have consistently under-estimated the extent to which he believed his character to have been shaped by 'the stars', and his life ruled by them.

He was evidently familiar with his astrological birth-chart, or horoscope, from an early age. This is not surprising, for very few intelligent and educated sixteenth-century men and women ignored

what 'the stars' had to tell them about their personal characters and the possible shape of their futures. The subject was continually in the minds and mouths of Cellini's patrons – particularly the popes. Leo X not only relied greatly on his personal astrologer, Franciscus Priulus, who wrote a whole book about the pope's birth-chart, but engaged the services of other astrologers – Pellegrino Prisciano of Ferrara, Thomas Philologus, Castaneolus and Nifo and Bernard Portinarius. Astrological almanacs were dedicated, with permission, to his successors, Adrian VI and Clement VII, while Paul III – with whom Cellini had a long and somewhat bumpy relationship – made his astrologer, Luca Gaurico, a bishop and instructed him to elect the precise time when the foundation-stones of important church buildings should be laid, to attend the ceremonies, and cry out in a loud voice when the attendant cardinal should lay the marble slab.

Cellini himself possessed several almanacs, and was probably familiar with the best-known astrological texts of the time. He may very well have read, for instance, in the famous *Astronomica* of the Roman astrologer Manilius that a child born when the Sun was passing through the astronomical sign of Scorpio would have 'a spirit which rejoices in plenteous bloodshed and in carnage more than in plunder. Why, these men spread even peace under arms . . . they wage fierce warfare now against man, now against beast . . . and devote their leisure to the study of war and every pursuit which arises from the art of war.'[1] During his life Cellini was to be continually embroiled in combat of one sort or another, often physical, was quick to anger, injured several men and killed at least three, made war under siege, and assisted in designing the defences of his native city. At one point in his life he seriously suspected that he should have been a professional soldier rather than an artist. Astrologers would have told him that not only the Sun, but Mars and Venus were in Scorpio when he was born (Pluto also, indeed, but he could not have known that), and it is inconceivable that he was not considerably influenced by the knowledge, which may well have contributed to the fieriness of his temperament and his apparent inability to control it.

Mars is a specially significant planet when it occupies the sign of Scorpio in a horoscope, for until modern times it ruled that sign. The great astronomer Ptolemy wrote in his *Tetrabiblos* that the planet was inclined to make men 'addicted to natural sexual intercourse . . . adulterous, insatiate, and ready on every occasion for base and lawless acts of sexual passion'.[2] Cellini accepted the fact that from Scorpio Mars and Venus together demanded sexual satisfaction, that the former supported his naturally strong physical energy while the latter sharpened the jealousy which often led him into trouble. Knowing that the sign Libra was ascending over the eastern horizon at the moment of his birth,[3] he also read or was told that he was likely to be self-satisfied (nothing could have been more true) and also that he was highly susceptible to romance – and his admiration of male and female beauty was certainly not entirely free of sentiment.

It would be foolish to dismiss the probability that self-fulfilling prophesy contributed to Cellini's actions, and that some of his more outrageously irrational and violent acts were exacerbated by his conviction (repeated time and again in the *Life*) that 'the stars' – in particular the effect of Mars in Scorpio – made him short-tempered, capricious, vengeful. Writing of his violent assault on a fellow-goldsmith and his family[4] he points out that the entire incident is proof of how the stars do not merely influence us, but force us into certain acts. The positions of the planets at the moment of his birth not only made him violent and vengeful – they gave him permission to be violent and vengeful.

He did not find it in the least difficult to reconcile this aspect of his character and his religious beliefs. These were not strong, but they were of their age; it would have been extremely unlikely for him, intellectually, not to believe what the whole world – his whole world – believed. But as John Addington Symonds put it,[5] 'His God was not the God of holiness, chastity and mercy, but the fetish who protected him and understood him better than ungrateful men . . . [his] impressible, imaginative nature lent itself to mysticism and spiritual exaltation no less readily than to the delirium of homicidal excitement.'

He clearly had immense charm which he could exert when he cared to do so; but he did not often care. He was almost dangerously proud and self-assured, and while he could restrain himself, exerting what I have called his salamander side (see p. 17), he was likely at any minute to forget the courtesy due to princes and the tact best shown in dealings with wealthy patrons and let the King of France or the Duke of Florence know precisely what he felt about their cupidity and lack of artistic taste. He was, one contemporary wrote, 'in his every action spirited, proud, vigorous, most resolute, and truly terrible, and a person who has been only too well able to speak for himself with Princes, no less than to employ his hand and brain in matters of art'.[6]

The aspect of his character which he omitted to mention in his autobiography was his bisexuality. While modern editors of the *Life* have properly alluded to this in their notes, little has been written about his sexual nature. Homosexuality was more rife in the Florence of his youth than perhaps in any other city in Europe, and while heavy penalties were available when prosecutions for sodomy were brought, they were very rarely imposed. By the time Cellini settled to write his autobiography, in the decade following 1558, the atmosphere had changed considerably, and there was much less tolerance. Even coded references to the homosexual side of his nature would have been dangerous. Nevertheless, an attentive reader is left in no doubt about the nature of his relationships with several of his apprentices and young workmen. My own allusions to these may seem overconfident, but I believe are supported by the tone of his references to, for instance, his friend Francesco Filippo, his servant Paulino and his model Cencio.

There is nothing mysterious about Cellini's sexuality. His attitude to his male and female lovers was very different; in the *Life* his references to the boys with whom he fell in love are much more tender and affectionate than his allusions to his mistresses, or even his wife (though there is no reason to suppose that his domestic life with her was other than contented). It is difficult to avoid the suspicion that his interest in women was closely allied to his desire for children (and he fathered eight in all, illegitimate and legitimate),

while his interest in the boys and young men with whom he fell in love was considerably more emotional – and I use the words 'in love' purposely; the inference is clear if one reads, for instance, what he says about his apprentice Paulino.[7]

However, if love or lust drove him mainly in the direction of the male sex, he was perfectly capable of relationships of one kind or another (perhaps to a degree sadistic) with women, and this had one advantage where his art is concerned, for it is very clear indeed when one looks at his sculpture that he admired both the male and female figures. Unlike Michelangelo, whose work strongly suggests that his interest in the female form was almost imperceptible, Cellini clearly loved the shape of the human body of either sex; he was clearly deeply aroused both by the beautiful male and female body, and if he chose to look to the male body when creating his major works, there is no doubt that he was as interested in depicting the female form as that of the male.

He was obviously a very fine jeweller indeed, and was recognised as such by contemporary experts and by his peers. Those of his medals which have survived show him to have been a master of that art, while the salt is a proof of his mastery as a goldsmith – probably one of the greatest the world has known. It may well be that some jewellery has survived in obscure collections; perhaps one day modern techniques and scholarship will succeed in identifying it. One or two studies for his sculpture have turned up during the past century.

* * *

Cellini was born in Florence, a city he adored, from which he hated to be exiled, and in which he continued to live despite his unsatisfactory relationship with its duke, Cosimo I. A boy whose destiny was to become an artist could scarcely have been born at a better time or place than in 1500, and in that city, which stood alone in its magnificence. There was no coherence in Italy between the fifteenth and eighteenth centuries: while the Kingdom of Naples held sway in the south, northern Italy was a patchwork of states – the

Papal State, centred of course on Rome, the Republics of Florence and Venice, the Duchies of Tuscany, Urbino, Ferrara, Modena, Parma, Mantua, Milan, Genoa and the rest. These were virtually little countries, so individual that their dialects were almost different languages – the remarks of a traveller who addressed a Mantuan in the Calabrian dialect would be received with puzzled incomprehension. Florence, however, was an exception: because of its long tradition of mercantile prosperity, everyone could make themselves understood there – especially merchants and men of money. The city republic was so confident of its prosperity that it did not even trouble to erect defensive walls, relying for its security upon its commercial and financial importance.

One of the five largest cities in Italy (only Venice was larger) Florence was almost as fragmented as the country. It was divided into four highly individual quarters, each named after one of its churches – S. Giovanni, S. Croce, S. Maria Novella and S. Spirito – and profoundly proud of its own identity. The quarters were themselves divided into wards or *Gonfaloni*, each of which bore the names of a heraldic device on its flag – the Red, Black, White or Gold Lion, the Unicorn, the Keys, or the Green or White Dragon. (Some of these symbols, carved in stone, hung then as they do now on the inner walls of the courtyard of the twelfth-century Bargello.) The citizens felt themselves to be members of a family, eager to crowd behind their own flag, borne proudly in procession by the *gonfaloniere* on public occasions.

Florence had for centuries been celebrated by its citizens. The fourteenth-century poet Lopo Gianni wrote that an ideal life would be to be as beautiful as Absalom, as strong as Samson and as wise as Solomon, and surrounded by a thousand girls singing with him evening and morning – so he supposed he should go to Paradise. But he would rather stay forever in Florence, young, healthy, happy and free from care. The city was to him and his fellow Florentines irresistible – a vital, bustling metropolis presided over by its heraldic icon, the lion (a pair of lions were kept in a large enclosure near the Signoria, and children when snow fell made not snowmen but snow-lions).

It was extremely beautiful, the façades of its 110 churches bright with dark green or rose marble inlaid on white. As one looked down from the surrounding hills, three buildings stood out, two of them recent – the pink-and-green campanile designed and built by Giotto and the Duomo with Filippo Brunelleschi's enormous dome: a triumph, and when it was built in 1420 the first dome constructed in western Europe since classical times. Then there was the tower of the Signoria, from which Tuscany was governed and below which stood Michelangelo's masterpiece, the sublime sculpture of David.

The centre of Florence was then as now a tangle of streets, twisting and turning upon themselves as they connected its fifty piazzas. In them the creative life of the city went on: *botteghe* or workshops snuggled behind the walls, only an open door signalling that within an artisan was beating a piece of gold or silver, cutting cloth or shaping leather. The owner of a *bottega* would signal his presence by hanging a straw hat or a shoe, a horse's bit or snaffle or a wine bottle outside the entrance. The smell of beaten leather, garlic, roasting meat, wine, wood-shavings scented the air. Jewellers' shops on the Ponte Vecchio (where a bust of Cellini now looks down on the straggling tourists) sold cameos, coral, amber, turquoise, trays of unset stones. It was a city in which a great deal of business was done: something like 55,000 inhabitants were served by over 2,000 *botteghe* – in the middle of the sixteenth century the city had 96 cobblers, 131 bakers, 101 mercers, 99 wood-sellers and 69 tailors.[8]

Much of Florence was grand and impressive, with massive palaces whose blind façades protected their owners from prying eyes or unwanted visitors. Rich Florentines took great pride in their spacious houses, the most modest of which might have twenty rooms rising in four floors. Courtyards were freshened by water plashing from charmingly designed fountains, while beautifully proportioned sweeping staircases of marble led up to equally splendid spacious apartments furnished with sculpture and paintings, many of which now hang in the Uffizi, the Pitti, the Accademia, or, sadly exiled from Florence, in other of the world's great museums. The merchant Giovanni Rucellai, who built himself

a magnificent *palazzo*, wrote: 'I think I have done myself more honour by having spent money well than by having earned it. Spending gave me deeper satisfaction, especially in the money I spent on my house in Florence.'[9] The possession of a fine house advertised one's status not only as a person of wealth, but of taste – as (happily for the city's artisans and artists) did the possession of a fine wardrobe and a gallery of fine pictures.

There were no signs of town planning in the layout of the city. It had just grown, ad hoc. There were occasional fine vistas, but between the handsome piazzas narrow, dark alleys unevenly paved with flat stone slabs and overhung by balconies, unlit at night except for an occasional votive candle within a niched shrine, were dangerous places, excellent for assignation or mischief. Many of them were notorious not only for violence but for sexual activity – the lanes of the red light district between the Old Market and the archbishop's palace, the Chiasso de' Buoi and the streets around the nearby public baths at San Michele Berteldi were commonly used for open-air sex. But if the weather was inclement, there was no hesitation in using the most public buildings. The authorities took a dim view of sexual activity in churches, and prosecuted men for sodomy in the choir of the cathedral, in Giotto's campanile, and even beneath Brunelleschi's cupola – for much of the sex was gay sex: Florence throughout the fifteenth and early sixteenth centuries was particularly a centre of homosexuality. At some periods the city's governors actually sponsored heterosexual brothels, in the hope of setting young men straight – but between 1478 and 1502 no fewer than 4,062 men were successfully prosecuted for sodomy.[10]

No wonder that the citizens of Florence were regarded by the rest of Italy as having dubious morals (indeed, by the rest of Europe – the Germans used the word *florenzen* as a verb meaning 'to sodomize'). In other ways, however, the citizens were admirable: they kept much of the city clean, for instance, and took precautions against spreading disease. The architect Leon Battista Alberti advised that 'goldsmiths, silversmiths and painters may have their shops in the public place, and so may sellers of drugs, habits and other creditable trades; but all nasty, stinking occupations should be

removed out of the way', and his advice was generally taken – the butchers' shops which sold the lamb, pork, kid and veal which were the staple food of the Florentines were some distance from residential areas.

There was, of course, poverty – as in any great city. The citizens did as much for the poor as any others of the time, supporting various charities through the Church, which in 1500 administered 24 nunneries, 5 abbeys and 2 priories, 2 orphanages and a large home for aged women. There was also a hostel where 1,000 pilgrims could sleep on feather beds, and 28 hospitals staffed by 60 physicians and surgeons. But charity was not enough to cope with the problems of the poorest citizens, who lived in damp, dark basements, sleeping on straw mattresses or loose straw thrown down on earth floors, forced to contrive what means they could to cope with the stench and filth, the ordure collecting in corners until it became so offensive that it must be removed. The more fortunate lived in hovels or shacks which were at least above ground, but which were still cold and damp in winter and broiling hot in summer, with the same insanitary conditions. No wonder that plague, when it took hold, flourished.

Aristocratic and middle-class Florentines – those who prided themselves on their houses and on the cleanliness of the streets outside their own doors – took care that they themselves were clean: baths were taken once a week in tubs of hot water or, more conveniently for the men, at one of four public baths run by Florentine barbers. The custom was, however, not universal – Michelangelo's father advised him never to wash, but rather to have himself 'rubbed down' by one of his assistants.

Both men and women were fond of such finery as they could afford: the women were known for their love of fashion – a look at portraits of the period shows them dressed in embroidered brocades, velvet, damask, silk of every shade, often with sleeves slashed to reveal a second colour. Innumerable silver buttons – sometimes as many as 200 – decorated each dress, accompanied by ornaments and jewels, giving business to the many jewellers of the city. Topaz was particularly popular because it was believed to protect the

wearer against lustful men. The men themselves were equally splendid in brightly coloured trunk-hose and jackets under ankle-length gowns with long flowing sleeves. On ceremonial occasions they would wear their swords hanging from beautifully designed belts, the buckles of which would be equally attractive (many goldsmiths made a good income by designing decorative buckles, medallions and cap-badges).

It is not easy to make sense of the way in which the top layer of society worked in the Florence of 1500, or indeed in most of the cities and duchies of Italy. The rulers of Florence, Naples, Sicily, and of course the pope, had their own courts, but the courtiers were by no means all rich and by no means all 'noble' – indeed, that word itself is difficult to define in the context of the time. Some courtiers were certainly members of ancient and distinguished families, but others were *nouveau riche* financiers. Next to a woman of fine lineage might stand one whose place at the court depended on her own personality and beauty, and often amorous skills. Then there were the artists – musicians, writers, architects, sculptors, painters – who were almost always relatively humbly born, and whose presence at court depended on their talent and skill, and also on the (frequently capricious) taste of their patrons. Though they reigned like little kings, the patrician families of the country almost invariably stressed their republican credentials. In Florence, the Medici, the Strozzi and the Rucellai were wealthy, and considered themselves to be natural rulers; but they insisted that they were staunch republicans – and it was not for another 250 years that a formal nobility was recognised, though in 1537 the Medici announced themselves as Dukes of Tuscany and Cosimo I reigned as a virtual monarch.

The Medici family – originally of Tuscan peasant origin – had been closely identified with Florence since the fourteenth century. Members of the family had set themselves up as rulers of Florence by the middle of the fifteenth century, and Cosimo the Elder (1389–1464) became an enormously important and valuable chief citizen. Although in 1433 he was forced to leave the city as the result of one of those sudden revolutions which occurred from time

to time in Italy throughout that period, he returned the following year and led the city until his death, pursuing a strategic foreign policy which succeeded in preserving the peace, and spending enormous sums of money on art and literature. He set up an academy for the study of philosophy, collected classical literary manuscripts and encouraged some of the finest artists of the day.

His grandson, Lorenzo 'The Magnificent' (1449–92), was an even more remarkable patron of the arts. Though himself extremely unprepossessing – an ill-favoured man with a broken nose who, peering short-sightedly at his beloved artworks, would comment on them in a high, squeaky voice – he nevertheless laid the foundations of a culture in which the artist was really important in the life of the state. A poet, he founded his own academy to study the antique world, which brought many Greek and Latin manuscripts to the notice of Western scholars, and supported Johannes Lascaris, the editor of the Greek Anthology, through whom he acquired over 200 manuscripts from the monastery of Mount Athos, forming the core of the Laurentian library (where his other manuscripts were also placed). He filled the Medici palace with handsome contemporary furniture, bronzes and majolica, and an unparalleled collection of gems, cameos and medals. He also set up in a garden near his palace a collection of antique sculpture which was not only accessible to the public, but was studied by young artists. Among these was the young Michelangelo, and Lorenzo's myopic but quick eye picked out the fifteen-year-old as a promising young sculptor, giving him rooms in the palace and a seat at his table, and later commissioning him to design the Medici tombs in Florence.

In 1500 the High Renaissance still flourished, and three of its greatest artists worked in Florence: da Vinci, Michelangelo and Raphael. The reason why Florence and its people – particularly, of course, the nobility and rulers of the city – were so hospitable to art is obscure; but the fact is that even the Romans were not more so. Apart from the work of the great triumvirate, Ghiberti and Donatello had produced wonderful statues of the patron saints for niches in the Or San Michele, and wealthy merchants – in particular the Medici – financed the building of palaces, churches and

monasteries, and saw that they were wonderfully decorated. Leonardo, who in the year of Cellini's birth was in Florence working on the Mona Lisa, four years later competed with Michelangelo for a commission for some battle paintings for the Signoria (neither artist won: the work was never completed). Piero di Cosimo also worked in the city; Fra Bartolomeo presided over the distinguished S. Marco workshop, a position which Fra Angelico had once held; the young Raphael was to arrive in 1504 at the age of twenty-one.

And then, above all, there was Michelangelo. Almost everyone in the city must have watched as the 29-year-old sculptor marshalled the slow procession of horses and forty workmen hauling the huge statue of David across the Piazza della Signoria, only its head protruding from the wooden casing, then the dismantling of the cradle and the revelation of the huge likeness of a recognisably human, but at the same time godlike, young man. Can there be any question that the event must have had a profound effect on a boy of six? Certainly the figure itself spoke to the heart of Benvenuto Cellini who was even at that early age susceptible to the beauty of that most stunning of tributes to the male body. His adoring hero-worship of Michelangelo was born at that moment, firing his appetite for beauty and his determination to make beautiful things.

ONE

Becoming Himself

In 1500, when Benvenuto Cellini was born, his family was already well established in Florence. In his *Life*, Cellini suggests without the slightest foundation that he was descended from a certain Fiorino who had left the village of Cellini to serve as an officer under Julius Caesar. More credibly, he traces his ancestry to a family living in the Val d'Ambra, between Siena and Arezzo, 100 kilometres south of Florence. The Cellinis, he says, were all hot-tempered fighting men, and his great-grandfather, Cristofano, had as a young man been forced to leave his birthplace because of an ungovernable feud between himself and the son of a neighbouring family. This vendetta became so splenetic that other relatives joined in, and in the end it was so troublesome that a serious attempt had to be made to dampen it down, and the young men at the centre of it were exiled from home – the neighbour's son to Siena and Cristofano to Florence, where he was established in a small house in the Via Chiara, close to San Lorenzo cathedral.

Cristofano settled down, wed, and brought up a family. After his death, his daughters having been married off, his sons inherited his house, which was finally settled on Andrea Cellini, who himself married and had four sons. These all seem to have had an artistic bent: the eldest, Andrea, became an architect, and the third, Giovanni, studied the same subject, though working professionally as an engineer, designing various pieces of building equipment (including an apparatus for raising and lowering bridges). He evidently had a number of interests – above all music, which he took up after reading what the first-century Roman architect Vitruvius recommended in his famous thesis *De Architectura*, that a study of music is essential for anyone interested in architecture. He played

15

both the viol and the flute, and made musical instruments – viols, lutes, harps, organs and harpsichords. But his main profession was carving in wood, bone and ivory.

In due course, Giovanni fell in love with Elisabetta Granacci, the daughter of a neighbour, and in about 1480 married her. There is no record of the marriage or of their ages, but the Florentines tended to marry late, and Giovanni may have been in his middle to late twenties. The couple was childless for the first eighteen years of their marriage, but then to their great pleasure Elisabetta conceived. Their doctor was blamed for her miscarriage – of still-born twins. Her next pregnancy went well, however, and a healthy daughter was born. When she fell pregnant for a third time, Elisabetta was convinced that she was carrying a girl and even chose a name for her – but to her delight, at 4.30 a.m. on the morning of 3 November 1500 she bore a son in their house in Borgo San Lorenzo, near what is now the fruit and vegetable market of Florence. Taking the infant in his arms, Giovanni exclaimed: 'Lord, I thank thee with my whole heart; this child is very dear to me. *Sia il benvenuto.*'[1] And so he was christened: the welcome child, Benvenuto.

Cellini's earliest memories were of two events which some commentators have called 'highly symbolic'. He was sitting by the fire with his father one evening, when the latter pointed into the flames, and gave the child a box on the ears. This was, he explained, so that Benvenuto would always remember the little creature which seemed to be gambolling unharmed amid the red-hot coals – something no one had ever seen before.

In classical times salamanders were alleged to be able not only to live in the heart of a fire, but by their extraordinary coldness actually to extinguish flames. For this reason they were said to represent chastity, the righteous souls who, sexless, are unconsumed by the fires of temptation.[2] An unlikely symbol to represent anything in Cellini's life, who was far from chaste, positively welcomed temptation, and in his sculpture celebrated the erotic lines of the bodies of both men and women. On the other hand, it is also true that the salamander was an emblem of the King of France, and Cellini believed that the incident was prophetic of the close

association he was later to have with the French court; he may have recalled it when in the 1540s he carved a salamander over the lunette he designed for King Francis I at Fontainebleau. There was also a salamander-like cooler side to his personality on which he could call when the violence of his Scorpionic temper, given full rein, might have ruined him.

The second incident had occurred a couple of years earlier, when he was two years old. His father and grandfather (the latter then over a hundred years old) were working on a water cistern when the child noticed something scramble from beneath it. It was an enormous scorpion, which he picked up and proudly showed the two men. They were horrified and tried to persuade him to drop it, but he refused. At last, his father managed to approach him with a pair of scissors and cut off its tail. Giovanni Cellini regarded the nearness of such danger, but with a happy outcome, as a good omen, while Benvenuto's identification with the Zodiac sign of Scorpio was strengthened by his later recollection of the incident. The two symbols together are emblematic of his life – the Scorpionic heat which drove him into so much trouble, and the coolness of the salamander which enabled him to subjugate his passions sufficiently to transmute emotion into art.

Benvenuto's father was determined, from his birth, that his son should be a musician, and had him taught the flute almost as soon as he could walk. Though he disliked the lessons intensely, the child became adept at a very early age, and while he was still virtually an infant was set to play the fife in a small band of musicians at the court of Lorenzo the Magnificent, to which his father had belonged. This appears to have been completely amateur, many of its members being distinguished Florentine merchants. To be a court musician was quite as reputable as being employed in making artworks – but when it was realised that Giovanni was spending far more time at music than at his bench, Lorenzo had him removed from the band, though he continued occasionally to play with them. Little Benvenuto appeared among the adult musicians while he was still young enough to have to be held up in someone's arms in order to be properly heard. Piero Soderini, who became head of state when

Piero de' Medici (Lorenzo's incompetent son) was exiled from Florence, complimented the child's father, though he trusted that the boy would also be taught some of Giovanni's skills as artist-craftsman. The father was reluctant: he taught Benvenuto to read and write, but wanted him to concentrate entirely on music.

Giovanni had benefited from the modern Renaissance view of education. A century earlier, he would positively have been discouraged from reading – the Church had always considered the study of literature a waste of time, preferring to concentrate on logic, law and theology. But in the middle of the fifteenth century the climate had changed, and students were encouraged by a new brand of humanist educators to study everything that appealed to the intellect of man – the work, for instance, of both Latin and Greek writers – *literæ humaniores* – as well as mathematics, astronomy, history, natural history, natural philosophy and music. The methods and curricula of the grammar schools of Europe were born, and largely born in Italy. From what we know of him, it is clear that Benvenuto's father benefited from this great sea-change – 'the Revival of Learning', as it was called – and passed on the benefit to his eldest son. Benvenuto's contemporaries mostly received their education from the parish priests, men who by all accounts were more often than not worse than useless as teachers. He himself had a much more liberal education, however it was acquired – certainly partly from his father – obtaining for instance at least a rudimentary knowledge of Greek and Roman myth.

From the start, he had no intention of fulfilling his father's ambition that he should become 'a great musician' – an instrumentalist and composer. Though he continued to practise and play the flute to please or placate his father, he knew at an early age that what he wanted was to be an artist. No doubt he was warned of the insecurity of the profession – music was, at that time, rather more likely to provide a regular income. The ability to print musical scores, which came at the turn of the century, had greatly encouraged both performance and composition, and by 1510–20 there was more music-making in Italy than there had ever been, and a great deal of it went on in Venice, which employed the greatest

organists of the day, although Rome, Florence, Ferrara, Mantua and Milan all had their musical establishments. A really accomplished musician would have no difficulty in making a good living here or there, at one court or the other. Italy had a great number of reasonably competent painters and sculptors, but relatively few competent musicians.

It soon became clear to Giovanni that his son only played the flute to please him, and that his paramount interest was in art. After some grumbling, he grudgingly accepted the fact, and allowed Benvenuto to begin to study with Michelangelo de' Brandini, a distinguished Florentine craftsman and artist (and the father of the sculptor Baccio Bandinelli, with whom Cellini was later to have many passages at arms). It must have seemed to the boy that he was on the way to achieving the training he wanted. But it was a short-lived triumph: after a few months he was removed from Brandini's workshop because Giovanni 'could not live without my being with him all the time'.[3] Even given the passionate love the father had for the son, this seems unlikely to have been the whole truth. Giovanni may have been aware of the ill-repute of some artists' studios, and in addition may have found Brandini uncouth – his father had been a blacksmith, whereas the Cellinis were firmly middle class.

Benvenuto was furious, and the next two years were extremely uncomfortable for the family, which now consisted of the two boys, and two daughters, Cosa and Liberata. Cellini barely mentions his mother in his memoirs; but she, and the other children, must have suffered from the continual disagreements between Benvenuto and his father. The boy continued to play the flute, under protest, and even learned the cornet, but never ceased nagging for permission to study art, and once or twice actually ran away, once as far as Siena – where a goldsmith called Francesco Castoro, who was working at the Duomo, took him in out of kindness and recognition of his talent. But it would have been unwise to keep a boy of thirteen or fourteen without his father's permission, and Castoro sent for Giovanni, who fetched his son home.

When he was fifteen, Benvenuto really put his foot down, and by dint of simple pig-headed insistence persuaded his father to

apprentice him to Antonio di Sandro di Paolo Giamberti, a distinguished Florentine goldsmith known as Marcone.

Benvenuto showed a talent for draftsmanship at a very early age. Though it was relatively easy for a lad to get a position as apprentice to a goldsmith or silversmith – there was always plenty of menial work to be done in and around the studios, such as sweeping the studio and keeping it tidy, which would involve no artistic talent whatsoever – there was never any question that Benvenuto was not worth training as an artist. From the first, every knowledgeable man or woman who saw any of his work recognised his artistry, and he himself was always perfectly confident of it.

His life now delighted him. He was in a privileged position among the apprentices, bound to Marcone but not paid by him – Giovanni had swallowed his pride and agreed to make his son an allowance, which meant that he could be independent of his master, and would not be forced to perform the menial duties that most apprentices were bound to do. Apart from that he received lessons in draughtsmanship, learned how to make small items of gold and jewellery and incise patterns on metal; there were also basic lessons in architecture. A promising apprentice might fairly early on be able to produce small items worth selling, for his own profit. Benvenuto did this, very successfully.

He was sufficiently grateful to his father to go home regularly, and even play the flute to him, but he was glad to be at last doing what he had always felt he was meant to do. He also enjoyed the relative freedom of living away from home – though his father must have been rather less sanguine, for the workshops and studios in which apprentices served their time while learning a trade or an art were notorious centres of homosexuality.

In most cultures where girls are very carefully protected, a boy's sexual education has been to some extent dominated by homosexual experience. In Renaissance Italy it was extremely difficult for a growing boy or young man to have any kind of intimate relationship with a girl, and heterosexual rape was treated as a very serious offence. So a boy's early sexual experience was almost always with another boy. Though there was severe punishment for boys who

molested girls, and serious penalties were available in cases where violence was used – the rape of a young boy, for instance – there was no sanction against mere homosexual skirmishing, and consensual sex between male adolescents was winked at even by their parents.[4] That has never been particularly unusual, even in the most traditionally heterosexual societies, but in Florence things went further than adolescent fumbling.

Of the places where young men indulged in homosexual sex, the *botteghe* were towards the top of the list. The studios and workrooms were reasonably private, and often included sleeping quarters for the apprentices. These were places where warm friendships were established between boys and young men in their early teens and mid-twenties – though older men were also often involved. But what could be called affectionate friendship apart, some workshops became unofficial brothels. In 1467 the shop of a well-known sculptor in wax, Francesco di Giuliano Benintendi, was described as 'full of boys', and he was said to encourage sodomy on the premises.[5]

Sodomy (which, incidentally, had various meanings – not only anal intercourse, whether with a man or woman, but mutual masturbation, fellatio or even mild sexual play) was officially illegal in Florence, and the Eight – the *Otto di Guardia a Balià*, a powerful and wide-ranging criminal court – was obliged to punish offenders. Torture could be used to exact confessions from the accused and corporal punishment was obligatory. For extreme offences – perhaps a very violent rape by an older man on a boy – the death penalty could be imposed. However, while Cellini was working in Marcone's *bottega*, a new and much more liberal law was passed which considerably restricted the punishment available to the Eight, making corporal punishment optional, and setting out a graduated list of fines ranging from 30 florins for youths aged between eighteen and twenty-five to 60 florins for older men. The death penalty was replaced by exile or loss of office-holding privileges.

There is no reason whatsoever to suppose that Cellini was assaulted by Marcone, but every reason to suspect that he was

introduced to the pleasures of sex by the other apprentices. Statistical evidence indicates that few young men between puberty and the middle twenties failed to enjoy themselves in that way, and Benvenuto's subsequent sex life suggests that he would have been unlikely to resist. The casual attitude to sex among his fellows, and to some extent the fact that several of those artists he valued most highly were homosexual, no doubt helped to convince him that, sexually, there was no need for him to live his life with one hand tied behind his back.

But sex was never as important to him as his work, and he was kept busy learning goldsmithing techniques – how to work with precious metals, how to handle files and pliers, scorpers and snarling-irons and the jeweller's saw; how to work with fire, how metal behaved when heated, how to draw out gold into the thinnest cords, how to be economical in the use of precious metals, how to model intricate decorations in wax and convert them into gold or silver. He also spent much time copying the drawings he most admired – he shared the Renaissance fascination with the nude male body, which he drew with dazzling facility.

However, his temperament did not permit him to be merely the student, spending every waking moment bent over the jeweller's bench. There was a life elsewhere, and he lived it with pleasure. Among the things he had already learned by the time he was sixteen was how to protect himself, how to use a sword and a dagger. The first recorded incidence of his being ready to take physical action when it was needed came on one hot afternoon in 1516, when his younger brother Giovanfrancesco, always known as Cecchino and quite as hot-tempered as Benvenuto, unwisely started a fight about nothing with a twenty-year-old. Reading Cellini's account of the incident, it is impossible not to be reminded of the opening scene of *Romeo and Juliet*:

Do you bite your thumb at us, sir?
I do bite my thumb, sir.
Do you bite your thumb at *us*, sir?
No, sir, I do not bite my thumb at you, sir; but I do bite my

thumb, sir.
Do you quarrel, sir?
Quarrel, sir? No, sir.
But if you do, sir, I am for you . . .[6]

At fourteen, Cecchino also carried a sword and knew how to use it – to such effect that he immediately wounded his antagonist. Onlookers began to join in the fray, which soon developed into a Montagu-and-Capulet brawl. A stone struck Cecchino and stunned him. Benvenuto, who had so far only been looking on and shouting to his brother to clear off home, now picked up Cecchino's sword and held off the antagonistic crowd until the pair were rescued by some soldiers.

After being carried home unconscious Cecchino recovered, and the brothers were brought before the Eight. They could have been treated very severely – they were both considered to be adults (minors were twelve years old or less) and might have been sent to the Bargello prison, or even worse to the Stinche, which was notoriously unpleasant. However, the court clearly took the view that the Cellinis were the less guilty party, for having imprisoned one or two of the mob who had pelted the brothers with stones, the magistrates merely ordered Benvenuto and Cecchino to take themselves off for six months to a distance of at least ten miles from the city.

Benvenuto decided to make for Siena and take refuge with Francesco Castoro, the goldsmith who had been kind to him a couple of years earlier. With Giovanni's permission, Castoro agreed to take the boy as a temporary apprentice. Giovanni had decided that his younger son should study law, but Cecchino was quite as antagonistic to the idea of becoming a lawyer as Benvenuto was to a career as a musician. He wanted to become a soldier.[7] In the meantime, he simply lounged around Siena enjoying himself. Meanwhile, Giovanni was at work trying to get his sons' sentence revoked. He appealed to Cardinal Giulio de' Medici (later Clement VII), who intervened, and the boys were allowed to return to Florence before the six months were up – where to Benvenuto's horror it was

proposed that he should go to Bologna to study music with a minor composer and instrumentalist called Ercole del Piffero.

He was having none of that. No sooner did he arrive in Bologna than he attached himself to an artist called Scipione Cavalette. Cavalette was a distinguished miniaturist, and Benvenuto learned much from him about portraiture and design. He also, he tells us, did some work for a rich Jew – though he does not say what sort of work, it was almost certainly the making of decorative buttons, buckles and basic jewellery. Within a few years he was producing very advanced pieces indeed – silver belt clasps and cap-brooches, settings for precious stones – with a natural talent and technique which advanced almost daily. He was able even at seventeen years of age to produce many pieces which Cavalette's customers were happy to purchase. In the meantime, admitting to himself that after all he did have a certain talent for music, he continued to take lessons in the flute and cornet, and evidently made progress, because when he returned to Florence and his father heard him play, he was even more enthusiastic about the possibility of persuading the young man to become a professional instrumentalist: 'I shall still make a marvellous musician out of him!' he declared.[8]

But Benvenuto did not stay long in Florence. Clearly he was irritated by the shackles of living at home, and found an excuse to leave when his sisters handed over to Cecchino some particularly fine clothing Benvenuto had bought for special occasions, and the fifteen-year-old made off with them. Giovanni made the mistake of excusing him, and Benvenuto caught at the excuse to fly into a rage and storm out of the house and the city, taking the road for Rome. Or so he thought. In fact, he missed his way and found himself in Lucca, where shrugging his shoulders he turned towards Pisa.

Even as an adolescent, Cellini never found it difficult to get work. Clearly, his talent was very obvious; but he must also have had a strong and appealing personality, a charisma which enabled him to charm those he needed to charm. At Pisa, for instance, simply by dint of standing by the side of a craftsman and admiringly scrutinising his work, he managed immediately to enter the studio of a well-known goldsmith, Uliviere della Chiostra, where he spent

some months working in gold and silver and studying the artworks of the city – the antique carvings in particular. He let his father know where he was, but came to regret that, for almost every post brought another letter imploring him to come home and nagging him to persist in his musical studies. Della Chiostra clearly liked him, for he lived as a member of the family, and felt so at home that for a while he was able to resist any nagging homesickness – his resistance strengthened by the fact that in letter after letter his father badgered him to return to Florence. As is not uncommon with young men, this simply encouraged him to stay where he was.

However, when della Chiostra travelled to Florence to sell some of his work, the boy agreed to accompany him, and despite himself was moved by his father's tearful welcome. He himself was somewhat tearful, for he had a touch of fever which had weakened him, and spent some time in bed – his father sitting next to him talking incessantly about music, so that in the end he sent for his flute and played a little. How he had improved, through all his practising, Giovanni said!

By the time Benvenuto was fully recovered, della Chiostra had returned to Pisa, and the former apprentice – now decidedly a young man – returned to the studio of his former master, Marcone. He continued to work in gold and silver and to improve his draughtsmanship – it was important to be able to produce beautifully drawn prospectuses of the jewellery he proposed to make, or designed on commission. Among other exercises, he made a copy of the cartoon Michelangelo had produced for the fresco intended for the Palazzo della Signoria – a scene of naked soldiers bathing in the Arno at the moment when an alarm was given for battle. This panorama of nude male figures in convoluted postures became a popular subject for young artists to copy, and was a difficult exercise to bring off with any success. Cellini certainly succeeded – and his copy was admired by a visitor to Florence, Piero Torrigiani, who had returned to Italy from London, where he had been at work on the bronze tombs of Henry VII and Elizabeth of York in Westminster Abbey. He came to Marcone's studio as part of a search for young assistants to return with him to England and help

him with that and other work, and immediately offered to train Cellini as a sculptor, especially in bronze. He thought, he said, looking at the copy of Michelangelo's cartoon, that Cellini was likely to be a better sculptor than goldsmith. We can only conjecture what might have happened had Benvenuto accepted the offer; he developed late as a sculptor – an early commitment to sculpture would have changed the whole course of his artistic life.

Cellini's reason for declining what was a tempting offer seems a little weak. In conversation (he tells us in the *Life*) Torrigiani made a serious mistake. As they were discussing the original cartoon, he casually remarked that he and Michelangelo had been students together when they were boys, and that in fact, provoked by some comment or other, he had broken the other's nose – and been exiled from Florence as a result. 'He'll carry my mark until he dies!' he said.

Cellini assures us that he could never have thought of working for someone who spoke of his idol in those terms – much less someone who had actually assaulted him, even as a child. He says that he immediately took against Torrigiani, and that nothing could have persuaded him to work for him. It is clear that the older man was splenetic and quick to anger (he had already boasted about the fear he had put into the coarse and brutal English with whom he was forced to work). Both he and Benvenuto were quick to quarrel, and when they did so the flying sparks were highly combustible. But perhaps there was another reason to reject his proposal: Benvenuto was doing very well as a designer of jewellery – the prospect of travelling to England as a mere assistant, and of committing himself to an uncertain future as a sculptor when he could clearly do well at home as a goldsmith and jeweller (Marcone now allowed him to sell whatever he produced for his own profit and the *réclame* of the studio) may well not have seemed as attractive as maintaining the status quo.

It was at this time that Benvenuto formed his first really passionate friendship – with a young man of his own age, Giovanni Francesco Lippi, a grandson of the well-known artist Filippo Lippi. They became inseparable, spending hours together poring over

books of drawings that Lippi's father had made from the antique. In his memoirs Cellini emphasises that their main pleasure was in studying these drawings; but in the oblique language he always uses about his relationships with boys and young men, he seems to be signalling that the friendship was something more. 'We were never apart, day or night,' he says; and 'we went together for about two years.'[9] In the atmosphere of Florence at the time, when applied to two boys of seventeen, this implies a sexual relationship – and a happy and rewarding one.

At some stage (perhaps there was a quarrel about Torrigiani, who may have complained to Marcone of his apprentice's rudeness and lack of gratitude) Benvenuto changed workshops, and joined that of Francesco Salimbene. While working there, he attracted the attention of the goldsmiths' guild of the city. There was a fashion, in the early years of the sixteenth century, for large ornamental belt-buckles, and Cellini designed one in silver which was particularly admired – it was about two to three inches in diameter, in low relief, and bore a pattern of leaves, together with little cherubs and masks. It was either noticed by, or he showed it to, members of the goldsmiths' guild, and was immediately recognised by his peers as a young craftsman of outstanding promise. The professional guilds were still extremely important to craftsmen, and had considerable control over who could practise a particular craft in a city. They were beginning to lose some of their power – most highly skilled craftsmen were less amenable to control than artisans, more often than not having influential friends among the wealthy citizens whose protection was more valuable and effective than that afforded by any 'union' – but membership of the goldsmiths' guild was still mandatory for all artists who worked in gold, and was therefore valuable to a young artist.

By the autumn of 1519 Benvenuto was beginning to feel restless. His father was still badgering him to become a full-time musician, and perhaps his relationship with Lippi had cooled off somewhat – he begins to speak of a new friend, Giambattista Tasso, a wood-carver. The two young men were always talking of going to Rome, and one evening as they strolled through Florence after dinner

Benvenuto pointed out impatiently that talk led nowhere, and that if they really meant to go to Rome they should do something about it. By this time they had reached the San Piero Gattolini gate – the gate by which one still leaves Florence to travel towards the Holy City. They looked at each other, threw their aprons over their shoulders, and set off along the road.

By the time they had walked the forty miles to Siena, Tasso announced that his feet hurt, and he was going home. But Cellini hired a horse, and the two young men mounted and 'singing songs and joking together' plodded on to Rome. He was, at nineteen, already thoroughly himself: fierce pride, quick temper, the capacity for hard and detailed work, a devotion to his craft and skill in its exercise. He was, entirely, Benvenuto Cellini.

TWO

'I Mean to be Free'

In the first decades of the sixteenth century Rome rivalled Florence as a centre of artistic excellence. In the years following his election in 1503, Pope Julius II had been a patron whose generosity – or as some would say, appetite for self-aggrandisement – financed many glories of the city.

Cardinal Giuliano della Rovera, who took the name Julius, was a nephew of Pope Sixtus IV. He had always been notoriously immoral, swore, drank and had three illegitimate daughters – which did nothing to quell strong rumours that he was in fact homosexual. He was a bitter foe of the Borgias, and secured the papacy by making liberal promises to the cardinals which he failed, after his election, to fulfil.

His patronage of the arts was in proportion to the enormous sums he raised through simony. Ambitious to leave his mark on the Holy City, he decided to tear down the basilica of San Pietro and have it raised again to a design by Donato Brabante, who was also instructed to enlarge the Vatican. He employed Raphael to embellish a suite of apartments there, and commanded Michelangelo to decorate the ceiling of the Sistine Chapel – resulting in the first case in the greatest allegorical paintings of the period, and in the second the most splendid and moving depiction of the creation.

In addition to the majestic major works by these masters the pope encouraged many minor artists, and his example was followed by members of his court and those Romans who wished to be acknowledged as members of the aristocracy. Many wealthy Romans became to a greater or lesser extent patrons of the arts, and painters, sculptors and craftsmen benefited from the circumstances – goldsmiths in particular, whose guild was reorganised in 1508 and given its official church (the Sant Eligio

degli Orefici) in recognition of the ingenuity of its members' crafts-manship and the excellence of their work.

When Julius II died in 1513, he was succeeded by Leo X – Giovanni de' Medici, Lorenzo's second son – who was an even more enthusiastic patron of the arts, though less discriminating than his predecessor. Created cardinal at the age of thirteen, Giovanni had had plenty of experience as a prince of the Church, but there is little evidence to suggest any devotion to a monastic life of simple prayer. His celebrated remark on his election, 'Now that God has given us the papacy, let us enjoy it!', may be apocryphal, but has a certain plausibility. A plump little man whose every finger bore a sparkling ring, he enjoyed parties, fireworks, ceremonial displays of horsemanship – indeed ostentatious displays of any sort, many of which were recorded in specially commissioned tapestries. He very soon lost the respect of his clergy – 'reverence for the Papacy has been lost in the hearts of men', the historian Francesco Guicciardini wrote in 1515; his reign was called 'the age of gold' because of the amount of money which he acquired through the sale of indulgences (he guaranteed, for a sufficient fee, the forgiveness of the sins not only of the living but the dead) and even so he was said to have spent six times the money he collected.

Despite his best intentions, somehow no commission which went out from the pope's throne produced a masterpiece. Raphael achieved nothing for Leo which could be compared in quality with his paintings for the *stanza* of the Vatican, and when Michelangelo was reluctantly persuaded to turn architect and design a façade for Brunelleschi's church of San Lorenzo, the result was a fiasco, the façade never in fact built, while the tomb for Julius II which Leo commissioned from him – with four huge statues representing St Paul, Moses, and the Active and Contemplative Life – was never finished (although the Pope constructed a 120-mile-long road especially to carry marble to the chapel for it). Michelangelo regarded this as the tragedy of his life.

But if the Pope failed to draw the highest achievements from the best artists, there was no shortage of commissions for silver and gold plate, both for ecclesiastical and lay purposes, while there was

also a taste for decorative jewellery: buttons, medallions and buckles for men, elaborate often enamelled settings for precious stones and cameos for women, seals and regalia and plate for cardinals.

Benvenuto Cellini, then, chose an excellent time at which to appear in Rome as a young man of talent and enthusiasm. On his arrival, he went straight to the workshops shared by the well-known goldsmiths Giovanni de' Giorgio, Giovanni da Caravaggio and Giannotto Giannotti. The main work done there was on the *lavori di minuteria* – church and table plate – ceremonial dishes, incense-burners, great silver salvers and dishes and vases. De' Giorgio, who worked under the name of Firenzuola and was the chief partner in the firm, recognised Benvenuto's talent when he was shown the large and elaborate silver buckle he had brought from Florence, immediately invited him to join the establishment, and set him to work on a silver salt-cellar which was being made for a cardinal, the design based on a well-known porphyry sarcophagus which then stood just outside the main entrance to the Pantheon[1] (it is now in the Lateran, on the tomb of Pope Clement XII).

Cellini was not content with the fairly simple copy which had been planned, and decorated the piece to his own taste with a number of exquisite miniature masks.[2] The result was admired not only by Firenzuola but by everyone to whom it was shown. Benvenuto was well paid for it, sent half of what he had earned back to Florence for his father, and used the rest to support himself while he wandered around Rome making studies from the antique. When the money ran out, he joined the workshop of a different goldsmith, Paolo Arsago, a Milanese whose showrooms were next to the church of San Eligio, the saint who was to be the patron of his art.[3]

Perhaps understandably, Firenzuola was not pleased by what he regarded as Cellini's defection; but when tackled on the matter, the young man was perfectly firm: 'As a free man, I said, I meant to be free, and go where I pleased . . . I'd finished the work I'd started, and I meant to be my own man. Anyone who wants my services should apply to me.'[4]

Firenzuola lost his temper, Cellini followed his example and laid his hand on his sword's hilt. This was a mistake, as he later admitted –

Firenzuola was a better swordsman than a goldsmith. Fortunately a man who had originally been Firenzuola's teacher, Antonio de' Fabbri, happened to pass by, and enquiring about the dispute took Benvenuto's side. The quarrel was resolved, at first grudgingly and later with more warmth – years later Cellini became godfather to one of Firenzuola's children.

He spent two years working as a freelance for Arsago and a number of other goldsmiths who had their own businesses. Then, towards the end of 1521, Pope Leo X died, and in January 1522 was succeeded by Adrian VI, a rather austere character from Utrecht (the last non-Italian Pope until modern times). His interest in art was minimal, and his disapproval of personal grandiloquence was clear. Work for goldsmiths, silversmiths and jewellers fell off severely (during his pontificate only one commission was received by a goldsmith).[5] Benvenuto packed his bags and returned to Florence.

His father, of course, was delighted when he went back to the workshop of his old master Salimbene, picked up his friendship with di Filippo, and ironically discovered that he really rather enjoyed playing his flute, spending rather too much time music-making with friends. However, he never let pleasure immoderately interfere with work, and setting up a small shop in a room borrowed from another goldsmith made a number of small pieces which he had no difficulty in selling, and a more ambitious, highly decorated silver girdle some three inches across which Raffaello Lapaccini, who had commissioned it, proudly showed around the city, attracting much admiration for his own taste and the skill of the artist who had made it.

In his *Life* Cellini records his progress over the next few months with some satisfaction, but understandably omits to mention that in January 1523 he was prosecuted for sodomy. He was summoned by the Eight to answer the charge that he and a friend, Giovanni di Ser Matteo Rigoli, had had sexual relations with Domenico di Ser Giuliano da Ripa.[6] We have no details, but it is reasonable to assume that the two accused men were of about the same age, and that Guiliano, the passive partner, was somewhat younger, perhaps an apprentice. More than likely the episode was the result of an evening spent in one of the taverns where such things were common-

place – somewhere like the Buco[7] just off the via Lambertesca near the Ponte Vecchio, where after a few hours drinking one could retire to rooms upstairs to complete the evening with a little dalliance. There was no suggestion of rape, and the Eight clearly regarded the offence as venial, for sentenced under the law of 1514 as an adult and a first offender Cellini was fined only *stariis duodecim farinae* –12 bushels of flour, to be given to the Franciscan convent of SS Annunziata delle Murate. Had the Eight regarded the offence as really culpable the affair might have cost him 30 gold florins – and apart from the fact that they only rarely dealt severely with such offences, they may well have known Cellini as a promising young artist, and have recalled that his great precursors Botticelli, Leonardo da Vinci and Donatello had all been accused of the same offence, and been excused by the authorities.

While from time to time during the previous century there had been a crackdown on homosexual offences in the city, during the first half of the sixteenth century they raised few eyebrows.[8] Young men went to it, and if they were under twenty-five the view was that they were indulging a youthful foible, extending their sexual experience before taking a wife and starting a family. Benvenuto never lived a monkish life, and it seems that he had at least one lover during this period – a young man called Piero Landi, the son of a prominent Florentine banker; in the kind of language he always uses when referring to homosexual affairs, he records that they 'loved each other more than if they had been brothers'.[9] There would normally be no fear of prosecution in such circumstances; indeed no prosecutions are recorded by the Eight except those made after a complaint by a private citizen, which seems to suggest that the prosecution brought against Cellini was spiteful.

Though there was plenty of work for all the goldsmiths in Florence, the world of the artist in precious metals was never so large that the appearance of a successful and ambitious young master was not likely to cause envy and jealousy, and later in 1523 there was an open and violent altercation between Cellini and the two most powerful goldsmiths in the city, Salvatore and Michele Guasconti. They owned three prosperous shops in Florence, and

Cellini's success in the city would have been regarded as serious competition. To lay information with the Eight about his homosexual adventures (he was never as discreet in his life as he is in his *Life*) would have seemed an easy way of discrediting him.

This would certainly have been one reason why he and the Guasconti family came to blows, one day in November 1523 in the Mercato Nuovo, outside one of the family's shops. He says one of the Guascontis began blackguarding him, and that when he replied (no doubt in similar terms) a Guasconti cousin, Gherardo, drove the heavily loaded mule he was leading into him. He immediately gave the man a tremendous slap on the side of the head. The family complained bitterly to the Eight, and Cellini was arrested.

The accusation was a serious one, for though he had struck a man 'with empty hands' – that is without an offensive weapon – and no blood had been shed, he had done so in the business district, where violence was strongly discouraged, and very near the man's own shop, which was regarded as being as sacrosanct as his home.

Both parties were made to sign a pledge of future good behaviour,[10] and Benvenuto was fined another 12 bushels of flour (had he assaulted the man in a less public and respectable locality the fine might have been only 4 bushels). He was allowed bail, and sent for a cousin of his, Annibale Librodori, and asked him to stand surety. For some reason, the man refused even to come to the Palazzo del Podestà, where the Eight met – at which Benvenuto unwisely lost his Scorpionic temper. Left alone while the guards went to lunch he walked out of the prison, went home and picked up a dagger, made his way to the Guascontis' shop in the Mercato Nuovo, climbed the stairs to the flat where the family was at their midday meal, shouted that he was going to kill the lot of them, stabbed Gherardo, injuring his kidneys and arms, and also knifed a friend of the family, Bartholomaeus Salvatoris de Genuensibus.

Calming down a little, he saw the danger in which he had placed himself. He had broken bail, defied the injunction of the Eight to keep the peace, and committed armed aggression and wounding. He had also attacked a family in what should have been the inviolate shelter of their home. Now, piling offence upon offence,

he decided to flee from justice rather than give himself up. He sought asylum at the cell of Fra Alessio Strozzi at Santa Maria Novella, who did not know him but nevertheless gave him a Dominican habit in which he left the city by the Prato gate, making for Siena. Piero Landi brought him ten crowns, a fine sword and a coat of mail for his defence, and the two young men wept as they bade each other farewell – Piero leaned forward at the last moment to pluck out a few hairs which had recently shown on Benvenuto's chin. The fugitive then set off for Rome.

His father was distraught, and went to the Palazzo del Podestà to plead on his knees for his son's life. The officers of the Eight were furious. 'Get up from there, and begone at once,' they told him, 'for tomorrow we shall send your son into the country with the lances.'[11] The significance of the phrase has been missed by some translators. Though public executions were sometimes held within the city, in the Piazza della Signoria, unimportant offenders were escorted by officers armed with lances to a place of execution known as the Pratello della Giustizia, outside the city walls – in 'the country'.

By fleeing from justice, Cellini, it seemed, had admitted his guilt. In his absence he was sentenced to death by hanging, and proclaimed by the town crier as a *bandito* (the usual sentence when a prisoner absconded). His name was written in the *libro dei banditi*, and apart from the fact that his civil and political rights were withdrawn, and any marriage he made would automatically become null and void, anyone who helped him would also be branded as a *bandito*. As for himself, if he was caught he could be executed without further trial.

On his way to Rome, Cellini heard that the pope had died – and that the new pope was to be Cardinal Giulio de' Medici, who took the title Clement VII. Everyone was pleased, Benvenuto among them. Another Medici on the papal throne; surely new and better commissions might be expected. Reaching the holy city, he went to the workshop of the late Santi di Cola, who for many years had been the most admired goldsmith in Rome – he had been head of the goldsmiths' guild and mace-bearer to the pope when Cellini was last in the city. The chief occupation of his *bottega* (now directed by a

young former pupil of Santi) was making ecclesiastical plate, often designed by artists such as Raphael, who had no knowledge of goldsmithing but produced drawings which were handed to the experts for translation into three dimensions.

It was a pupil of Raphael, one Gian Francesco Penni, who put Cellini's name before the Bishop of Salamanca, Don Francesco de Cabresa y Bobadilla, as the best possible craftsman to interpret his design for a huge ceremonial silver vase or ewer (in Italian, *acquereccie*). It was a handsome commission which would do the workman's reputation a great deal of good – the bishop was enormously rich and enormously influential.

During the months while he worked on the ewer, Benvenuto tells us that he had only one assistant, a fourteen-year-old boy called Paulino, whom he had employed against the advice of his friends (perhaps because they suspected his motives). He writes of his 'passionate love' for the lad, who had 'the most perfect manners, the most honest character, and the prettiest face of any I have ever come across in all my life. His honesty and amazing beauty and the great love he showed towards me made me love him in return – almost more than I could bear.'[12]

Paulino loved music, and was always encouraging his master to play the cornet to him, at which 'such a frank, beautiful smile came over his face that I am not at all surprised at those silly stories the Greeks wrote about their gods. In fact if Paulino had been alive in those days he might have driven them even more mad.' It is perhaps unnecessary to elaborate – but worth mentioning that Paulino had a sister called Faustina, described by Benvenuto as even more beautiful than the empress of the same name, who had been notorious for her beauty and lust. Here is the first hint in the *Life* that Cellini was capable of being quite as interested in women as in boys: 'her father would have liked me as a son-in-law', he says.[13]

Another woman came on the scene at about this time, and while there is no question of a sexual relationship, the incident shows how potent was the combination of Benvenuto's skill and personality. He continued his practice of taking a few hours away from work at the *bottega* when he could, to study and draw the architecture,

sculpture and other artworks of the city. It was possible for an artist of reputation and talent to gain admittance to private art collections, and Cellini obtained permission to study the magnificent work (including fine frescoes by Raphael, Sodoma and Peruzzi) displayed by Agostino Chigi, a wealthy Roman banker,[14] in his villa, the Farnesini, in Trastevere.

One day Chigi's wife Sulpizia happened to pass by as Benvenuto was sketching, and asked if she could see his drawings. When he showed them, she said it was difficult to believe that he was merely a goldsmith – surely he must be a painter. This was a compliment: a painter was a true artist – a goldsmith, however skilled, merely an artisan. However, taking advantage of his knowledge, she asked him to value a particularly impressive jewel – a lily made of diamonds and gold – and asked whether it would not be possible to set it more attractively. He drew her a design on the spot, and they chatted so familiarly that an elderly lady who came upon them was evidently slightly suspicious, for Sulpizia had to assure her that Benvenuto was 'good as well as handsome'.

The older lady was not convinced, and when Sulpizia gave Benvenuto twenty crowns and sent him away with the jewel, she clearly believed that they would never see him again. However, he returned with a wax model of the setting he proposed, and when that was approved worked on the setting itself, 'shaped like a lily, decorated with little masks and cherubs and animals, all of them exquisitely enamelled, so that the diamonds of which the lily was formed were enormously beautified'.[15]

Sulpizia was delighted with the result, paid him generously, and gave him several additional profitable commissions. Meanwhile, he must have been spending at least some of his time with music – perhaps playing for his own amusement with a few friends as well as serenading his apprentice – for news of his adeptness on the flute and cornet got abroad, and one of the members of the pope's private band, a musician called Giacomo da Cesena, invited him to play the treble cornet part in an instrumental motet to be performed at the Belvedere or summer villa of the Vatican on 1 August, during the Ferragosto festival – the feast of the Assumption of the Blessed Virgin.

He accepted, and practised with the band for two hours every day for a week.

The musicians performed while the pope was dining, and Clement was particularly impressed by Benvenuto's cornet-playing, summoning da Cesena to ask the identity of the young instrumentalist. The pope recognised the name Cellini, and sent an invitation for him to become a permanent member of the band, together with a gift of a hundred gold crowns (divided among the eight musicians). Da Cesena had warned His Holiness that Benvenuto would not wish to give up his profession to become a musician; the pope appears to have promised that he would see to it that Benvenuto received plenty of commissions to exercise both his talents. This seems to have tempted the young man, for he says in the *Life* that he allowed himself to be registered as a member of the band – an act which was to have a completely unexpected consequence a few months later.

All this somewhat interfered with the progress of the bishop's ewer, and it was increasingly difficult to explain to him why its delivery was continually delayed. Salamanca was rich enough to be accustomed to having his wishes granted almost before they were expressed, and became increasingly testy, sending his servants almost daily to enquire where the vase was – and once, when Cellini was not at the *bottega*, became so enraged that the workman was not at his bench that he threatened to cancel the commission. Finally, after three months, it was finished – the first truly monumental piece of plate Cellini ever made. In his *Treatise* on the subject he gives a detailed account of the technical problems and how he solved them, using methods he had learned in Rome. His studies had obviously been meticulous, embracing not only the arts of design and modelling, but of the mechanical tricks which could enliven otherwise static works, for he was able to make an extremely elaborate egg-shaped cup with extravagant handles, not only decorated with foliage and playful animals but with an ingenious lid which sprang open when a spring was pressed.

The bishop appeared to be well satisfied, and was particularly gratified when Lucagnolo da Jesi, who ran the Santi *bottega*, valued

it a great deal more highly than he had expected. Nevertheless, he was not ready to forgive Cellini for his dilatory attitude, and swore that he would take as long to pay the goldsmith as the latter had taken to complete the work.

There was little Cellini could do about that: for several reasons it would not do to grumble too openly – a rich patron who delayed payment was better than no patron at all, added to which the bishop was notoriously quick-tempered and had plenty of servants who could be relied upon to make life extremely uncomfortable for an impertinent employee. However, fortune put the means of redress in the goldsmith's hands, and quickly. The bishop, showing off the ewer to some friends, had left it in the hands of a Spanish nobleman who had interfered with the ingenious spring which opened the lid. Perspiring freely, the man brought the ewer to its maker for repair – and returned in a couple of hours pleading for its return, as the bishop wished to display it for someone else.

Cellini repaired the piece with ease and sent the bishop a message saying that he would happily return the ewer when he received payment for it. The Spaniard pleaded, and when that did no good gathered together a band of bravos to take the ewer by force. Benvenuto had meanwhile taken the precaution of loading a handgun; shown this, the Spaniards retreated, followed by the jeers of a small crowd of neighbours which had collected – the Romans had no love for the Spanish.

The bishop was furious – first that the situation had been allowed to arise, and second that Cellini had been permitted to get away with his impertinence. He sent a message that the ewer was to be delivered immediately, or the largest part of Cellini which remained would be his ears. Benvenuto threatened to place the whole matter before the pope for arbitration – then thought better of it, and took the ewer to the bishop's palace, taking the precaution of putting on a chain-mail vest and carrying a concealed dagger.

I made my way in, with Paulino at my side carrying the silver vase behind me. All the Bishop's people were in attendance. It was just like walking through the middle of the Zodiac – one of them

looked like a lion, another like a scorpion, the third like a crab, and so on, until we came face-to-face with that wretch of a priest. He started spitting Spanish like a madman; I just stared silently at the ground.

This made him even madder. He waved some writing paper at me, and insisted that I should write out a statement that I had received my payment, and was perfectly happy. I looked him straight in the face and said I'd certainly do that, as long as I first saw my money. He went red as a beetroot, and began blustering and threatening. However, I got my money, and I wrote him a receipt, and went away happy and satisfied.[16]

The pope heard about the story, and none too fond of the Spanish himself, was delighted by it. The Bishop of Salamanca thought better of his behaviour, and attempted a reconciliation with the goldsmith, which was roundly rejected.

Not for the first nor the last time, firm behaviour and a certain amount of bravado had paid off, for Pope Clement now instructed his cousin, Cardinal Innocenzo Cibo, whose skill as a politician was accompanied by great taste as a connoisseur of the arts, to see to it that Cellini was generously employed. There was an immediate commission for an even larger silver ewer.

Still only twenty-three, Cellini had achieved a commanding position in his profession, and recognition by the pope resulted during the next two or three years in almost more commissions than he could fulfil – pieces of ecclesiastical plate and jewellery, buckles and other personal ornaments for no less than three cardinals[17] and from other wealthy Romans. He also opened his own shop – at the suggestion of Sulpizia Chigi – and produced minor pieces of jewellery and plate to sell from it. The lack of any surviving pieces of his work is tragic; he is continually described as a master, even at a relatively early age. Giorgio Vasari in his brief biography of Cellini describes him as unequalled, producing work the like of which had not been seen for many years – objects such as the cap-badge or medal he designed and made for the Governor of Rome, Gabriello Ceserino, which bore a relief of Leda and the swan – a badge so fine

that it was valued much more highly than the governor had expected, and he declined to pay the price asked.

Then a surgeon, Giacomo Berengario da Carpi, who had come to Rome to make his fortune as a specialist in venereal disease, commissioned Benvenuto to make some small vases. Syphilis, from which Cellini himself was to suffer from time to time, had become a considerable problem in Italy by the 1520s – though it did not yet bear that name.[18] Astrologers claimed that the disease had suddenly swept the country because of the influence of a conjunction of Saturn and Mars, and as a student of astrology Cellini may well have accepted the theory (which was particularly prevalent in Italy).[19] But the way in which it was spread was no mystery, and many Italian cities stricken by venereal disease had attempted to outlaw prostitution and expel all prostitutes. Da Carpi certainly made a fortune in and around the papal court, treating the illness with mercury (administered mixed with pork fat), with sulphur, myrrh and incense and with *lignum vitae* or holy wood – guaiac, used by the natives of the American continent and brought to Europe by Spanish explorers; infused and administered for a month after a prolonged fast, it was said to be extraordinarily efficacious.

Having made his fortune, da Carpi spent much of it on personal jewellery and *objets d'art*, and Cellini's cups brought both him and his goldsmith a great deal of admiration – those to whom da Carpi showed them often refused to believe that they could be new: they must surely have been made by some ancient master? Word of mouth sent news of Cellini's skill, expertise and taste far and wide, and commissions came from outside Rome as well as from the wealthy of the city itself.

He did not rest on his laurels: he still found time to continue to study the ancient artworks of Rome and to draw them, and paid urchins to bring him bits and pieces of ancient sculpture they picked up around the ruins of the Forum and elsewhere – often pieces which could be refurbished, re-set, and sold at a considerable profit. He mentions a topaz carved as the head of Medusa and a cameo of Hercules and the three-headed dog Cerberus. Never proud where learning was concerned, he studied with other artists whom he

admired – from Lautizio di Meo, a Perugian goldsmith, he learned a great deal about how to make cardinals' seals; he worked with Cristoforo Foppa, an expert in enamelling and in the making of medals – he found the craft of enamelling enormously difficult, and wrote about it at length in his *Treatises*. Known as Caradosso, Foppa had been working in Rome since the turn of the century, and had been employed by three popes, making papal mitres and jewellery. Cellini learned an enormous amount from him – enough to be regarded, when Caradosso died, as his natural successor. Rich and influential Romans and Florentines competed to 'discover' promising young artists, and still in his early twenties Benvenuto was recognised as one of the most promising – indeed 'promise' is the wrong word; he was already remarkably mature both in designing and making highly embellished jewellery and plate.

Apart from all this, he enjoyed pigeon-shooting with Paulino in the ruins of the Colosseum or the Caracallus baths, using a fowling-piece he designed and made himself, primed with gunpowder he manufactured – so powerful that it could send a ball 200 yards. Then, in 1524, came an enforced rest. Plague had hit Rome, as it did from time to time, but now with an epidemic which was particularly severe. Though like every sensible person Cellini was apprehensive, he ignored the disease. He appears always to have been reasonably meticulous in his personal habits, and cleanliness at first protected him. However, one evening a friend brought a young woman to supper – a thirty-year-old prostitute called Faustina. Her age protected her from any amorous attention from Benvenuto – but she had with her a very beautiful thirteen- or fourteen-year-old maid, and when Faustina and Benvenuto's friend had retired to bed, he took the maid to his own room.

He had, he tells us, 'a wonderful time – much more enjoyable than [he] would have had with Faustina'[20] – but next day felt all the symptoms of the onset of the plague: exhaustion, headache, and a carbuncle on his wrist. His friend, the prostitute, and her maid immediately fled with all but one of Cellini's servants. 'I was left alone with a pathetic shop-boy who refused to leave me. I felt my heart was stifled, and I knew for certain that I was dead.'[21]

THREE

The Music of the Guns

Benvenuto's case was serious – there was no reliable remedy for the plague. He was lucky enough to be treated by a sensible doctor – the father of the single apprentice who chose to stay with him. Being in the service of Domenico di Cristofano Iacobacci, a distinguished Roman cardinal, the doctor was furious when his son tricked him into attending Benvenuto, and took every precaution against infection. Wearing long gloves and holding before his nose a sponge soaked in vinegar in which had been dissolved a powder of cloves and cinnamon, he concluded that Benvenuto's sickness was at such an early stage that rest, cleanliness and good food would result in recovery. He may have followed the practise of the best medical men of the period, and recommended that the sick man's room should be regularly ventilated, the doors and windows opened frequently during the day and at least once at night. This intelligent treatment was by no means common, and most people who caught the plague died of it. Between 1522 and 1528 the mortality rates were seven or eight times higher than normal in the worst affected areas – of which Tuscany was one, so Cellini was not only troubled on his own account, but for his family in Florence.

At a time when astrology was in the ascendancy, the scourge of plague was, as usual, blamed on the behaviour of the planets. There were no firm ideas as to treatment. Many doctors relied on magic, on elixirs like the *Flos Coeli* (made up from secret alchemical recipes) or on the curative powers of religious relics. Others lectured their patients on morals. One anonymous authority[1] suggested godly behaviour as a prophylactic:

First see the writing of Jeremiah the Prophet that a man ought to forsake evil things and do good deeds and meekly to confess his sins. For why it is the best remedy in time of pestilence – penance and confession to be preferred [to] all other medicines.

It was also important to avoid the disease spreading, and so, sensibly,

common baths are to be eschewed. For a little crust corrupts all the body. Therefore the people as much as is possible is to be eschewed, lest of infected breaths some man be infected. . . . Every foul stink is to be eschewed, of stable, stinking ways of streets, and namely of stinking dead carrion and most of stinking waters where in many places water is kept 2 days or 2 nights. Or else there be gutters of water cast under the earth which caused great stink and corruption. And of this cause some die in that house where such things happen, and in another house die none. . . .

As for remedy:

Bleedings, evacuations, and electuaries and cordials were used. The external swellings were softened with figs and cooked onions, peeled and mixed with yeast and butter, then opened and treated like ulcers. Carbuncles were cupped, scarified and cauterized. . . .[2]

Benvenuto suffered none of this. His close friend Giovanni Rigoli – the same Giovanni with whom he had been fined for 'obscene acts' in 1523 – nursed him and prepared good food, and he gradually recovered, recuperating by the sea at the village of Cervitere, near Bracciano, then returning to Rome to discover who among his friends and acquaintances had survived.

After any great emergency there is an air of relief and celebration, and Cellini and his friends marked their survival by forming a club for the most talented artists, sculptors and craftsmen of the city – a sort of dining club which met regularly for no better reason than the enjoyment of good food, wine and companionship. Among the

members were Giulio Romano, the painter and architect who was one of the creators of Mannerism, and Gian Francesco, the best of Raphael's pupils.

One weekend, it was decided that each member must bring his 'crow' or mistress to the next meeting, and that anyone who failed to do so should pay for a meal for the entire membership. Benvenuto had not got a regular mistress. He was under siege by a beautiful young woman called Pantasilea, who was pursuing him with avidity, but she was loved by his friend Francesco Ubertini, known as Bachiacca, and he was not inclined to succumb to her wiles. He had no desire to take some girl picked up off the streets, but was puzzled by the lack of a possible partner. Then he thought of Diego, a beautiful sixteen-year-old boy, the son of a Spanish coppersmith who lived next door. He was slovenly and ill-dressed, but had a wonderful complexion and stripped well – Benvenuto had made many drawings of him as the Emperor Hadrian's favourite Antinous, regarded as the ideal classical beauty. He persuaded the boy to dress in woman's clothes, arranged his hair around his pretty face, put pearl earrings in his ears and decorated his neck and hands with jewels. Diego was, not unnaturally, somewhat confused when he saw himself in the mirror, but agreed to accompany Benvenuto to supper, where he was introduced as Pomona.[3]

The entire company was dazzled by the beauty of Benvenuto's companion – the founder of the club, Michelagnolo di Bernardino di Michele (a sculptor who was working on the tomb of Pope Adrian VI, and an acknowledged connoisseur of female beauty) not only fell to his knees, but forced his friends also to bow before this wonder of loveliness. Diego clearly began to enjoy himself, blushing as the members of the club crowded round to kiss his cheeks while their own partners looked on with qualified rapture. When members began reading poetry, one of the activities of the club, Diego surprised Cellini by proving capable of reading a sonnet to great effect – and the membership was even more beguiled when the time came for singing and 'Pomona' showed off a beautiful (presumably unbroken) singing voice.

The women in the company were clearly by now in a highly irritated state, and Pantasilea in particular, infatuated with Benvenuto, set out to annoy 'Pomona' by twittering throughout his singing, and then by talking nonsense. Diego in turn got irritated and began twisting and turning in his seat. When one of his female neighbours asked what was wrong with him, he replied (ingeniously, he must have thought) that he believed he must be pregnant. At this, the ladies kindly began to feel his body for evidence, discovered he was a young man, and were furious. The men, however, thought it a great joke, and Benvenuto was acclaimed as its author.

Though his friends were delighted by Benvenuto's joke, Pantasilea, among the ladies, was outraged – not only had he spurned her when she made it quite clear that she wanted him, but he had appeared with a boy on his arm whose beauty had outshone her own. She was not going to forget the slur, and soon had an opportunity to – as she thought – put Benvenuto in his place.

At home in Florence he had got to know a handsome young Florentine called Luigi Pulci who had an exceptional singing voice – Michelangelo was among the many admirers who made a point of seeking the young man out whenever he performed. Benvenuto used often to accompany him on the flute, with a friend who played another instrument. Now, Luigi turned up in Rome and confessed that he had caught the pox (syphilis, the *mal francese* or French pox, was a major problem in northern Italy). Though neither Pulci nor his family had a good reputation (Luigi's father had been beheaded in 1532 for incest with his daughter), Benvenuto took him home, summoned da Carpi, who soon put him on the road to recovery, and provided him with books and other amusements while he was convalescing. Fully recovered, Luigi attached himself to the household of Girolamo Balbo, Bishop of Gurck in Corinthia and a Latin scholar, and became the lover of the bishop's nephew Giovanni. He perhaps attempted to keep this fact from Benvenuto, but when he began to appear every day in new and splendid velvet and silk clothing, was seen riding a mettlesome and clearly expensive horse, and entirely neglected scholarship in favour of more sensual pleasures, the inference was clear.

Benvenuto was the last person to rebuke a friend for enjoying pleasures to which he was himself addicted, and Luigi was after all an impoverished young man who had to make his way in the world, so when Giovanni asked his lover to introduce him to Benvenuto, the latter invited the pair to supper one evening. Pantasilea was among the guests, and immediately began to make eyes at the two handsome young men. Noticing this, Benvenuto took Luigi aside and warned him, without rancour, that he had best have nothing to do with her. At the same time, he gave a friendly hint that perhaps Luigi was becoming too much the slave of his passion for Giovanni. He himself enjoyed sexual pleasure keenly enough, but never allowed it to interfere with, much less take the place of, work, and warned his friend against an addiction to sex. Giovanni was notoriously fickle, and what would happen when he went after fresh game?

What followed might, if Benvenuto had had a less mercurial and jealous temper, suggest that his interest in Pantasilea was stronger than he protests. At a party she absented herself from her seat next to him, and he overheard her and Luigi giggling together in the street below. Though he claims not to have cared a straw for the woman, he leaped to his feet, crashed through a window knife in hand, and had the youth not leaped on his horse and escaped, might have done him a serious damage. When Cellini's friends remonstrated with him, he repeated that he was not in the least interested in the woman – what had offended him was the scorn with which an alleged friend had treated his advice, and the damage to his own pride.

His friends quietened him, but later that night he went to Pantasilea's house, secreted himself behind a thorn hedge, and waited. His old friend and Pantasilea's protector Bachiacca appeared – having guessed his intention – and pleaded with him to leave her and Luigi alone; they were not worth his attention. But Benvenuto was determined to teach them a lesson, and waited. When Luigi turned up, he was accompanied not only by the woman, but by an official of the pope and a number of soldiers, many of them bearing swords. Benvenuto was about to retire in the face of such numbers

when Luigi kissed Pantasilea and made a disparaging remark about Cellini. At this, enraged, he leaped from behind the hedge and before anyone could move struck Luigi a blow with his sword, which glanced off his coat of mail and also struck Pantasilea. He then laid about him at anyone who came near. In the subsequent confusion, he escaped – as did Bachiacca, slightly impeded by the fact that when the fight broke out he had been defecating behind the hedge, and was caught with his breeches about his ankles.

The papal official, who had seen all, insisted that a peace should be patched up – the pope was reluctant to prosecute one of the best-known and most accomplished artists in Rome because he had become embroiled in a fracas with a young sodomite and a well-known whore. The two men unenthusiastically embraced; and a few weeks later Luigi, showing off his horsemanship to Pantasilea, miscalculated a manoeuvre, the horse fell on him breaking his leg, and he died shortly afterwards in her house.

The incident seems to have more significance than Cellini gives it. Does he equivocate, in his *Life*, about the three-way relationship between Pantasilea, Luigi and himself? Could it be that the woman's clear malice against Benvenuto was not merely because he did not react to her blandishments, but because he showed that he was far more strongly attracted to Luigi? Did Luigi flirt with Pantasilea to teach Benvenuto a lesson because of the goldsmith's attempted interference in his relationship with Giovanni? This whole anecdote suggests that Benvenuto, while clearly bisexual, was actually more interested in men than women – a suggestion supposed by other incidents in his life.

The political scene now darkened, and Cellini was caught up in an event which shook Europe. In 1521 war had broken out between Francis I of France and the Holy Roman Emperor Charles V of Spain. For years King Francis had been competing with Charles V for the domination of Europe. The pope had supported both in turn – first the emperor, until 1525, and then the king. Now Francis's Imperial Army advanced on Rome under the renegade French nobleman Charles of Bourbon, the emperor's forces in Italy racing to reach Rome before the king's, to deal with the pope and bring him

to terms before the French army could relieve him. On the way, they bypassed the cities of Bologna and Florence, which avoided sacking by offering large indemnities. The pope attempted to do the same for Rome – but the agreement he made was dishonoured, and on 5 May 1527 an army of 40,000 men appeared outside the walls of the city. The following day they moved to attack.

The Imperial troops consisted of some 10,000 Lutherans, about 6,000 Spanish *tercieros*, legendarily fierce, cruel and unregenerate, and a numberless horde of assorted mercenaries who received no pay, and therefore sought out plunder.

The city was easily taken, and pillaged with the greatest violence. The pope rose from his knees in his private chapel in the Vatican and hurriedly took refuge with some of his cardinals in the Castel Sant' Angelo, which defended the Vatican quarter. They could only look on from a distance as the city was laid waste in the worst atrocity of the century. The Lutherans, extreme in their hatred of Catholicism, slaughtered every priest they found, razed altars and looted the wealth of the churches – antique statues, tapestries (including the series woven for the Sistine Chapel to designs by Raphael), stained glass and much ornate medieval gold and silver plate.

Cellini formed a band of some fifty youths whose temper was as high-spirited as his own, and accepted service with Alessandro del Bene, a friend and the head of a distinguished Roman family. On the day Charles of Bourbon entered Rome, Benvenuto, Alessandro and a mutual friend, Cecchino della Casa, went to the Porta Torrione, where they found the Roman forces about to retreat. They decided also to retire, but as they were turning, saw in the mist a group of men on horseback. Benvenuto raised his arquebus[4] and let loose two shots at the tallest. There was enormous confusion among the enemy, and climbing the parapet he was able to overhear cries that Charles of Bourbon himself had been killed. He immediately claimed that he himself had done the killing.[5]

He and his friend only reached the Castel Sant' Angelo with difficulty, forcing their way through the confusion (some of the commanders of the Roman troops were killing deserters who were

fleeing from the battlements). The portcullis was drawn up just as they entered the castel shortly after the pope. The huge building, which still lours over the Tiber, had been conceived by the Emperor Hadrian as his mausoleum, and its massive central keep was already 500 years old by the time of the Sack of Rome. It was as nearly impregnable as any building could be, but when Cellini reached it he found those supposed to defend it in a state of hysteria, many of the gunners neglecting their duty, simply staring over the battlements, tears streaming down their faces, at the fires which were consuming their homes.

Cellini was, he claims,[6] 'on the staff of the castle'; what this means, it appears, is simply that he was a *piffero*, or registered member of the pope's band, which made him formally a member of the papal household. But he now took control:

> I seized one of the fuses, got help from some of the men who were just standing around, and lined up some heavy pieces of artillery and falconets[7] on the enemy, firing them where I saw their support was needed. In this way I killed many of the enemy . . . I went on firing, with the blessings and cheers from a number of cardinals and noblemen to accompany my feat. The applause encouraged me to attempt the impossible. Anyway, all I need say is that it was through me that the castle was saved that morning, and because of me that the other bombardiers returned to their duty.[8]

There is little doubt that throughout the siege Cellini behaved not only with gallantry but with an acutely intelligent military instinct, and he probably does not make too great a claim when he suggests that he saved the day. There were those in the castel who certainly believed so – among them a young goldsmith called Raffaello da Montelupó, who had been in bed with his lover Vica d'Agobio when the fighting began, immediately leaped from the sheets, seized some shirts and a sword, left Vica to his own devices, and made his way to the castel to join the defenders. He witnessed and recorded many of Benvenuto's feats of arms,[9] and later confirmed that he had indeed been an heroic actor in the drama.

Antonio Santa Croce, into whose charge the pope had placed the castel, recognised Benvenuto's military talent, gave him a good supply of bread and wine and placed him at the highest platform of the castel with the best gunners available and instructions to do what he could. He was also charged with the important task of making sure that three cannon shots were fired each evening and three beacons lighted on the platform, as a signal to Francesco Maria della Rovere, Duke of Urbino – waiting with the Venetian forces, outside the city – that the castel had not surrendered.

The siege lasted a month, from 6 May until 5 June. The excitement and confusion of the time is vividly conveyed in Cellini's *Life*, and the vigour and enthusiasm with which he writes – even decades after the event – confirms the fact that he found soldiering extremely satisfying. He spent almost all his time with the guns – hand-guns and cannon – and his skill in handling them was much admired by the professional soldiers and by the cardinals, who showed such enthusiasm that he had to warn them to stand away – their red birettas made them far too good a target for comfort. He tells several highly coloured stories about the siege, the most fantastic of which is of a Spanish officer standing organising the digging of some trenches below the castel. Cellini aimed a falconet with care, and the ball struck the officer 'right in the middle' – he happened to be wearing his sword across his front, and the shot struck the sword and cut him neatly in two. The pope, who happened to be standing by, was 'astonished and delighted' and absolved Benvenuto 'of all the murders I had committed and all the murders I ever would commit in the service of the Apostolic Church'.[10]

He did not get away completely scot-free. On one occasion a cannon-shot hit the wall above him, and the masonry collapsed on him and knocked him unconscious, severely bruising his chest. A bystander ran for wine, heated it, soaked wormwood and applied it to Benvenuto's chest, whereupon he recovered – with some difficulty, however, as thinking him dead some friends had filled his mouth with earth (a common custom with those killed in battle), so that he had difficulty in breathing. But his recovery was complete, and such a minor injury was a small price to pay for the excitement

of the siege. Scarcely a day passed when he could not claim to have killed one or two of the enemy. He writes that he 'spent all my time firing away, almost every shot striking home. My drawing, my admirable studies, the music I loved playing were all forgotten in the music of the guns. . . .'[11] He quite genuinely felt that he was better and more useful at soldiering than at his usual occupation.

He was now to be additionally useful to the pope, who one day after prayer in the little chapel Michelangelo had built for Leo X on one of the ramparts of the castel summoned Benvenuto to a private conference attended only by himself and a Frenchman called Cavalierino, a lowly born but well-trusted servant. In front of them, on a table, lay a quantity of jewellery – tiaras, rings, encrusted vessels, all from the Treasury of San Pietro. Cellini was instructed to remove the jewels from their settings, and he and Cavalierino sewed them into the lining of the Frenchman's and the pope's clothes. Cellini was then instructed to melt down all the gold. He built a small furnace in his room at the castel, placed a dish beneath it, and threw the wrecked gold settings on to the coals. The gold dripped slowly into the dish while Benvenuto, at the window, continued to fire at the enemy. There was some dissension at his continuing to fire while peace overtures were being made, but he was not the man to obey orders he considered mistaken, and persisted – he claims to have injured the Prince of Orange with one of the shots from his falconet.

When the gold was all melted, he took it to the pope, who gave him twenty-five *scudi*. Two days later, on 5 June, peace was declared, the pope agreeing to remain a prisoner in the castel at the discretion of the emperor. The defenders were allowed to leave, and Cellini made eagerly for Florence to discover how his family was faring. He travelled part of the way with Orazio Bagliuoni, a *condottiere* whom the pope had appointed to defend Rome. Bagliuoni was on the way to Perugia with a company of 300 men, and asked Benvenuto to command the force while he devoted his time to overseeing the general campaign. Benvenuto decided against it; he wanted to go directly to Florence, but agreed to help as best he could with recruitment when he was there.

His father, happily, had escaped the plague, as had his elder sister Cosa. His younger sister Liperata had lost her husband and child; but just as Benvenuto arrived was married a second time, to a sculptor. They were all delighted to see him, and Giovanni was specially pleased at the money he had brought with him; but not pleased to hear that Benvenuto was considering an army career. There was already one soldier in the family – Cecchino – and that was quite enough.

Giovanni Cellini was insistent that it would be best for Benvenuto to go on immediately to Mantua, a city not yet infested.[12] It had less than half the population of Florence, but the Duke, Federigo II Gonzaga, was one of the greatest of all those rulers who made the city a centre of cultural splendour, and whose patronage of writers and artists was to become legendary. Cellini would be likely to find very profitable employment there.

That was probably not Giovanni's only reason for persuading his son to leave Florence almost as soon as he had got there. The city had been through its own difficulties over the past year. When Cardinal Giulio de' Medici was elected Pope as Clement VII, he moved from Florence (which Leo X had sent him to rule in 1519) to Rome, and was concerned about the future rulership of the former city. He produced, as though from the bishop's mitre, two previously unknown Medici boys, Ippolito and Alessandro. Both were bastards, and the paternity of both was highly questionable. Ippolito, who was twelve (and already a cardinal) was said to be the illegitimate son of Giuliano, Duke of Nemours, and an unidentified mother; Alessandro – the future Duke of Florence – who was possibly somewhat older than his brother, was said to be the son of Lorenzo, Duke of Urbino, who had ruled in Florence just before his death in 1519. Most people then, and most authorities now, believe him to have been Pope Clement's son.

The two boys were put in the care of a Cardinal Passerini, and were raised to rule Florence. The citizens were not pleased – they did not so much object to the boys themselves as to their guardian, who was an avaricious bully. When Pope Clement was under siege in Rome, they took their opportunity and rebelled – on 17 May 1527,

Passerini and his two wards slunk out of the city, and the Florentines sang in the streets.[13] The city settled down to a system of democratic rule, with a Grand Council and an elected seigniory, or council of eight priors, and a *gonfalonier* or Justice.

But the situation was uneasy, and knowing Benvenuto's flair for getting into trouble, Giovanni was eager to get him out of the way. Hence his insistence on Mantua.

The journey was fraught with difficulty in time of war and with plague raging across the country, but Cellini made it without too much trouble, and arriving called on Niccolò d'Asti, goldsmith to the duke, who knew him by reputation and was pleased to employ him. He also called on an old friend, Giulio Romano, who he had known in Rome, and who had made a fine career for himself in Mantua as Vicar of the Court, superior general of the Gonzaga palaces and superintendent of the streets of the city. He was working on the final stages of building the Palazzó del Te outside the city, designing plate for the duke's table, and collecting antiquities to add to his collection.

Romano took Cellini before the duke and spoke enthusiastically of his work – commending him so strongly that the duke commissioned him to prepare a highly important work: a reliquary for the blood of Christ which was believed to have been brought to Mantua by Longinus.[14] Benvenuto made a wax model of the reliquary, which much impressed the duke, but it was never executed – perhaps because of the jealousy of Mantuan goldsmiths.

He also worked on a number of seals. Every cardinal, when appointed, needed a seal, and there was some competition for the most beautiful design. Cellini began to learn the craft of seal-making from 'a certain master from Perugia, called Lautizio, who practised nothing else but the making of seals for the bulls of cardinals, bearing their titles and rebus. Lautizio was paid at least 100 scudi for each seal he made',[15] so it was a profitable occupation.

Cellini was commissioned to prepare a seal for the brother of the duke, Ercole Gonzaga, raised to the purple by the pope in May 1527. He spent four months making it, in silver, engraving in fine detail the ascension of the Virgin and the twelve apostles. He was

paid 200 ducats for his work – the seal, alas, has not survived, but is said to have displayed a remarkable elaboration on the more usual designs for cardinals' seals. He made other seals during this period, some of which he describes in his *Treatise on Goldsmiths' Work* – one, for instance, for the Cardinal of Ferrara, for which he received 300 ducats:

> On [it] was engraved St Ambrose on horseback, with a whip in his hand chastising the Arians. And as two stories had to be wrought upon it, for the Cardinal had a two-fold title, it was divided down the middle and the legend of John the Baptist preaching in the desert was engraved on the other part, and both subjects were wrought with figures.[16]

In 1528 news came that the epidemic of plague in Florence and Rome had died down, and Cellini decided to return to the Holy City. En route he stopped in Florence, where he found his home empty – or rather occupied only by an unfamiliar old woman who immediately began cursing him. Hearing the noise, a neighbour came out – to tell Benvenuto that his entire family had died of the plague. He had naturally feared that this might be so – and was all the more delighted to discover that his brother Cecchino had in fact survived; when they met, Cecchino took him to his sister Liperata, who now had a small son. She fell into his arms with such enthusiasm that her husband, coming suddenly in, was suspicious about the relationship – but the misunderstanding was soon settled, and the four adults together with Benvenuto's little nephew sat down happily to supper and gossip.

He heard, among other things, that the pope was still determined (as far as anyone knew) that the pair of bastards should rule Florence, and that he had appointed one Bartolomeo Valori to prepare an assault on Florence, and made funds available to support it. The city had enlarged its militia, intensified its training and hired mercenaries (Cecchino among them) and was seriously worried about the state of the always nugatory fortifications. Happily, Michelangelo had just returned to Florence, where he had been

commissioned to complete a colossal statue of Hercules which had been started by a rival as a companion piece to his own *David*, already standing in the Piazza della Signoria. The Grand Council appealed to him to help redesign the fortifications, and as a lover of the city he immediately accepted an appointment as supervisor.

Despite the uneasy situation – or perhaps because of it (he always relished excitement) – Benvenuto decided to remain in Florence for a while. There were few decades of the sixteenth century when there was little artistic activity in Florence. At this time Pontormo was painting his great *Deposition* and his *Martyrdom of the Theban Legion* with its almost obsessive concentration on violence and horror, Andrea del Sarto, the best painter in the city, had just finished work on the series of *grisailles* in the Church of the Scalzi, and other painters including Bronzino, Vasari and Salviati and such sculptors as Ammanati and Giovanni da Bologna were also busy in their studios.

Cellini took a shop in the Nuovo Mercato, where he was soon doing good business. A wealthy Sienese merchant, Girolamo Marretti, who had made a fortune trading in Turkey, commissioned a gold medal bearing a figure of Hercules forcing open the jaws of the Nemean lion. Michelangelo, who had taken to dropping in to see Benvenuto at work, was extremely complimentary about his skill – and particularly about the piece he designed for Marretti. He told Benvenuto that if the medal had been larger and made in marble or bronze it would have astonished everyone. 'Even at its present size,' said Cellini's great hero, 'it is so beautiful that I don't think even a goldsmith of the old world made anything to compare with it.'[17] Such praise, supported by the fact that Michelangelo started sending to him a number of people who had asked the greater artist himself to prepare designs for them, must have delighted the goldsmith immeasurably.

Florence, though its citizens always had time and money to commission gold medals to wear in their hats (Cellini designed one which Michelangelo said 'would astonish the world'), was now seriously preparing for a siege, and Cellini made ready to join in any action. However, one day when he was involved in a heated

discussion with a shop full of fiery young men, he was handed a letter from an acquaintance in Rome, a textile designer called Jacopa della Barca, who was a close acquaintance of the pope's. Clement had, he told Cellini, ordered him to write to him commanding that he return to Rome. Any supposition that a Florentine might be prepared to work for, with or under Pope Clement VII would not have been popular, and Benvenuto must have been distinctly worried when his friends started asking what was in the letter. He was even more worried when another letter arrived promising extravagant and remunerative commissions, and expressed surprise that he might be thinking of remaining in Florence to fight against the pope with a load of rebels.

There is no doubt that Cellini loved his native city; but he also loved his work, and he was not averse to making money from it. He decided to leave Florence for Rome. The decision presented its difficulties, for Florence was more or less under martial law, and to leave it was tantamount to desertion, and could involve the confiscation of all personal property. The advantage of rejoining the pope and once more being in receipt of Medici patronage was strong, however. Benvenuto went to his former lover, Piero Landi, and handed him the keys of his shop, with instructions to see that certain people received certain work which was owed to them, and to keep the rest of the contents safe.

Then, very quietly indeed, he left for Rome.

FOUR

Murder, Revenge and Magic

Cellini returned to Rome in the middle of 1529, and perhaps because he did not wish to give the impression that he had rushed there over-hastily at the first hint of renewed patronage – and also maybe feeling a little guilty at having deserted his friends in Florence – neglected to pay immediate court to the pope. Instead, he accepted the invitation of an elderly goldsmith, Rafaelle del Moro, to join his workshop, which was patronised by Clement VII, and so could in due course be a stepping-stone back to the papal court.

After the Sack of Rome, the pope had for a time been virtually the prisoner of Charles V of Spain, his future dependent on the result of the struggle between Charles and Francis I of France. In 1528, Francis's army in Italy was forced to surrender (mainly as the result of a dreadful pestilence which decimated his forces), and it was clear that France's influence in the region would be negligible for some time to come. Clement, who had been vacillating for years, was forced to come to terms with Charles. Fortunately for him the latter was a devout Catholic, and felt ashamed at the humiliation of the head of the Church, so he was inclined to be generous. Signing the peace treaty of Barcelona in June 1529, the pope officiated eight months later, in Bologna, at Charles's coronation as Holy Roman Emperor. On 12 August the same year the besieged city of Florence capitulated, surrendering not to the pope, but to the emperor.

After a fortnight during which he settled down to some relatively unimportant work at the *bottega*, setting jewels and working with lapis lazuli, Cellini accidentally encountered della Barca, the man who had prompted his return, who insisted that he should pay his respects to Pope Clement at the earliest opportunity. On the Thursday of Holy Week Benvenuto found the pope abed 'with a

slight illness', kissed his feet, and whispered a confession that he had stolen some residue gold which had remained in the ashes of the improvised furnace in which he had melted down some of the papal regalia at the castel during the siege.

The pope immediately forgave him – the gold had been worth only about 140 *scudi*, with which, Benvenuto said, he had paid for his journey to Florence, giving the rest to his father. The reason for the 'confession' is obscure – possibly there were already rumours that Cellini had made away with some of the Vatican's treasure, or perhaps he believed the pope might be seriously offended by his delay in returning to Rome, and was deliberately putting himself in the wrong by confessing to a minor offence which he knew Clement would be likely to forgive. At all events, the pope said that Cellini had been so useful to him that he would have been perfectly happy had he taken a whole tiara, and immediately began discussing possible commissions. At first he thought of asking Cellini to remake the tiaras which he had dismantled at the castel – but then thought of a more important commission. He needed, he told the artist, a button or morse for his cope – that is, a ceremonial clasp, about 6 inches or 15 centimetres in diameter. It should bear the image of God the Father in half-relief, and be decorated with one large finely cut diamond and a number of other precious stones.

The commission was an extremely important one – not only would Cellini's work be on display every time the pope appeared on a notable occasion, but the diamond which he was to set at the centre of the morse was said to be the second largest in the world, and would always attract attention. Unsurprisingly, the other members of the Goldsmiths' Guild were extremely jealous – in particular a distinguished elder called Michele, who clearly thought he should have been given the commission. He immediately set about making mischief by asking thirty of the best-known goldsmiths in the city to prepare their own designs for the morse, and trying to persuade the pope that the young Florentine goldsmith was not experienced enough to do the work.

The pope agreed to look at the competing designs, and did so. It is not known how many other artists submitted work, nor their

names, but it is clear that they could not compete with Cellini, whose model was so ambitious that Clement's one reservation was that it might be too difficult to work in gold – at which Benvenuto said that if the final result was not ten times better than the model, he would accept no payment for it. There was immediate uproar among his rivals at this upstart proposal – but the pope sent for 500 gold *scudi*, handed them to Cellini, and urged him to finish the work as soon as possible, while he was still alive (his slight sickness had concentrated his mind on his mortality).

From time to time, Cellini brought the unfinished morse to show the pope. He devised a new way of working which speeded up the progress. Goldsmiths had formerly started with a wax model which was then cast in bronze, to which the gold was applied in layers until the sections in relief were sufficiently distinct. It was a slow process. Cellini preferred to work on the gold itself, dispensing with the bronze. This was a dangerous procedure, for great skill was needed to avoid crudeness and defects in the surface of the gold; but clearly he succeeded in producing a masterpiece.

Unfortunately, the morse has not survived – it seems to have been melted down in 1797 by Pope Pius VI to help raise money for an indemnity paid to Napoleon. Fortunately, three fairly detailed drawings of it were made in 1729 by an Italian artist, Francesco Santi Bartoli. On the back of the drawings, he made notes describing the morse:[1]

Obverse. The famous Pectoral of Gold made by Pope Clement 7th, adorned wth Figures in Relievo Basso and Alto-relievo. In ye middle is a pointed Diamond, which they say cost ye Pope 3800 Roman Scudi. It is sett wth 4 very fine Emeralds, 2 exceeding large and fine Saphirs, & 2 very fair Ruby-balasses. It is kept in ye Castle of St Angelo, wth the Triple Crowns, & is not to be taken thence but when ye Pope sais Solemn Mass. This rare piece is valued at 15000 Sterling. Ye workman was Benvenuto Cellini a sculptor and silversmith a Native of Tuscany.
Reverse. The back part of the said Pectoral shewing ye Arms & Impresses of Pope Clement, finely embossed in gold.

Rim. The profile of ye same Pectoral adorn'd with Figures in Bass-relievo and finely enamell'd.

Despite its solemn context, the design – as Bartoli's drawing shows – was delightfully light-hearted. The obverse showed God the Father sitting on the huge diamond, which formed His throne, His right hand lifted in blessing, His left holding an orb. He wore an emerald as a crown, and was surrounded by putti or cherubs, all at work supporting the other precious stones set in the gold morse. Two of them sat comfortably on emeralds, with two enormous sapphires on their shoulders. Two more, at the bottom of the morse, leaned with their backs against two huge rubies, their hands joined over the top of another emerald. Other putti peeped out from under God's cloak and played amiably with its flowing draperies, cheerfully smiling at the beholder. It is a piece whose charm must have been quite as notable as its spiritual fervour.

Cellini says in his own description of the work that the scene was in high relief, and it must have been original not only in conception but execution (at one point a cherub's head actually nods out in front of the sapphire he is holding). The drawing of the morse's profile shows that the stones stood out considerably from its surface – the diamond in particular – and a strong feature of the reverse was a pair of lions' heads holding a hooped loop or fibula of gold by which the morse was attached to the pope's cope. On the face itself were the Medici arms, one of the six balls enamelled with a tiny *fleur-de-lys*, above this the papal tiara; on one side of the armorial shield, towards the bottom, was an eagle holding a snake, on the other a laurel tree and a brightly shining sun.

The morse must have been a superbly effective piece of jewellery, and Cellini can be believed when he writes that 'everyone said it was the most beautiful piece of craftsmanship ever seen in Rome'.[2] There was something of a drama while he was working on it. The pope had sent him all the jewels which he wanted set except the enormous diamond, which he kept in his own possession until the last possible moment. These were kept in Cellini's workshop with other precious stones he was setting for other people, and with a certain amount of

gold and silver for everyday use in the business. While presumably Benvenuto's five workmen were sworn to secrecy, and his impressive 'shop' in the Via dei Banchi Nuovi obviously did not have plate-glass windows with expensive goods on display, it must have been clear to everyone that such a successful goldsmith's *bottega* contained valuable material. So it should have been no surprise when the watchdog (a spaniel given to Cellini by Alessandro de' Medici as a hunting-dog)[3] started barking in the night. A robber had forced entry, collected a few handfuls of precious stones which had been left lying about, and was attempting to force some drawers containing more valuable jewels.

Unfortunately, Benvenuto himself was abed with one of his female models, and as usual on such occasions was sleeping in a room which was at a tactful distance from the rooms in which the workmen slept. Moreover, he was soundly asleep, and so, it seems, were his workmen – so soundly that even when the dog ran upstairs into their bedroom he could not at first rouse them; and when he succeeded in doing so, they simply cursed and threw things at him to quieten him. He then ran downstairs again to the shop and attacked the thief, who was just leaving. He refused to let go of the man's cloak until the thief called for help, asserting that he was being attacked by a mad dog. Some neighbours came out and helped him drive the spaniel off.

Next morning, chaos in the *bottega* revealed that someone had turned it over; Cellini's workmen, dressed only in their shirts – the thief had stolen their clothes, which they had left in the workroom – were terrified that the pope's jewels might have been taken. Happily, the thief had not found them, and at first the incident did not seem to have done much damage – but Cellini found soon enough that some of his enemies at court were hinting that he had made up a story about a robbery because he was himself preparing to steal the pope's jewels. (Though the pope declined to believe them, he privately arranged for Benvenuto to be watched in case he showed signs of leaving Rome.)

A few days later he was walking in the Piazza Navona with his dog when the animal began barking madly and then threw himself

on a young man who was being taken into the police headquarters under arrest on suspicion of theft. The spaniel became so violent that the police threatened to kill him if Cellini did not keep him under control – but then the suspected thief dropped a paper parcel, out of which fell a small ring which Cellini recognised as one of his own. The man immediately confessed, and handed over some pieces of rough gold and silver, some more rings, and 25 *scudi*, together with goods he had stolen from someone else. He begged for mercy, but no one was impressed, and the man was hanged a few days later in the Campo di Fiore.

A much more serious incident followed. One of the stipulations of the surrender of Florence to the emperor was that the bastard Alessandro de' Medici and his heirs should be named as the city's future governors, and the pope gave him the title of Duke of Penna. To mark the occasion Alessandro made a formal visit to Rome, with members of the Bande Nere accompanying him as a ceremonial but also an active guard, one of whom was Benvenuto's brother Cecchino.

The pope's police, or *sbirri*, had an extremely bad reputation, being in general brutal and corrupt, recruited from the dregs of society, and when irritated by the very presence of the bande they made an excuse to arrest one of its members, there was bound to be trouble. As the prisoner was being taken through the streets an attempt at rescue was made by some of his friends. During a brutal fight (only four of the bande against much superior numbers – but the former relished such odds) Cecchino's closest friend, Bertino Aldobrandi, was seriously wounded. When Cecchino was mistakenly told that his friend had been killed, he went mad with fury, and given a description of the man who had been seen to do the deed, chased after the police and ran the supposed killer through the stomach with such force that his sword pinned him to the ground. The police, even in their superior numbers panicked by the fury of the young man, fired on him, and an arquebus ball struck him in the right leg.

Cellini, who happened to have been dining close by – the incident took place near his shop in the Via Banchi – appeared on the scene, and found his brother severely injured,[4] the *sbirri* standing by waiting for further orders from the Bargello or chief of police,

Maffio di Giovanni. He was an extremely unpopular man – as were all of his rank: it was seriously said to be the ambition of all spirited young men in Rome to murder the current Bargello.[5] He was not, therefore, happy to face any antagonistic citizen, much less the infuriated Cellini. Fortunately for him a Florentine friend of Benvenuto's who happened to be present restrained him, shouting to Maffio to leave before he was attacked. The Bargello and his men immediately took refuge in the Torre di Nona, a prison behind the Piazza Navona, and Benvenuto had Cecchino carried into a nearby house; while doctors were discussing whether or not to amputate his leg, Alessandro himself appeared – Cecchino was apparently much admired by the future Duke of Florence – and instructed that he was to have the most attentive medical care.

The doctors were presumably incompetent, for the injured man's wound was allowed to bleed so copiously that he rapidly weakened. While still in possession of his senses, he took leave of his commander, Alessandro, with the words: 'My Lord, this only grieves me, that your Excellency is losing a servant than whom you may perchance find men more valiant in the profession of arms, but none more lovingly and loyally devoted to your service than I have been.'[6] In the early morning of the following day, he became delirious, believed he was being pursued, and threw his legs in the air as though trying to mount a horse; then he said 'Goodbye' very clearly, three times, and died.

Benvenuto buried his brother only a few yards from his workshop, in the church of San Giovanni dei Fiorentini – the Florentine church in Rome – and placed a finely carved memorial stone with a graceful epitaph:

To Francesco Cellini, a Florentine who after achieving many victories while still young under the command of Giovanni de' Medici, whose standard-bearer he was, proved clearly of what strength and intelligence he would have been capable had he not been struck down by cruel fate and an arquebus and died in his twenty-fifth year.[7] Erected by his brother Benvenuto. He died on 27 May 1529.

Cecchino had not been an insignificant figure; his exploits were widely known – his contemporary, Giorgio Vasari, gives an account of his life in his book on Florentine worthies, *Storia Fiorentina*, and his valour in arms was well-known enough to ensure that his name was commemorated in various other histories of the time.

For a while Benvenuto carried on with his work – which now included the design of coins for the pope's mint. This was controlled by two men – an *incisiore* responsible for the appearance of coins, and a *pesatore di zecca* who ensured that the material used in making them was of the right degree of purity. In June 1529 Cellini had been appointed *incisiore* or Maestro delle Stampe (a post he held until January 1534), and the pope had ordered him to make a particularly impressive coin which should show his head on one side, and Christ walking on water on the other. Benvenuto's work on this was slower than His Holiness wished, and it was clear that the goldsmith's mind was very much on the slaying of his brother and the possibility of revenge – indeed, he was losing sleep and neglecting to eat. Clement VII was not particularly sympathetic, merely pointing out that Cecchino was dead, and that there was nothing to be done about it.

Cellini took a different view. He might not have been especially close to Cecchino, but loved him as a brother and admired him as a soldier. He had discovered the identity of the arquebusier allegedly responsible for his brother's death, and watched him 'as closely as though he were my unfaithful mistress'.[8] One night he went to the man's lodging and found him standing in the doorway, sword in hand. He crept up and struck out with a double-edged dagger. Some instinct made the victim turn at the last moment, and rather than cutting his throat the dagger shattered his shoulder-blade. He dropped his sword and ran. Cellini followed, and drove his dagger deep into his victim's back just below the neck, with such force that he could not withdraw it. Four soldiers ran out from the nearby house of a notorious courtesan, Signora Antea, and were on Cellini's heels as he fled to Alessandro's house between the Pantheon and the Piazza Navona.[9]

The soldiers soon arrived to show the duke Benvenuto's dagger, which they had with difficulty tugged from the murdered man's

wound. However, when it was explained that the killing had been a matter of revenge for the killing of a beloved brother, they apologised for having followed Benvenuto, and left. The duke advised Cellini to lie low for a while, but after a week the pope sent for him. He clearly knew all, fixed Benvenuto with a steady eye, hoped he had been 'cured', and told him to continue with his work. In other words, the avenging of a brother's death by murder was dismissed as an entirely excusable act.

Such episodes as this show Cellini at his most Scorpionic, impetuous, violent and temperamental. In calmer moods he was capable of compassion and consideration. For instance while he was still working at the *bottega* of Raffaello del Moro, the old goldsmith's daughter (to whom Benvenuto says he was strongly attracted) suffered from disease which damaged two of the finger bones of her right hand, and the doctors Raffaello consulted told him that her whole right arm was likely to be affected, and would have to be amputated. When Benvenuto heard this, he summoned one of the pope's doctors, Jacomo Rastelli, who treated her, and set about cutting away the diseased parts of the finger bones. Cellini, who was present, saw that his instruments were blunt and that he was causing the girl undue pain:

> I ran to my workshop and made a very delicate little steel device, curved, and sharp enough to be used as a razor. When I came back the surgeon began to work with it so gently that the girl felt no pain at all, and the operation was soon over.[10]

* * *

Much of Cellini's time was now spent working on coins and medals, some of which are among the few works of his to survive from this period. This demanded a technique very different from that used in, for instance, making jewellery or belt-buckles. In his *Treatises* he describes how he made the steel dies from which the coins were minted, and explains certain short cuts which could be used to ease the burden of the work. After casting the seals,

you work the silver with your punches, gravers and chisels, touching up and completing your subject now here, now there, figures, swags, arms, bodies, legs, all alike, accentuating them in the matrix with your steel tools. To see better how you are getting on, you may occasionally press in a little black wax, or whatever colour pleases you better, to gauge the projections. Now note this; my custom was to cut out the heads, hands and feet of my figures on small steel punches, and thinking to work clearer and get a better result, I struck these punches with dextrous strokes upon the seal with a hammer into their different places. Also you should make in a similar manner an alphabet of steel punches, likewise many other conceits according as taste prompts. When I was in Rome, or elsewhere, working in this line, I ofttimes amused myself by making new alphabets, each for its occasion, for they wear out soon, and I got much credit by my inventiveness.[11]

His eyes must have been preternaturally keen; the fine detail of almost all his coins and medals is exceptional – particularly so in the 2-ducat gold coins he designed on subjects suggested directly by the pope. One shows (as Cellini records in his *Treatises*) 'the form of a nude Christ, His hands bound, done with all the care and study I was capable of'.[12] On the reverse side is the head and title of the pontiff. The figure of Christ is extraordinary in its power, especially considering the size of the coin. Two similar coins made at the same time are scarcely less impressive, one showing 'a pope in his pontifical robes and an emperor also in his regalia; the two were supporting a cross which was in the act of falling to the ground', the other 'a Saint Peter, at just the moment after he has plunged into the sea at a call of Christ, and Christ stretches out his hand to him . . .'.[13] There is an example of the latter in the British Museum, and one can still admire the composition and delineation of the scene on the reverse – Christ with his feet firmly resting on the waves, his right hand firmly gripping St Peter's left wrist and lifting him from the sea in which he has sunk to the waist. The diameter of the coin is only 29 millimetres, the detail astonishing even in the coin's worn condition.

It may have been increasing ill-health that made Pope Clement tetchy and ungrateful where Cellini was concerned; though he promised much, he delivered little. He did grant his goldsmith's application in 1531 for the vacant post of *mazziere* or mace-bearer, a sinecure which brought with it a salary of 200 *scudi* a year, but when the office of Piombo – the bearer of the papal seal – fell vacant, the pope merely remarked that the office 'brings in more than eight hundred crowns a year, and if I let you have it you'll spend all day scratching your belly, lose all your marvellous skill, and I will be blamed for it'.[14] This was scarcely grateful. When Benvenuto made it quite clear that he thought the man the pope did appoint, the painter Sebastiano Luciani (afterwards known as Sebastiano del Piombo) was unworthy of the post, Clement ignored him for a full two months.

But such a master craftsman as Cellini had become could not be ignored for long, and in 1532, when Clement was eager to commission a present for his niece Catherine de' Medici on the occasion of her marriage to the future Henri II of France, the second son of Francis I, he approached his goldsmith once more to ask him to prepare a design for the mounting of a unicorn's horn in a highly decorated gold setting. (Those who thought themselves likely victims of assassination still liked to drink out of unicorns' horns – usually really made of rhinoceros's horn or ivory – as they were said to negate the effects of poison.) But the commission was not to go automatically to Cellini – the pope had also approached another goldsmith, a Milanese called Tobia, who Cellini tells us had been accused of forgery in Parma, and sentenced to be hanged and burned, but was pardoned by Cardinal Giovanni di Jacopo Salviati, a nephew of Giovanni de' Medici, because of his exceptional talent.

Tobia prepared a design in the shape of a candlestick with four small unicorn heads at its base, into which the horn should be fixed. Cellini presented a design for an elaborate beast's head – part horse, part stag, with a magnificent mane and subtle decoration. The pope's advisers persuaded him that the French were so uncouth that the excellence of Benvenuto's design would be lost on them, and the commission was handed to Tobia. The real explanation may be that

Cellini's design would have required more gold than the pope was ready to pay for. He was told to get on with another commission – for a chalice to be carried in procession when the pope bore the host. He made a model of it in wood and wax, which he describes in the *Life*:

> I made three reasonably sized figures of Faith, Hope and Charity in full relief, balanced on the base by three scenes in low relief, one showing the Nativity, another the Resurrection, and the third, St Peter being crucified upside down.[15]

The progress of designing and making of the chalice was attended by considerable frustration. First, the pope simply ignored his very reasonable request for an advance payment to secure a sufficient amount of gold for the work. Then Clement set off for Bologna to meet the emperor Charles V (on 18 November 1532), to discuss among other things the marriage of his niece and the French dauphin. He left the ordering of the commission to Cardinal Salviati, a bully who actually threatened Cellini with imprisonment in the galleys if he did not get on with the work. When the pope returned to Rome in March 1533 he was told that Cellini was uncooperative and lazy, and berated the artist. In fact, perhaps under the stress, Benvenuto's eyes had given way, and for a time he was almost blind. He ascribed this to an attack of the pox, of which he cured himself with *lignum vitae*; but blindness is rarely associated with syphilis, and its real cause remains obscure. Happily, a friend of the pope saved the situation by recommending him to bathe his eyes with a decoction of the stalks and flowers of 'flower-de-luce' or irises.

The pope agitated for the speedy completion of the chalice, but still refused to give the goldsmith the money he needed for materials. Cellini used his own savings to buy gold, and worked away quietly at the commission, while at the same time giving Clement the impression that he was not touching the chalice. Irritated, the pope dismissed him from the post of *incisiore* at the Mint, and gave the position to a young man called Tomasso d'Antonia, a Perugian whose nickname was 'thick-head'. Then he actually had Cellini

arrested because he declined to hand over the chalice in an unfinished state so that it could be completed by someone else – probably Tobia, who had been asked to prepare a competing design (it was dull and botched).

In the end, the affair of the chalice petered out in a highly unsatisfactory manner. Though Cellini had done much work on it, it remained unfinished, was pawned for 200 *scudi* to the merchant banker Bindo d'Antonio Altoviti (whose bust he was later to make), and subsequently redeemed to be finished by the goldsmith Niccolò di Francesco Santini, and presented in 1569 to Pope Pius V. Eventually it was broken up.

Although he never ceased to be attracted to young men, in the 1530s Benvenuto began to pay attention to women – it may be that his mind had turned to the idea of begetting children. At all events, in 1534 he started an affair with a young Sicilian girl, Angelica, planning to elope with her and take her away to Florence. Her mother did not approve, and suddenly removed the girl from Rome.

Probably through the girl and her mother, he met a Sicilian priest who he found an agreeable companion, and when one evening they were idly talking it turned out that the priest was interested – as Cellini was – in necromancy. (His interest may well have been connected to his fascination with astrology.) One of the best-known and most popular serious occult works of the time, *Of Things Occult and Manifest, or The Book of Intelligence*, by a Christian doctor of medicine, Antonius de Monte Ulmi,[16] was an exposition of astrological necromancy, and explained how the angels appointed to children at their birth were allied to the planets, and how they might be used to control the spirits or 'intelligences deprived of divine grace' – fallen angels – which could be raised by necromancy.[17] It seems highly likely that Cellini's friend knew the book, for much that he said and did mirrored the instructions and suggestions in it.

The Sicilian priest was clearly one of those Christians who believed that there was much to be learned from spirits who could be raised from the dead, and when Cellini expressed his own interest, was very happy to attempt a demonstration. They followed Ulmi's instructions for raising spirits: the place where this should be

attempted must be secret (the spirits disliked publicity), fetid odours should be spread, and the attempt should be made within a circle – the most perfect shape, and a symbol of the prime mover, which would protect the magicians from furious spirits.

Where could be more ideal for the experiment than the ruins of the Roman Colosseum? It was a place frequented by thieves and prostitutes, and therefore shunned by honest folk, it was certainly circular, and as to fetid odours, there was no shortage of those – the place was a popular public latrine. The first hour of the night was said to be most favourable for raising spirits, and at that hour four men gathered there: Cellini and the priest, a friend and colleague at the Mint, Vincenzio Romoli, and a second necromancer. The priest, in robes designed for the occasion, drew circles within the larger circle of the Colosseum, burned tablets which gave out both sweet and evil-smelling odours, and then having made sure everyone was safely within the circles recited incantations for ninety minutes. Chanting was an important part of magic – a modern theory is that the endless repetition of often meaningless words had (indeed, has) an hypnotic effect which leads to the seeing of visions.

For whatever reason, the priest's activity had a result: Cellini describes how 'several legions of devils appeared, till the Colosseum was filled with them'.[18] The priest encouraged him to question the spirits, and Benvenuto asked them to arrange a meeting between him and Angelica. There was no reply. When the spirits had vanished and the experiment was over, the priest suggested a second experiment – but Cellini should bring along a virgin boy. This was not, in the circumstances, a strange request – Ulmi laid it down that the spirits appeared more readily to virgins because they themselves were incapable of having sex, and thus were not infuriated by jealousy.[19] So a few days later Cellini returned to the Colosseum with Romoli, a mutual friend called Agnolo Gaddi, and Cencio, a twelve-year-old shop-boy from his studio. The same preparations were made, and Cellini was given a pentacle – a disc-shaped object inscribed with a pentagram or five-pointed star, and supposed to represent the earth – to hold over the cowering boy and give him additional protection from malignant spirits.

The priest now called by name on the demons he wished to raise, addressing them in a mixture of Hebrew, Greek and Latin, and once more a swarm of spirits crowded into the Colosseum. Benvenuto again asked to be reunited with Angelica – and this time the priest assured him that the spirits promised that he would be guided to her within the month. Then many more violent spirits appeared – the boy said that he saw millions of them, together with four giants. The priest himself looked terrified, and Romoli was shaking so much that he could scarcely hold the vials of perfume he had been told to flourish.

Cellini himself, though alarmed by the terror of the others, appears to have seen nothing, and attempted to comfort the boy, who now claimed that the whole Colosseum was aflame, and that they were all going to die. Cellini instructed Gaddi to throw some asafoetida on to the fire – gum resin from an Indian plant of the carrot family, used as a perfume in the West and with its onion-like odour much employed by necromancers. As he turned to do so, Gaddi let out a loud and malodorous fart[20] which reduced Cellini to helpless laughter. The spirits, the boy said, now all beat a hasty retreat, and in a while the Colosseum was empty. Having packed up the necromancer's robes and books the five experimenters made cautiously for the exit, the only two remaining spirits (the child said) leaping from roof-top to roof-top in the distance.

The priest was much impressed. He had never, he said, had such a success – raising millions of spirits, even if they had only been seen by the boy. He and Cellini should collaborate, raising the spirits regularly, questioning them, and setting the information they obtained in a book, which would inevitably become a best-seller and make their fortunes. Benvenuto was tempted, but kept putting the priest off. He appears to have believed that he had been part of a genuine and successful necromantic event, but was disinclined to pursue the matter.

He was now more interested in a competition with a visiting goldsmith – Giovanni Bernardi, a designer and maker of coins, cameos and carved gems who was also a mace-bearer to the pope – and was concentrating on making a medal which would show up his

much-touted rival as an inferior artist. To give himself more time for this, he put his workshop in the Via dei Banchi Nuovi in the hands of a partner, Felice Guadagni, and worked uninterrupted at his own house. Guadagni was having some difficulty in extracting payment from a friend of Benvenuto's, a notary called Ser Benedetto, and had embarrassed him by demanding money from him while he was walking with a group of Sienese merchants whose professional representative he was. Benedetto was furious, and meeting Cellini in the street began abusing him. Cellini had no idea why his friend should suddenly revile him, and told him he should take the matter up with Guadagni. Benedetto accused him of knowing all about it, and continued his abuse – at which Cellini lost his temper, picked up a lump of mud from the gutter and threw it at his friend's head.

Unfortunately there was a stone inside the lump of mud, and Benedetto fell to the ground, unconscious. In the gloom of the early evening a passer-by, the jeweller Pompeo de' Capitaneis, mistook the fallen man for Cellini's enemy Tobia, rushed to the pope and reported that the goldsmith had killed his rival. The pope immediately ordered Cellini's arrest and execution, and a message reached the latter (who had taken refuge at the house of a friend, Monsignor Giovanni Gaddi) from Cardinal Ippolito de' Medici,[21] advising him immediately to escape from Rome.

Gaddi loaned his friend a fine black Arab stallion on which, narrowly escaping arrest by police guarding the Ponte Sisto, he made his way towards Naples. En route, he met an acquaintance, the painter and sculptor Antonio di Giovanni da Settignano, who told him that the pope had discovered that Tobia was alive and well – as indeed was Benedetto. Clement had berated Pompeo, and now invited his goldsmith to return to Rome.

Cellini, however, had had enough of Clement's demands for the moment, and went on towards Naples together with da Settignano. They stopped at an inn about half a mile outside the city, where Benvenuto discovered to his astonished pleasure that Angelica was staying at the house next door. There was a passionate reconciliation – all, Benvenuto recalled, foretold by the spirits raised in the Colosseum.

Angelica travelled with him to Naples, where he spent much time studying the ancient classical busts, figures and carvings discovered there and thereabouts, and was also introduced to the city's Viceroy, the Marquess of Villafrancas. He stayed only a short time, soon returning to Rome – leaving Angelica behind after she and her mother had attempted to extract more money from him than he thought the girl was worth (he had a keen appreciation of beauty and sexual expertise; but an even keener appreciation of money). He enlivened his journey by a flirtation with a beautiful young woman who happened to be travelling in the same direction – and settled back to work in Rome, concentrating on two medals for the pope, both of which presented the same portrait of Clement, generally recognised as the finest to have survived, and prepared, it seems, from life drawings. The pope had a noble appearance, and Cellini made the most of it. About a hundred copies of the medal were eventually struck.

The reverse of one medal was especially impressive: 'the subject of Moses with his folk in the desert at the time of the scarcity of water. . . . I made it just full of camels and horses, and ever so many animals and crowds of people.' An alternative reverse bore the figure of peace, 'a lovely maiden with a torch in her hand burning a pile of weapons & at the side the temple of Janus with a Fury bound to it'.[22] Both these scenes were designed and executed with the greatest delicacy, and when Cellini presented them to the pope for his approval, Clement was ecstatic: 'They never had such medals in the old world,' he said.[23]

Taking advantage of the situation, Cellini asked for protection against his enemies, who had taken advantage of the 'hostile stars' to attempt to bring about his destruction. The pope, Cellini says, blushed when reminded how quickly he had mistakenly ordered Cellini's arrest and execution, drew the goldsmith into discussion of the technique of medal-making, and commissioned another medal, this time to show Moses striking the rock and releasing the stream of water.[24]

On 22 September 1534, having finished the design and produced a model, Benvenuto took the new medal to the pope.

I found him in bed in a most deplorable condition. Nevertheless, he received me with the greatest kindness, and wished to inspect the medals and the dies. He sent for spectacles and lights, but was unable to see anything clearly. Then he began to fumble at them with his fingers, and having felt them a short while, he fetched a deep sigh, and said to his attendants that he was much concerned about me, but that if God gave him back his health he would make it all right. Three days later the Pope died.[25]

FIVE

'Not *without* a Little Pride . . .'

The death of a pope was not only a religious but a notable political and social event, and at the end of September 1534 the streets of Rome were a-bustle with people going to and from San Pietro's, where the body of Clement VII lay in state. Cellini went with the rest to kiss the feet of the dead pope. He had as much to lose from the death as anyone attached to the papal court. Clement had been a vacillating patron, as he had been a vacillating politician, but he had always admired Cellini and valued his skill, and their joint experience of the siege had formed an additional bond. Though conscious of the brawls and killings with which Benvenuto had been involved, Clement had always been sufficiently convinced of his goldsmith's genius to continue to patronise him. Who knew what view the next holder of the triple crown might take of art and artists, and especially of a man so volatile, self-centred and independent-minded?

That volatility was to lead, before the new pope had been chosen, to a fresh crisis in Cellini's life. On 26 September, within twenty-four hours of Clement's death, he was sitting with some friends in the Via dei Banchi, near his shop, when Pompeo de' Capitaneis passed along the street with some cronies, paused, and stared insolently at him.

De' Capitaneis had been a thorn in Benvenuto's side for some time. Himself a jeweller with friends at court – he was a relative of a Milanese clergyman who had been secretary of the pope's private bedchamber and had had the pontiff's ear – he had first indulged in some political juggling in an attempt to gain for himself the commission to design Clement's morse. Then he had attempted to persuade the pope to take Benvenuto's position at the Mint away from him on the specious grounds that the goldsmith would have

more time in which to work on the commissioned chalice. And finally, it had been he who – whether through a genuine mistake or through malice – had wrongly reported the death of Tobia to the pope, and almost caused Cellini's arrest and execution.

There was something more than simple rivalry between the two men. Now, as de' Capitaneis and his companions giggled among themselves and began to make dismissive and insulting gestures, tension rose. Cellini's friends were inclined to start a fight, but he firmly told them to go – he could look after himself. Perhaps his best friend in Rome, Alberto ('Albertaccio') del Bene, suspected that what Benvenuto really wanted was to tackle de' Capitaneis and his associates alone, and tried to persuade him to drop the matter. But no one could persuade Cellini to refrain from action when he was intent upon it, and he rose and followed his enemy in the direction of the Campo di Fiore, where de' Capitaneis went into a chemist's shop. When he left it, Benvenuto pushed through the crowd and struck out with a dagger.

Certainly Cellini's temper, which on this and some other occasions can only be described as vicious, was the least admirable thing about him. His description of the event is chilling:

> I grasped my small sharp dagger, forced my way through his guards, and punched him in the chest so coolly and quickly that none of them could stop me. I wanted to hit him in the face, but in terror he turned his head and my dagger struck him just under the ear. I only stabbed him twice more, and he fell to the ground, dead; not that that had been my intention, but you don't stop to discuss things when you're fighting.[1]

We may believe that Cellini did not mean to murder de' Capitaneis but merely to mark him; however, first missing his aim, then striking once more and striking twice again, finally killing the man is hardly the action of a man in control of his emotions. Fortunately for him, the dead man's friends were too stunned by the incident to take immediate revenge, and Cellini was able to retrieve his dagger and stroll calmly off along the Strada Julia, where he met an acquain-

tance who accompanied him to del Bene's house. Cellini claims that there he was treated as a hero, that many friends came to the house to offer their aid and protection. It is possible. De' Capitaneis was not a popular man, and his machinations against his rival had been common knowledge. And this was an age in which extreme physical action, however hot-tempered, was admired rather than reprehended. Moreover, a matter of honour was involved, and the dead man had started it.

Soon enough there came a large band of men sent by Cardinal Francesco Cornaro, a former Venetian soldier and diplomat, to invite Cellini to attend him – thirty soldiers, thirty halberdiers, pikemen and gunners. It sounds more like an arrest than an invitation, but in his *Life* Benvenuto makes it clear that the cardinal wanted to protect rather than seize him. His attitude was shared elsewhere, for no sooner was Cellini at Cornaro's palace than a bishop appeared with a message from the Florentine cardinal, Ippolito de' Medici, asking Cornaro to hand Benvenuto over to him – *he* wished to be the goldsmith's protector. Cornaro, jealous, refused even to let the bishop speak to Cellini. Recognising that he could scarcely, in his present position, afford to alienate anyone who was in a position to help him, Cellini sneaked out the following night and went to Ippolito, pleaded successfully to be allowed, for reasons of personal politics, to remain under Cornaro's protection, and returned to the latter's palace.

It was only a matter of eight days before a new tenant took the seat of St Peter. Alessandro Farnese had been a candidate for the papacy at the previous two elections. He was an intelligent and scholarly man who had been educated largely at the court of Lorenzo the Magnificent and was a close friend of Giovanni de' Medici, later to be elected pope as Leo X. His sister Guilia was one of the mistresses of Alexander VI, who partly through her influence made him cardinal in 1493 (consequently he was known to the less respectful Romans as 'Cardinal Petticoat'). He fathered four illegitimate children, Pierluigi, Paolo, Ranuccio and Constanza,[2] which again rather endeared him to the public, who more often than not rather approved signs of sexual vigour in their cardinals. While

some churchmen condemned the luxury in which he lived at the Palazzo Farnese, his profligacy was generally admired by the people, and when he was chosen pope almost without the formality of an election there was popular approval. Neither did his immediate appointment of his two grandsons, Alessandro Farnese and Guido Ascanio Sforza, as cardinals at the respective ages of fourteen and sixteen trouble the average Roman, though again some of those about the papal court were critical.[3]

Cellini's uncertainty about his position in Rome was not dispelled by the appointment. While he had no reason to suppose that the new pope was likely to be an enemy, neither had he any special hope that he would be a particular friend or patron. Yet one of Pope Paul III's first actions after being crowned on 1 November was to send for him, under safe conduct, and invite him to design the new papal coinage. Paul was not to be a great patron – he loved the hunt and magnificent ceremonies, but his main interest was in the literature of theology – though he did commission Michelangelo to finish the ceiling of the Sistine Chapel, later rebuking him for the nudity of the figures in it (an admonishment which Michelangelo repaid by depicting the pope among the damned, with ass's ears).

Whether Benvenuto was aware of the fact or not, a murder committed at the moment of the death of one pope and the election of another was subject to a general amnesty. At the Feast of the Assumption (15 August) the leaders of the city guilds and the *caporioni*, who were heads of the various districts, were allowed to pardon twelve accused men, and Cellini was pardoned, somewhat oddly, at the request of the butchers' guild. There were certain rumblings of discontent – the pope's secretary, Ambrogio Recalcati, told his master that it was very unwise to grant a pardon for such a deliberate and vicious murder within a day or two of his coronation.[4] The pope replied that 'men like Benvenuto, who are unique in their art, need not be subjected to the law'.[5] It was a statement of an attitude that forgave many an artist and writer his offences at a time when ecclesiastics and lawyers were quite as concerned to compete for the services of highly regarded artists as to maintain the law.

He was not, however, in the most secure of positions. No complete pardon could be granted by the lay authorities until August 1535, and while with the pope's favour he should have been safe enough to come out of hiding and start work on the new coinage,[6] there was another problem: that of the pontiff's son, Pierluigi Farnese, a notorious sodomite (he was popularly supposed to have raped the Bishop of Fano). De' Capitaneis had been close to Pierluigi, and his family now pressed for revenge – if not by legal means, then by illegal. There were wheels within wheels. The dead man had left a considerable sum of money to an illegitimate daughter, who Pierluigi wanted to marry off to a lover of his, a young peasant. He then intended to confiscate the girl's dowry. She was continually agitating for Cellini's arrest for her father's murder. There were rumours that an assassination was planned, and indeed a man seems to have been selected as a possible assassin. Cellini actually encountered him one night; but like called to like, and the man actually warned him of the plans made for his murder rather than himself committing it.

Eventually, Cellini heard that Pierluigi had ordered his arrest, and immediately left Rome for Florence. There, the duke, Alessandro de' Medici, received him with 'extraordinary warmth'[7] and was eager to employ him. Alessandro was intellectually moderately astute, physically somewhat less than moderately attractive, and lacked the social graces. The death of his father, Clement VII, had set him free to indulge with total freedom in the sexual excesses which had always been a major pleasure, and to give free reign to his tyrannical instincts and ambitions – he enriched himself by imposing vicious taxes on the Florentines. Perfectly well aware of their hatred of him, when he was not cowering inside the fortress he built for himself he ventured forth only when surrounded by a heavily armed guard. He was also protected by the fact that he had for some time been engaged to be married to the illegitimate daughter of Charles V – the marriage was planned for February 1536, when Margherita would reach the age of fourteen. The assassination of the prospective son-in-law of the Holy Roman Emperor would provoke instant and terrible revenge.

Repulsive though Alessandro undoubtedly was, he would be an important patron for Cellini, who, however, gave himself some time for thought by claiming that he needed to visit Venice in order to do some special study. He promised to return to Florence within a matter of weeks. The duke agreed, and made Cellini a present of fifty gold crowns, no doubt in order to ensure that the talented goldsmith would in fact attach himself to his court.

Benvenuto had been invited to Venice in the company of an old contemporary and friend, Niccolò di Raffaello, a sculptor and architect who had been invited to join the *bottega* there of his old master, Jacopo Tatti, head architect to the Procurators of San Marco. There was some trouble on the way. Many disaffected Florentines had exiled themselves from the city when the appointment of the duke had put an end to its republican aspirations. They were well known to the authorities, and it was dangerous for any Florentine who wished to stay on Alessandro's right side to contact or speak with them. Di Raffaello warned Benvenuto to avoid doing so. But this was easier said than done, and at Ferrara, where they paused for the night, the two travellers were besieged by a number of exiles, asking for news from Florence. One of these, Niccolò Benintendi, who had been a distinguished member of the Eight and captain of the troops which had defended Florence during the siege, was irritated by the fact that Cellini and di Raffaello refused to discuss politics with him, and at last burst out with 'They and their Duke can kiss my arse!'[8]

Cellini tried to restrain his temper, but in the end Benintendi got to him, and he drew his sword, at which the exiles competed with each other who should retreat first. Next morning, however, a gang of them met by the canal where Cellini and his friend were to embark for Venice; Cellini saw them off, but they followed the boat, shouting threats. Nothing came of these (though Benintendi was seen shadowing Cellini around the city). Nothing came, either, of di Raffaello's visit to Tatti, who not only announced that he did not need the former's services after all, but was extremely discourteous, and irritated Benvenuto by continually criticising his hero Michelangelo.

So he and his friend set out to return to Florence, en route being involved in an adventure which demonstrated again how petty and spiteful Cellini could be when crossed. An innkeeper unusually demanded payment on the evening of their night's lodging instead of in the morning. Cellini was so irritated by this that although the beds were spotlessly clean and extremely comfortable, he 'had a wakeful night thinking up what I could do to get my own back. One moment I planned to set fire to the house, the next, to slit the throats of the four good horses in his stable.'[9]

Losing a night's sleep over such a petty incident seems silly enough – but Cellini was still boiling with fury on the following morning, and having packed and made ready to leave, sneaked back into the inn, went up to the room he had occupied, and slit the bedclothes of the four beds in it to ribbons, then made off highly satisfied that he had done at least fifty crowns' worth of damage.

Back in Florence, the duke seemed preoccupied with ensuring that his appearance was thoroughly recorded – he commissioned portraits from the highly neurotic painter Jacopo Pontormo, who continually interrupted sittings because of a nervous disorder of his bowels, and from Giorgio Vasari, the painter, architect and biographer of Michelangelo, and also ordered at least one marble bust and a number of medals bearing his likeness. He commissioned Benvenuto to design a 40-*soldi* silver coin with his profile on one side, and on the other the figures of two saints – Cosmas and Damian. These twin brothers were not only the patron saints of doctors but of the Medici family, several of whom were called Cosmo, and they were popular subjects with the artists of the time. The association does not seem especially apposite, since the twin saints were notably uninterested in financial gain, while the Medicis were notably avaricious.

Alessandro was highly satisfied with the coin when it was presented, and indeed his portrait, with straight nose and curly hair,[10] is either of a very handsome man, or is gently flattering. Despite all the many other paintings, medals and busts of himself, some of the best likenesses of him were left by Cellini, a true master of portraiture in the miniature form. Once more one can only

marvel at the skill of the portraitist and the keenness of the eyes which guided his manual adeptness. The detail of the portrait on the forty-*soldi* coin, with each curl of the duke's hair clear and sharp, the depiction of his level gaze, well-formed nose, mouth and chin, and the line of his collar, is all the more impressive because the coin is only 29 millimetres across.

Alessandro was so pleased that he invited Cellini to choose as a present any gun from his magnificent collection of weapons, and commissioned several small items to send as presents to Margherita, now his wife, who was in Naples. He also commissioned another coin, to bear a portrait of himself which he hoped would be as good as that of the late Clement VII. Realising that he was going to be very busy, Cellini sent to Monte Ritondo, near Rome, for a fourteen-year-old assistant, Pietro Pagolo,[11] who he had taken on as a small boy, and had taught how to make dies for striking coins.

The relationship with Alessandro was cordial. He gave instructions that in order to observe his appearance in proper detail Cellini was to be allowed access to him at any time and in any place. Later, Benvenuto recalled often seeing the duke snoozing in the company of his cousin, the slender and handsome 21-year-old Lorenzino[12] de' Medici, son of Pier Francesco de' Medici and younger brother of Cosimo. A playwright and poet, he shared Alessandro's taste for erotic adventures, often accompanied him in degenerate debauchery, and within two years was to conspire to assassinate him. Alessandro never troubled himself to conceal his dissipation, and indeed when Cellini took him a wax model of the proposed coin, he was told that the duke, attended by Lorenzino, was still in bed, where they had been 'enjoying a dissolute revel'.[13] This was slightly worrying – a hangover was not likely to set the duke in the mood to hear the news Cellini had to give him – that the pope had sent him a safe conduct to Rome and invited him to present himself at the Feast of Ferragosto in August, when he could be finally and completely pardoned for the murder of de' Capitaneis.

But Alessandro received the news with reasonable composure – Cellini was able to assure him that Pagolo was perfectly competent to supervise the production of the coins. He also promised that he

would return to Florence as soon as possible and continue in the service of the duke. The latter sent him on his way with his goodwill and a present of fifty gold ducats.

Cellini arrived in Rome between late March and early June 1537, and after spending a night with a friend moved into a small house he owned in the Via Giulia. Two male servants lived with him, one of them Cencio, who had accompanied him to Florence and was clearly a great favourite – his master speaks of buying him splendid clothes, and describes him as being of 'extreme personal beauty'.[14] He also made use of a laundress, the tenant of the ground floor of the house, as a cook, and on his first night in his own house gave a supper party for some old friends. That night he was wakened from a deep, wine-enriched sleep by hammering on the door and the arrival of the Bargello and a troop of policemen. There was a spirited *mêlée* before Benvenuto, waving the pope's safe conduct, was able to persuade the Bargello to retire. The event seems to have shaken him up rather more than one might have expected, for on the following morning he sought out a doctor and complained of feeling ill. The doctor examined him, told him he had a constitution of iron and the pulse of a lion or a dragon, and sent him on his way.

He called on the pope, who received him generously, commissioned him to make a large piece of gold plate, and promised him a pardon. To this, when it was sent him, was attached a certificate of reconciliation between himself and de' Capitaneis's brother Lodovico. In the meantime he did not forget Alessandro's commission, and appears to have done some work on the numismatic portrait.

Not long after receiving the pope's pardon, Cellini fell seriously ill. He had not been particularly reassured by the doctor's cheerfulness on the morning after the attempted arrest – he felt there was something wrong with him. Now he fell into a severe fever, and within days was weak and hallucinating, nursed by his worried and tearful boys. Several doctors, including Francesco Fusconi, who had attended the last three popes, examined him, but their treatment seemed to have no effect. Whether the infection which caused the pyrexia was viral or bacterial, it was clearly a severe bout. The treatment was extremely hit or miss: though fever was regarded by

doctors as 'the king of all the diseases', and much thought had been given to it – whether it was quotidian or ephemeral, hectic or putrid, intermittent or continuous – the treatment was dietetic or emollient without any governing theory about what sort of diet might best quieten the fever, or what conditions in the sick room would result in a speedy cure.

But for the devotion of Felice Guadagni, Benvenuto's business partner and friend, he might well have died – the doctors despaired of his life, and at one point Felice actually prepared a shroud, and the rumour of the goldsmith's death spread around Rome and further abroad. His brother-in-law arrived from Florence to collect any bequest to his wife, but was delighted to find Cellini alive, if only just.

Though the elderly Fusconi was particularly determined to effect a cure, applying lotion after lotion, together with plasters and leeches ('I had more than twenty leeches stuck to my arse, which had been punctured, bandaged and massaged. . . .')[15] Cellini's recovery followed the usual pattern of the time: it was the result of muddle, confusion and luck. One day one of his apprentices told him that his beloved Cencio was also ill, and on the point of death. This seriously upset him, and he asked a servant-girl for a drink of cold water. Fusconi had forbidden this, but she brought him a large jug, which he drained. Rather than killing him, as the doctor had anticipated, this seemed to do him a great deal of good, and within a day or two Cardinal Cornaro suggested that he was well enough to be taken to one of his estates on Monte Cavallo – the Quirinale, where the papal residence stood until the nineteenth century.[16] Swathed in blankets, the sick man was carried there in a chair – and the moment he arrived, vomited up 'a hairy worm, about five inches long. It was covered with long hair, and was repulsive, with various coloured spots – green, black and red.'[17]

The doctors said they had never seen anything like it, and indeed most modern doctors find the anecdote puzzling. There is no reason to suppose that Cellini made it up, but the creature sounds more like a myth than a monster, and attempts to explain it remain unsatisfactory – one authority has suggested that it may have been a

whip-worm, of the genus *Trichuris*,[18] which infects the large intestine – but no whip-worm would have sported such vivid colours. However, the phenomenon signalled the end of seven weeks of grave illness, though Benvenuto remained weak for some time. Too impatient to remain an invalid for long, he took himself off to Florence, where he arrived on 9 November 1535 to be greeted with relieved enthusiasm by his friends and his delighted sister.

It seems likely that one of the motives for his journey to Florence, undertaken before he had fully recovered from his illness, was to re-establish good relations with the duke. If so, he learned very quickly that he had miscalculated, for one of his first visitors, Niccolò da Monteacuto, told him that he had overheard the duke remark that Benvenuto had 'come here to have a rope put round his neck' (and Alessandro was perfectly capable of arranging the execution of someone who had displeased him).

Cellini learned that the source of the duke's displeasure was the painter and architect Giorgio Vasari, later the author of a celebrated volume of lives of his contemporaries. He had thought Vasari a friend – he had entertained him in Rome, even providing a pretty young apprentice called Manno for the visitor's bed (and later overlooking the damage he had done the boy by badly scratching his legs in an excess of passion).[19] He had also introduced Vasari to Cardinal de' Medici, who had become his patron. Now, Vasari had (he was told) spoken ill of him to the duke, among other things accusing him of communicating with exiled Florentines who were plotting against Alessandro.

Cellini was still extremely weak, and in no condition to fight his corner with his usual vigour. However, after treatment from a distinguished Florentine doctor, and nursing by one of his close friends, the poet Luca Martini, he recovered sufficient strength to be carried to the Medici palace, where he was able to convince a number of the duke's courtiers of his innocence, and had a brief meeting with the duke himself, who seemed disposed to believe that he had been maligned.

His friend da Monteacuto said he believed Benvenuto had weathered the storm, but advised him that it would be best for him

The only known surviving contemporary portrait of Cellini appears in a large painting by Giorgio Vasari of Duke Cosimo I with his architects, engineers and sculptors, which hangs in the Palazzo Vecchio in Florence. Centuries later the Venetians commissioned a bust based on the figure in the picture, which stands on the Ponte Vecchio to remind passers-by of a jeweller and sculptor who was also one of the most remarkable autobiographers of his age, and left us a vivid portrait of himself and his times. (*Author's Collection*)

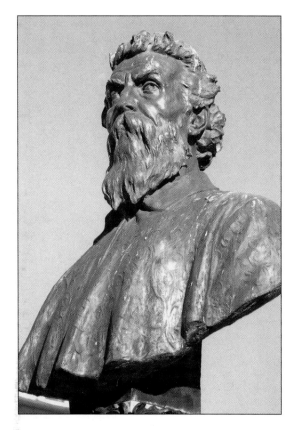

Castel Sant' Angelo where Cellini was imprisoned by the Pope in 1538, and from which he escaped by throwing a rope over the battlements. (*Corbis*)

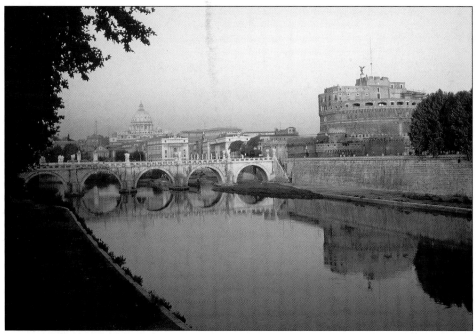

Francis I, King of France (1515–47) on a lead coin of 1537 by Cellini. (*Bridgeman Art Library*)

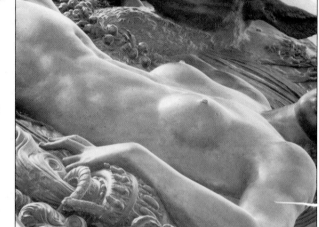

Detail of the torso of the *Nymph of Fontainebleau*, executed in 1542 for Francis I of France to stand over the main entrance of the chateau. (*David Finn*)

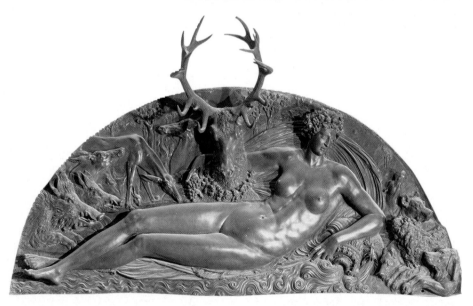

The *Nymph of Fontainebleau* in a grotto accompanied by a stag, hunting gods and other animals. (*Bridgeman Art Library*)

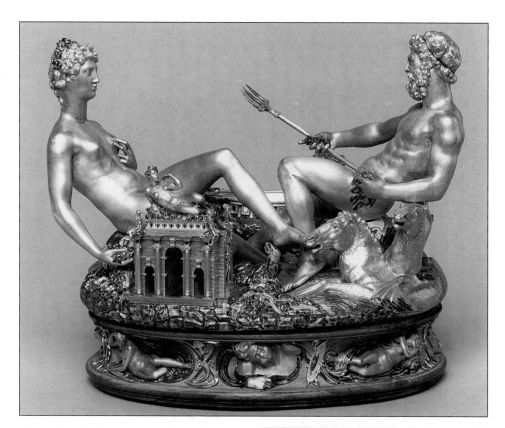

The gold and silver-gilt enamelled salt-cellar, designed by Cellini for Ippolito d'Este but made for Francis I in the 1540s. (*Kunsthistoriches Museum*)

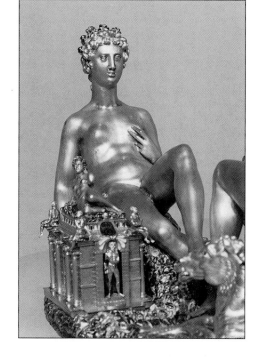

The goddess which represents Earth on the salt-cellar of Francis I, is said to be so perfectly executed that it could be enlarged to life-size without loss of detail. (*Kunsthistoriches Museum*)

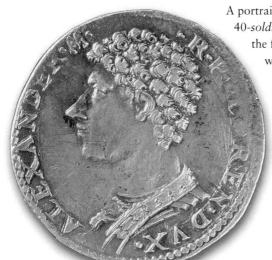

A portrait of Alessandro de' Medici on a silver 40-*soldi* coin of the 1530s. Cellini was one of the finest coiners of his time. His early work included coins for the Pope's Mint, and the designs he produced for these included masterly miniature portraits. (*Bridgeman Art Library*)

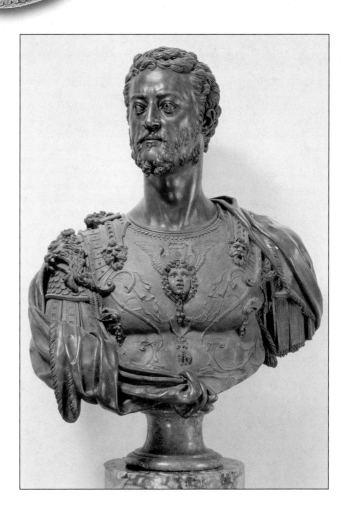

Cellini's magisterial over-life-sized bronze bust of Cosimo I de' Medici (1545), rich in detail in both visage and armour. (*Bridgeman Art Library*)

Cellini's vision in marble of Narcissus, the mythical youth 'looking', as Ovid put it, 'in speechless wonder at himself' in a mountain pool. The carving of *Narcissus* provided a challenge. Cellini had to pose the figure carefully in order to disguise two holes in the original marble block. Then a flood toppled the statue from its base and fractured it above the breast; the repaired break can still be seen. (*Bridgeman Art Library*)

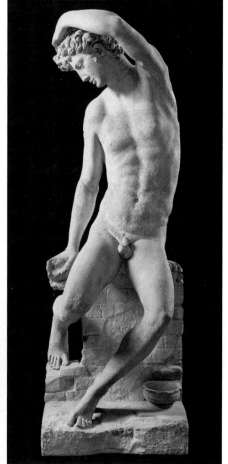

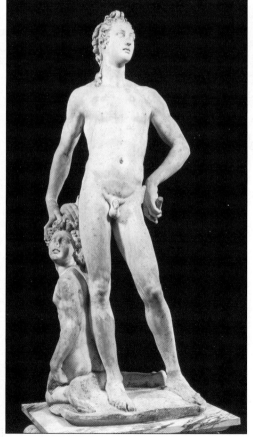

When Cellini's rival and culminiator Bandinelli, who accused him of being a sodomite, was forced to give him a piece of marble, the sculptor carved a statue of Apollo tousling the hair of the boy Hyacinth – a recognised symbol of homosexuality. (*Scala Picture Library*)

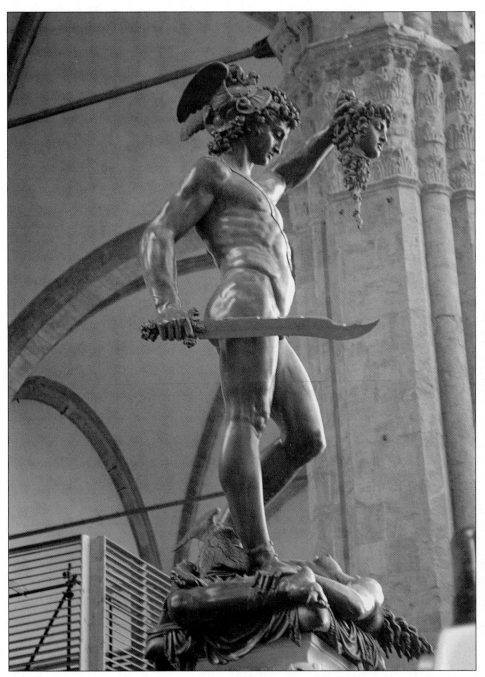

Cellini's masterpiece is his study of Perseus holding aloft the head of Medusa. The statue took almost nine years to complete, with the help of many artisans and a revolutionary method of casting which almost led to disaster. The artist's patron, Cosimo de' Medici, never properly paid for the statue, which is one of the greatest of Florence's public works of art. (*Author's Collection*)

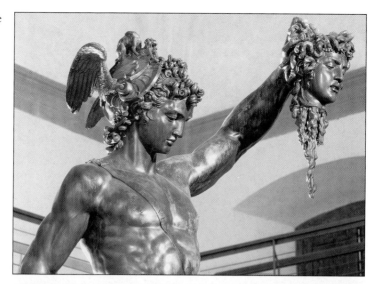

Detail of *Perseus* the hero holding the head of the gorgon Medusa. (*Scala Picture Library*)

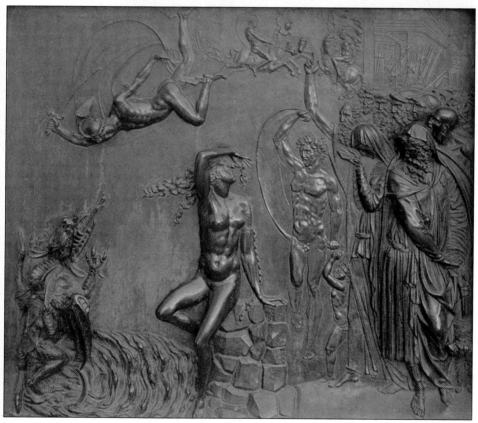

The relief beneath the base of *Perseus*: a panel showing the hero rescuing Andromeda, a group of interested spectators (right) representing Cellini's only attempt at general portraiture. (*Author's Collection*)

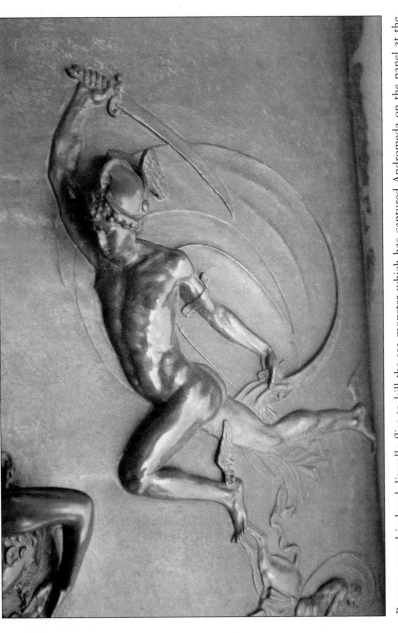

Perseus, sword in hand, literally flies to kill the sea monster which has captured Andromeda on the panel at the base of the *Perseus* statue. Michelangelo's great statue of David was idolised by Cellini; he relished but feared the comparisons which would be drawn between this work and his *Perseus*, which was to stand only yards from it. Unveiled in April 1554, his statue was immediately applauded by the people of Florence, who pasted poems to its base celebrating its beauty. (*Author's Collection*)

to return to Rome as quickly as possible; he had powerful enemies in Florence. Who those enemies were remains obscure – Cellini certainly believed that one of them was Ottaviano de' Medici, a distant relative of the duke who had failed to acquire the position of Master of the Mint for a favourite goldsmith of his own; but it might be that Alessandro's bosom companion Lorenzino had taken against him for some reason. He also suspected that the duke's instruction to him to 'make sure he remained an honourable man'[20] was a veiled threat, and decided to accept da Monteacuto's advice. In 1536 he returned to Rome, where he relaxed for a week or two in order to consolidate his recovery. For exercise, he resumed his old pleasure in shooting, often with his friend Felice.

On 5 January 1537 they were out with their guns and Benvenuto's dog Barucco on the banks of the Tiber, and had just turned for home as darkness began to fall when they saw a huge beam of light shining in the evening sky from the direction of Florence. This, they agreed, must signify that some 'great thing' had occurred in that city.[21] Late next day they heard the extraordinary news that on the night of 5 January Duke Alessandro had been murdered. His cousin and friend Lorenzino entered his bedroom at night accompanied by a hired assassin; the naked duke had no chance, and though he bit his cousin's finger to the bone, was easily killed. The reason for the murder remains obscure, but there is no doubt that Lorenzino was responsible. He fled to Venice, where he later published an Apology[22] in which he claimed to have been motivated by a desire to save Florence from a vicious tyrant.

The election fell on the eighteen-year-old Cosimo, the son of the heroic Medici condottiere Giovanni delle Bande Nere, in whose service Cellini's brother had died, and who himself had been fatally injured when his son was only seven years old. A handsome young man, Cosimo had seemed born to rule: there was a story that his father had once insisted that a nurse throw the infant down from an upper window to be caught by him as he sat on horseback below. The child had gurgled with excited pleasure, and Giovanni had smiled and said: 'Yes, you'll be a Prince – it is your fate.' Alessandro seems to have thought of him as his natural successor, insisting that

he should be addressed as *'Signore'* and treated as the most prominent person in company, after himself.

Cosimo's election was in part due to the enthusiasm of his father's former soldiers; he was to retain the dukedom for thirty-seven years. His first action was to put a price on Lorenzino's head, and in 1548 the assassin was himself assassinated, in Venice, by two *bravi*, or professional killers.

Gradually, Cellini got back to work after his illness, and rather too soon for comfort the pope approached him with a commission to prepare a gift for Emperor Charles V, who was to visit Rome after an expedition against Tunis. There was some discussion about the form of the gift, and the pope finally fixed upon a book of offices of the Virgin which had been commissioned from the distinguished Florentine illuminator Jacopo del Giallo by Cardinal Ippolito de' Medici as a gift for a lady. This appears simply to have been confiscated by the pope, and Cellini was immediately set to work to design and execute a handsome jewelled gold cover.

He had only six weeks in which to complete the work, and perhaps because he was still not entirely recovered from his illness failed to do so by 5 April 1536, when the emperor and his retinue of 6,000 people passed through Rome under the ancient imperial triumphal arches to the Capitoline Hill and the Vatican. He was to stay for just under a fortnight.

Charles presented the pope with an impressive diamond valued at 12,000 *scudi*, set by a distinguished Venetian goldsmith, Miliano Targhetta. Then there was a ceremony at which Cellini was to make his excuses for the incomplete book of hours.[23] First, two magnificent Arab horses, the gift of the pope, stepped elegantly through the corridors of the Vatican to make their obeisance to the emperor, then Cellini himself was presented, apologised for the fact that his recent illness had prevented him from completing the present, and went on to announce that

Your Majesty, His Holiness presents this book, produced by the hand of the greatest artist who has ever practised the art of calligraphy and illumination; I have not completed the gold,

jewelled cover because of illness, and because of this His Holiness gives me to you as well as the book, so that I may come along with your Majesty in order to finish it, and serve you as long as I may live in whatever you may command me.[24]

The emperor seemed flattered, said that he entirely understood why the work was not finished, and invited Cellini to bring him the complete book when it was ready. In the meantime the goldsmith turned his attention to the pope's new diamond, which Paul III instructed him to tint and set as a ring.

The process of tinting was a long and painstaking one, involving lamp-black, olive oil, and gum mastic. Cellini worked on the diamond for two days, 'and by great labour produced a composition which made a much finer effect beneath the diamond than had been made by the master Miliano Targhetta (never did any one better know how to fix foils and tint stones). And when I had made sure that I had beaten so admirable a man, what did I do but set to work anew with still greater energy to see if I could not beat even myself', he wrote in his *Treatises*.[25]

He gathered together four colleagues – including Giovanni Pietro Marliano (known as Gaio), Guasparri Romanesco, and a fellow-jeweller called Raphaello – to show off his skill. Perhaps understandably, they were not particularly pleased when they heard that they had been sent for to be lectured by a younger man on the subject of his own skill and expertise, and for a while there was a great deal of snappish back-chat. But when Cellini demonstrated his tinting even the bad-tempered Gaio was forced to compliment him on its excellence:

All three were agreed, and Gaio before all – his ass's face quite beaming up – and they declared most amiably that I was a clever fellow, that I had good reasons for my action, & that I had beaten Master Miliano's tint by a long way, a thing they never imagined possible. At this I made a bow, not without a little pride, but so as not to be noticed. . . .[26]

The three jewellers were genuinely astonished at their young colleague's skill, and agreed that he had added 8,000 *scudi* to the value of the diamond.

Paul was extremely pleased – but was less delighted when he was told that Cellini had a very low regard for him, and had compared him unfavourably to his predecessor, Clement VII. The tattler was one Latino Giovenale de' Manetti, a courtier and Canon of San Pietro's, one of those who had argued for severe punishment for the murder of de' Capitaneis. He reported Benvenuto as having said that Paul's head was so swollen that it was barely possible to get the tiara on to it, that he looked like a roughly tied bundle of straw, and that only good luck had secured him the chair of St Peter.

The pope appeared to laugh this off, but Cellini suspected that he held a grudge – and the fact that it became increasingly difficult for him to secure an audience supported his view. He began to think it might be a good idea to look elsewhere for patronage. In the meantime, he had become embroiled in a domestic dispute. This concerned his latest apprentice, a slim thirteen-year-old called Ascanio di Giovanni de' Mari, who Benvenuto had trained both as a servant and an assistant in his work. Since the last mention of Cencio in the *Life* is of his apparently fatal illness, we may presume that the boy had died, and that Ascanio had replaced him in Cellini's affections – he describes him as 'the most handsome young fellow in Rome'[27] and clearly loved him (he says, 'as a son').

Unfortunately, Ascanio had eyes for the daughter of a Spanish goldsmith with whom he had previously been in service, and began to visit her rather too often for his master's taste. Cellini suggests with some disgust that the boy had accepted the girl's fumbling at his body, and apparently enjoyed the experience. Then, one day, Ascanio seriously beat up one of Cellini's shop-boys and refused to explain or apologise – whereupon Benvenuto lost his temper (never an extraordinary event) and gave him a beating. Ascanio absconded and was discovered working for another goldsmith. After a great deal of argument he agreed to apologise and return to Cellini's service. The whole affair was disturbing, and contributed to the stress which had been mounting since Cellini's illness.

Suddenly one day he simply decided he had had enough of Rome, and announced that he was leaving to try his luck in France. Placing his business once more in the hands of the useful and devoted Felice, he decided that he would take one assistant with him, and chose a young Perugian, Girolamo Pascucci. The repentant Ascanio pleaded desperately to be allowed to join them. Cellini at first refused, but when the boy actually showed signs of following them on foot, gave way and bought a third horse. The three set forth.

SIX

Prisoner of the Pope

Cellini's friends were not altogether surprised when he left Rome. He had been grumbling about the neglect of the pope, and had not been altogether pleased when the pontiff gave him to the emperor, as it were, without prior notice, as a sort of present. Just after Easter 1537 Annibale Caro, an author who had been secretary to the pope when he was Cardinal Alessandro Farnese, wrote to their mutual friend, his fellow writer Benedetto Varchi, to warn him that 'Benvenuto's departure, so far as can be made out from the state of his preparations and from what he says, will take place before long. But you know how his mind works. Every small setback may make him change his plans. He told me himself that last Friday he would be on horseback. That he did not leave can be excused by the weather, because there were, and still are, violent rainstorms.'[1]

Rain or no, Cellini left Rome on 2 April with Ascanio and Girolamo. They rode first to Florence, then to Bologna, then on to Venice and Padua, where they stayed with his old friend Albertaccio del Bene, who now lived there. Benvenuto made a point of calling on the distinguished Venetian scholar and poet Pietro Bembo, highly respected for his books on literature and a disquisition on the art of love, and presently at work on a history of Venice.[2] Bembo had known Cellini by reputation for some time, and was eager for him to make a portrait medal of him.[3] He had mentioned the idea some time ago to Varchi, and been encouraged to write to Cellini on the subject. Cellini had presumably put him off, for the reason that he was too busy to take on any additional major work, for Bembo wrote to him again on 17 July 1535, making it clear that if Mahomet could not come to the mountain, other arrangements

might be made: 'It may well be that one day I shall come to Florence, where we could get you to come more conveniently and with less loss to the works you have always in hand.'[4]

He agreed to work on a medal – and Bembo provided accommodation in a room which would have been, Benvenuto noted, too grand even for a cardinal. The project took some time, partly because Cellini was a meticulous craftsman, and partly because Bembo had decided to grow a beard, and both he and the artist wanted to wait until it had become sufficiently handsome and luxurious to appear well in a portrait. They did not wait all that long, for Bembo's beard was, it seems, only two fingers long when the medal was completed.

It took 200 hours to complete the wax model from which the medal would be struck. Bembo had been impressed by the fact that in one two-hour sitting Benvenuto roughed out what seemed an excellent model of his head, and thought that the major part of the work was complete. He was astonished and somewhat irritated by the length of the subsequent process. But he was more than delighted by the result, and when Cellini showed signs of wishing to move on he pleaded with him to delay his journey until he had designed and prepared the reverse of the medal, which was to show a Pegasus. The goldsmith produced the design within a few hours, but firmly refused to spend the time necessary to prepare the steel mould from which the medal could be struck. He really must leave, he said; but he would certainly return to Padua to complete the commission.

As far as is known, he never did so, and there is some question whether the medal was ever struck. A medal of Bembo exists which has been attributed to Cellini and has a Pegasus on the reverse, but the inscription describes Bembo as a cardinal, and he was only appointed to that office some time after Cellini left Padua; he is also shown with a long and splendid beard rather than a short one. This unsettling difference between Cellini's description of the beard and its appearance on the medal has never been explained, but it is a fine work, and is very possibly Cellini's, with the inscription perhaps added by another hand.[5]

Though disappointed that the work on the medal was somewhat incomplete, Bembo was clearly delighted with it, and made Cellini a generous present of three fine horses for his journey on to France.

The journey was an arduous one. Bad roads made for ridiculously slow progress – at best travellers on horseback could count on covering 100 kilometres in 24 hours. Then, the countryside was racked with war – travellers through Europe in the sixteenth and seventeenth centuries often had to pick their way through battlefields. Cellini found a relatively safe route through the Swiss canton of Grisons and the Albula and Bernina passes, the horses fighting their way through deep snow. Though the boats available for crossing Lake Wallen were ramshackle and seemed thoroughly unsafe, Benvenuto insisted on packing the three travellers and their mounts on to one diminutive vessel. Halfway across the lake there was a storm and the boat was almost swamped; they just made it to shore. Later the best of the horses slipped while climbing a steep path and impaled itself on Ascanio's lance; another almost fell off the side of the mountain taking with it the two boys and all the travellers' belongings. Later still the party was attacked by robbers, who they managed to beat off.

Eventually, however, via Zurich, Lausanne and Lyons, they reached Paris, where Cellini sought out an old Florentine friend and drinking companion, the charming and good-looking Giovanbattista di Jacopo, known as Rosso[6] because of his red hair.

He had come to Fontainebleau in 1530 and been immediately successful in ingratiating himself with Francis I, who was always interested in new talent and was a patron on a grand scale. Between 1514 and 1524, during the early years of his reign, he built spectacularly in the Loire. At Blois, he had added a complete wing to the existing medieval château, with wonderfully decorated Italianate galleries and loggias, a polygonal open-work staircase decorated with his emblems, and an open colonnade terrace under the roof. He employed an Italian architect, Domenico da Cortona, to prepare for him a wooden model of a great château which he intended to build at Chambord – Leonardo da Vinci may have been involved in the final design. As for the Château of Fontainebleau,

that former medieval hunting lodge had become one of the most admired palaces in Europe, with a magnificent collection of paintings and sculptures.

The château was described by Napoleon as '*la maison des siècles*', the true home of the French kings; and it was Francis who made it so. In 1519, disappointed that his efforts to become Holy Roman Emperor had failed, Francis had gone to Fontainebleau '*pour mettre en oublie mélancholie*', and within the next ten years had become so fond of hunting deer and wild boar in the area that he decided to spend most of his time there. It became his favourite palace. Jacques du Cerceau, a contemporary, wrote that the king 'liked it so much that . . . all he could find of excellence was for his Fontainebleau of which he was so fond that whenever he went there he would say that he was going home'.[7] The buildings were virtually ruinous, but the place itself, by the waters of the Bléaud river, and convenient for hunting in the immense Forêt de Bière, was charming – an excellent cure for melancholy. Francis commissioned Gilles Le Breton to rebuild the ancient castle extensively, using the old foundations, to build a fine gallery which was eventually to become the glory of the place,[8] and in particular to turn the original gatehouse into a grand entrance – a virtual pavilion to be known as the Porte Dorée. There was also a fine Pavillon des Poêles with a range of stoves on the ground floor which heated the gallery above.

When Cellini arrived at Fontana Beliò (as he always called the château) Francis was still concentrating all his patronage upon it. He was exceptionally well disposed to Italian artists – indeed, they had invaded France artistically almost as completely as he had invaded Italy militarily; apart from Rosso, he was to employ Francesco Primaticcio, Niccolò dell' Abate, Giacomo Barozzi da Vignola, Sebastiano Serlio and Andrea del Sarto. The two principals, Rosso and Primaticcio, were paid by being given prominent and profitable positions in the Church – Rosso became a Canon of the Saint-Chapelle in Paris, and Primaticcio Abbot of Saint-Martin.

Rosso had been an almost immediate success. He was a natural courtier, with a talent for music and an intelligent interest in aesthetics, and his ability as an artist was considerable. He had come

to France at a low point in his fortunes. Practically nothing is known of his formative years, but from 1513 on – that is from his twenty-eighth year – his paintings began to be recognised and approved. But then he had been trapped in Rome during the Sack, when he suffered great privations, and spent the next two years wandering aimlessly about Italy. In 1530 he decided to take his chance in France, and was to work there for the remaining ten years of his life. By the time Cellini arrived he was settled at Fontainebleau, where he worked well with Primaticcio. Together, they could be said to have been the founders of the School of Fontainebleau.

The Italian artists already well established there really did not need competition from yet another compatriot, and so though Benvenuto had done Rosso good turns in the past – indeed, the latter still owed him a considerable sum of money he had borrowed years earlier – he was not disposed to be helpful, and warned his old friend off: the French king, he said, was concentrating on the exertions of war rather than the pleasures of peace, and would be unlikely to offer yet another artist paid employment. He might as well go home.

Cellini seems to have recognised Rosso's duplicity, and did not allow himself to be put off his stroke at the first attempt. He took lodgings for himself and the two boys with another court painter, Andrea Sguazzella, who introduced him to Giuliano Buonaccorsi, Treasurer to Francis, and himself a Florentine. He was sympathetic to Cellini, and his sympathy was sharpened when he learned that Rosso was going out of his way to malign Benvenuto. He immediately organised an audience with the king. It was a brief and somewhat unsatisfactory one, for Francis was about to leave for Lyons – he was planning a fresh invasion of Italy (Piedmont would soon be invaded by French troops). However, Benvenuto made an impression, and the king asked Buonaccorsi to arrange for the Italian to travel with them, so that he could discuss some projects he had in mind for the château.

Nothing immediately came of this, but on the journey to Lyons Cellini struck up an acquaintance with the Archbishop of Milan,

Ippolito d'Este,[9] a son of the Duke of Ferrara, which was to be one of the most important of this period of his life. This young man – he was twenty-eight years old – had been made archbishop when he was fifteen (in two years' time he was to be made a cardinal). He was a member of an enormously wealthy family which had been prominent in Ferrara since at least 1097, and had ruled it since the thirteenth century. He was highly literate, reading both Latin and Greek, loved music and dancing, hunting and making love (it has been suggested that he was homosexual). A generous patron of all the arts, he was to create the magnificent Villa d'Este at Tivoli, outside Rome, designed for him by the architect Pirro Ligorio.

He was keenly interested in the arts, and found Benvenuto an interesting and lively companion. Conversation was virtually impossible as they jogged on horseback over the appalling roads, where any hurry or lack of attention could lead to an unpleasant tumble. In the evenings, however, they had long discussions. D'Este advised Benvenuto to separate himself from the king's entourage as soon as possible – rather than getting mixed up in preparations for war, Cellini would find life a great deal more comfortable if he became a guest at the abbey of Esnay. When the entourage arrived at Lyons on 6 October d'Este had to go on to Grenoble, but said he would soon return, and they could perhaps talk about the possibility of Cellini doing some work for him.

Cellini agreed; but then Ascanio fell ill of malaria, and Cellini of a recurrence of his former dangerous fever. He became almost morbidly set on immediately returning to Rome, and the cardinal, recognising the fact that it would be best if he did so, kindly supplied some handsome horses and sent the goldsmith on his way with a commission for a silver jug and basin, for which he paid in advance, but which he did not expect to receive until Cellini was well enough to execute it.

The journey back to Italy via the Simplon Pass, as winter drew on, was arduous and unpleasant, and Cellini was pleased to reach the comfort of Ferrara, where he paused to kiss hands with the duke, Ercole II d'Este. He declined to join him for lunch, explaining that his appetite had still not returned after his fever, but when he

returned to the inn where he was staying he found a table laden with delicacies sent by the duke to tempt him, and for the first time for four months – so he says[10] – made a hearty meal.

After only a single night's rest, the travellers pressed on to Santa Maria de Loreto (where Cellini made his obeisance at the highly popular shrine of Santa Casa – a wooden building said to have been the Virgin Mary's house, which in 1294 had been carried there piecemeal from Nazareth by angels) and then on to Rome, where they arrived tired and relieved on 16 December.

Early in the new year – 1538 – Cellini made over his old shop to his friend Felice, who had faithfully maintained it while he had been away, and opened a new and more magnificent establishment with workrooms staffed by no fewer than eight assistants. One of these was the Perugian Girolamo Pascucci, who was not happy with an arrangement whereby the expense Cellini had been put to to keep him during the past eight months (some 70 crowns) must be repaid by him out of his wages at the rate of 3 crowns a month. He disappeared, without giving notice. Cellini could not be bothered to pursue him, whether through the law or in any other way, for the moment Rome heard that he was back in business, commissions flooded in. He merely supervised much of the less important work, reserving his own powers for the commissioned jug and basin for Ippolito d'Este – and for another lavish commission, to set in gold a collection of valuable stones for Francesca, the wife of Girolamo Orsini, Lord of Bracciano.

Then out of the blue came a letter from Ippolito himself – a virtual summons to attend upon Francis I at Fontainebleau. There was some argument about the expenses for the journey – the king had given instructions that sufficient money to fund his return should be forwarded to Cellini, but Cardinal de' Gaddi, the Papal Legate to France, claimed (on what basis we cannot know) that he had already sent sufficient funds to Cellini. This seems to have been pure fantasy – Benvenuto had barely met the man, whom he described as 'that little fool',[11] and told Ippolito, understandably, that he was extremely busy and disinclined to undertake a return journey to France unless his expenses were guaranteed.

If he had set off immediately for Fontainebleau, however inconvenient that might have been, he would have escaped a great deal of unpleasantness. Girolamo Pascucci had been nursing the ill-feeling he felt against Cellini for, as he saw it, trying to milk him of his wages because of the alleged expense of keeping him during the journey to France and back. We do not know what arrangement had been made between them before the journey – but from Cellini's reaction, we can suppose that he had made no guarantee to support the young man as well as paying him a wage. There had after all been no work for an assistant to do during the trip; the two boys had simply acted as body servants. But Girolamo evidently felt that he had been scurvily treated, and took his revenge by going to one of the secretaries of Cellini's old enemy Pierluigi Farnese and accusing the goldsmith of stealing jewels worth at least 80,000 *scudi*, the property of the Church, from the Castel Sant' Angelo during the siege.

The blow fell suddenly and completely on the morning of 16 October when Cellini had risen three hours before dawn to complete his work on another important commission – setting jewels for the wedding of Isabella de' Medici. When his apprentices and workmen rose and began to prepare for their day's work, he went out along the Via Giulia for a breath of fresh air – and was immediately arrested in the street by the Bargello, Crispino de' Boni, with the words 'You are the prisoner of the Pope!'

Cellini was astonished and appalled. Nothing he could say deterred the Bargello and his men from marching him off to the castel, where he was thrown into a cell at the top of the tower. His house was searched, and a careful list made of everything found in the room where he kept the valuable material he used in his trade. Apart from the fragments of some silver candlesticks (evidently to be re-used) and some pieces of crystal and unmounted jewels, there was only finished work, which included forty-five gold rings set with jewels, several gold chains and bracelets, hair embellishments of lapis and agate, two silver medals of the late pope, and the gold and jewels on which he was working for Orsini (all of which were returned to him).[12] There was no sign of any stolen material.

Despite the lack of proof, a week elapsed before he was examined – on 24 November – by three magistrates: the Governor of Rome, Benedetto Conversini, the Procurator Fiscal, Benedetto Valenti, and Benedetto da Cagli, the *giudice de' malificii* or judge of the Criminal Court.

The governor put the case against him: that when, during the siege, he had been asked by the pope to dismantle the jewels from his tiaras, mitres and rings, he had secreted a quantity of them – to the value of 80,000 *scudi* – about his person, and given them to one of his workmen to smuggle out of the castel. If Cellini cared to produce the jewels, Conversini added, so that they could be returned to the Vatican treasury, the court would be prepared to release him.

The rarely seen cooler side of Cellini's temperament for once came to his aid, and he was able to control his volatile temper. He had lived in Rome for twenty years, he pointed out, and had never been arrested or imprisoned, either there or elsewhere. Conversini pointed out, not unreasonably, that he was known to have killed at least two men. But, Cellini disingenuously replied, this had been in self-defence, and he went on to give an account of the work he had done for the popes and the Church in Rome, asked first how the court thought he could have disposed of the 80,000 *scudi* he was accused of stealing, and then why they had not thought to order an inspection of the inventory of Pope Clement's jewels kept by the Camera Apostolica, so that an accurate list could be produced of any which appeared to be missing? He added that the present pope might recall the sterling work he had done during the siege:

Besides which, consider all the silver, gold, and jewelled ornaments, the beautiful and highly praised medals and coins, I have made for Holy Church! Is this the arrogant priestly recompense you give a man who has served and loved you with such faithfulness, with such virtuosity of art? By all means go and tell the Pope everything I have said; go and tell him he still has all the jewels he ever had; that I never got anything from the Church but the wounds and bruises I got during the Sack; that I never counted on any reward beyond some little recognition from Pope

Paolo, which he promised me. Now I know exactly what to think
of his Holiness and you, his Ministers.[13]

The pope, when the magistrates sent him their report of Cellini's
reaction to their interrogation, at once ordered an inspection of the
inventory, which proved to be completely satisfactory. Nothing was
missing. Yet he failed to order the release of the prisoner. The reason
for this remains obscure – it may be that Cellini's enemy Pierluigi
exerted more influence than has been credited. The *Life* suggests
that Pierluigi recognised his innocence – while in the same breath
implying that both the pontiff and his son planned to compass his
death. Meanwhile, news of the goldsmith's imprisonment had
reached Francis I in Paris, who sent the Bishop of Valence, Jean de
Morluc, as an ambassador to the Vatican positively instructing the
pope to release Cellini, who he described inaccurately as 'one of my
men'. The text of the pope's reply has not survived, but Paul was
said to have informed the king that Cellini was a dangerous man,
always getting into fights, who was in prison 'because of the
murders and the other devilish crimes' which he had committed.[14]

The castellan of the Castel Sant' Angelo was a Florentine – an
Hieronymite friar, Giorgio Ugolini – and he treated his prisoner with
extraordinary generosity. Having given a guarantee that he would not
attempt to escape, Cellini's cell was opened and he was allowed to
move about the tower with perfect freedom. Ascanio was now
keeping the shop open and passing on Benvenuto's instructions to the
workmen, and visited him frequently bringing him work to do – such
as the basin and plate for Ippolito d'Este; but the strain of being a
prisoner made it difficult for him to concentrate, and for the most
part he simply modelled small figures in wax for his own amusement.

Unfortunately, he made the acquaintance of a fellow prisoner, a
Lutheran friar who in a very short time became a trusted confidant.
In the *Life* Cellini bad-mouths him firmly: he was 'the wickedest
rogue in the world' who had been sentenced to seven months'
imprisonment for 'bestial vices'.[15] This does not seem likely: a man
imprisoned for rape or homosexuality would more likely have been
confined in a minor prison than the castel. The friar was probably

there because of his Lutheran preaching. Benvenuto was getting his own back by slandering a man who practised on him the oldest trick in the world, and took him in as easily as if he had been a child – not an easy thing to forgive.

The friar first informed Benvenuto that the promise he had made the castellan, that he would not attempt to escape, was worthless – if his life was in danger, he had the right to abscond. Cellini would not agree; his word was his bond. But it would, he said, certainly be very easy to escape. Really, said the friar? Cellini showed him the wax Ascanio had been allowed to bring him, how it could be used to make impressions of the castel's keys, and how duplicates could easily be made.

The friar then stole a little of the wax, and with an accomplice, one of the clerks working in the castel, set about making a set of false keys. But they were discovered, the castellan recognised the wax as Cellini's, and though he realised that the goldsmith had been duped, confined him closely to his cell – without explaining why. Cellini's fury when he learned the reason (and his gaolers soon revealed the friar's duplicity) must have been exacerbated by the fact that he had been so easily taken in. How this happened remains a mystery: Benvenuto was normally quite sufficiently quick-witted to have foreseen such a trap. The friar must have had a remarkable personality. He was apparently generally recognised in Rome as 'a great preacher', and Cellini does make it clear that he fell completely under his spell – he thought his commentary on the sermons of Savonarola was 'more impressive than the sermons themselves'; he was kept 'utterly spellbound' by his talk. After a while 'there was nothing in the world I would not have done for him'.[16]

Troubles did not come as single spies. Cellini heard that his shop had been closed down and his workmen and servants dismissed (the story was that the pope had been infuriated by a new demand from Francis I that he should either prosecute Cellini formally, or release him). Ascanio was having a bad time, jeered at in the streets by those who were pleased to see his master taken down. Then, a silly squabble broke out between the two of them – and in a bout of temper probably instigated by the strain of the situation Cellini

dismissed Ascanio and told the castellan to see that he was never again admitted to the castel. Everyone was sorry about this – in retrospect, Cellini himself; he soon began to miss the regular visits of a young man who was, he admitted, so handsome that no one could resist him. But Ascanio never returned, for as he left the prison after being summarily dismissed he ran across two particularly unpleasant colleagues of his ex-master's – both goldsmiths. They sneered, and Ascanio lost his temper and attacked them, cutting three fingers off the hand of one of them.

The pope, when he heard of the incident, believed that Cellini had ordered his servant to attack the two fellow goldsmiths, and only clever advocacy convinced him otherwise. Ascanio meanwhile fled to his home town of Tagliacozzo, and he and Benvenuto were reconciled in tearful correspondence.

All this encouraged Cellini to think of escape. The first thing he would need was a rope. That was simple. He ordered new, clean sheets for his bed, and hid the soiled ones, telling the castel servants that he had given them to some of the soldiers – this should be kept very quiet, otherwise the men would be penalised for accepting the gift. The ruse worked, and he cut the sheets into strips, knotting them together until he had a rope sufficiently long to reach from his cell to the ground, and a spare one in case of emergency.

Next, he managed to filch a pair of heavy pincers from one of the guards, and contrived to draw out most of the heavy nails which fastened massive metal bands to the door of his cell, filling the holes left in the door with a mixture of wax and iron filings, so that his efforts would not be noticed. Every night, when he had finished work on the door, he hid the pincers and the extracted nails in the straw of his mattress, then made up the bed very carefully and placed some flowers on it. If one of the two men who invariably inspected his cell every morning came near the bed, he made a great fuss about the cleanliness of the sheets and became almost hysterical, even threatening to kill the senior of the two officers if he disturbed and dirtied the bedding. The officer obviously feared Cellini's temper, and reported him to the castellan – who ordered him to keep well clear of the bed.

After a while, the bands which strengthened the door were kept in place only by one or two strategically placed nails. One night, he extracted these, and with a considerable effort removed the bands and cut through the wood around the bolt. Then he wound the linen ropes he had made around three of the bands, so that they could be easily carried without getting tangled, and opening the door made his way to a vulnerable piece of parapet, mounted the roof of the castel's keep, tied a rope to a projecting tile, threw it down the side of the keep and half-climbed, half-slid to the ground many metres below.

Unfortunately, he had failed to reconnoitre the area, and found himself in a stable-yard where poultry was kept, surrounded by high walls and with a single door firmly bolted on the outside. By good luck a lengthy wooden pole was lying on the ground, and leaning it up against the wall managed to pull himself up and fall on the other side. By now he was almost exhausted, and the flesh of his hands was torn and bleeding. He urinated on them, to bathe them, and moved on to the last obstacle – the outer wall, not so high as the wall of the keep, but still not insignificant. As he made to tie the second of his ropes to a part of the battlement, he saw a sentry close by. If the sentry saw him, he may have recognised him and known his reputation for fierceness. At all events, he was not challenged, fixed his rope, and threw a leg over the battlements.

He never recalled whether he slipped, became dizzy, or whether the strength of his hands and arms simply gave out. Anyway, he fell, struck his head, and lay unconscious for some time. When he woke, the eastern sky was just lightening. He put a hand to his head, and drew it away covered in blood. He tried to stand, and found that one of his legs was broken just above the ankle (he thought because of a dagger which he had thrust into his boot). He cut a piece from his rope and bound it up, and crawled away from the castel towards the city.

Escaping from the attentions of some guard dogs which attacked him, he persuaded a water-carrier to allow him to lie across the crupper of his donkey until they reached the top of the steps to San Pietro's, whence he again crawled – it was all he could do – towards

the nearby Borgo Vecchio and the palace of Margaret of Anjou, the fourteen-year-old wife of Ottavio Farnese, the pope's nephew. He had heard, while in prison, that she had come to Rome from Florence, and knew that with her would be several of his friends. As he was wearily pulling himself up the steps to the door, he was recognised by one of the servants of Cardinal Cornaro, and carried to the cardinal's rooms.

Cornaro sent for doctors, who set the broken bone, and then went to the pope to beg pardon for his guest. The pontiff seemed reasonably welcoming, and promised to 'make it up' to his former prisoner. But he equivocated about a pardon, and about any definite promise of future employment. At the cardinal's palace Benvenuto became one of the attractions of the city – Romans of every age and rank clustered around him to hear the story of his dramatic escape. Though there is no means of discovering to what extent, if at all, he embroidered it, it is certainly a fact that with a broken leg he managed to make his way from the castel to the Borgo Vecchio, remarkable evidence of his determination and ability to withstand pain.

No papal pardon arrived. What came, indeed, was even worse news – and worse treatment.

SEVEN

Miseries and Visions

Pope Paul III was extremely anxious that Cellini should not return to France. Though there were other goldsmiths, medalists and coin-makers in Rome, some of whom – Francesco da Sangallo and Domenico de'Vetri, for instance – were almost Benvenuto's equal, the pope was fully aware of his pre-eminence and was eager to retain his services. Clearly, he believed that the escaped prisoner was thinking of leaving Italy (who would blame him, after his recent experience of the pontiff's changeable nature?) and began to think that the safest place for him would be the Castel Sant' Angelo. He sent for the castellan, asking some uncomfortable questions about security and discovering just how the prisoner had managed to escape. The details were filled out by the Governor of Rome, recently made a bishop, who visited Cellini and feigning friendship drew out every last detail of his now famous escapade, and reported back to the pope.

Paul was, despite himself, impressed by Cellini's ingenuity and courage, and remarked upon it in the presence of his son. Perhaps re-imprisoning the man for no good reason would after all be a little harsh? Pierluigi was still eager to placate the Capitaneis family, and insisted that it would be not only proper but advisable to re-imprison the goldsmith, and to support his argument accused Cellini of the attempted murder of the twenty-year-old cardinal of Santa Fiore, Guido Ascanio Sforza. It was a fiction easy to support, for though Sforza himself was ostensibly a friend of Cellini and one of his patrons, the goldsmith had recently been seen having a violent altercation with an impertinent servant of the cardinal, and everyone knew how Scorpionic Benvenuto's temper was. When he was seen shooting in the direction of the cardinal's palace, the Palazzo Sforza-

106

Cesarini, which overlooked his shop – actually he was firing at a particular pigeon which had survived the skills of several local gunmen – it was easy to find a witness who would allege that he had seen him take aim at a window at which Sforza was standing.

The pope swallowed the story, and took it with all the more gravity because Sforza was his grandson by his daughter Costanza Farnese. Two days after Pierluigi told his tale, Cardinal Cornaro approached the pontiff to ask for a bishopric for one of his retinue. Paul agreed only on condition that Cellini should leave the cardinal's protection and come to live in a room in the private garden of one of his own houses, where, he said, he would personally care for him, and where he could live as a papal guest, all his expenses paid. It sounded like a generous invitation, but to Benvenuto – whose recent experience would have made anyone a little paranoid – it seemed more like imprisonment, and he now believed that the pope planned to have him murdered. Cornaro was not convinced that Paul III would go so far, but though he gave his guest up, advised him to eat nothing but the food he, the cardinal, would send him. This seems, again, like paranoia: but Benvenuto was by now really worried that Pierluigi's malevolence might carry the day, and hatched a plan to hide himself in a mattress and be carried out of the city by one of his young friends, a handsome Greek boy.[1] To his despair the Greek, at first amenable, decided at last that the pope meant no harm to the goldsmith, and retracted his promise to assist.

Worse was to come.

On the night of 10 June 1539, the Bargello came to Cellini's rooms off the courtyard of the pope's house accompanied by a number of officers who, beating off the dog which made valiant efforts to protect its master, carried him through the streets, his leg still in splints, to the notorious Tor di Nona, a prison for common criminals from which no one had ever been known to escape. There, he was thrown into the condemned cell. Ironically, it was Pierluigi's wife, Jeronima Orsini, who, hearing of Benvenuto's fresh imprisonment, pleaded with the pope for his release.[2] To keep the peace the pope promised to have him set free, and soon afterwards, at nightfall, officers came again to him, and he was once more lifted into a chair and carried through the

streets – not, however, back to his rooms, but to his old prison, the Castel Sant' Angelo, where first he was taken up to a cell at the very top of the keep, and then transferred to a damp chamber below ground, where worms wriggled through the damp earth on the floor, and spiders lurked in every corner.

The next weeks, dragging into months, were certainly the most terrible of his life – and the adjective is perfectly justifiable. His account of them in the *Life* is an extraordinary record of imprisonment, together with the dreams, fantasies and delusions which torture and sometimes sustain prisoners. A descent into a half-world of visions and imaginings was inevitable. It was not so much the physical discomfort of his situation which reduced Cellini to the point of breakdown. He had not been born to luxury, and while he was never averse to it and was quite happy when any of his patrons chose to instal him in handsome apartments in their own houses, he was quite capable of putting up with Spartan conditions when he was forced to – as long as he could continue to work. But the thought of being deprived of his occupation – to be unable to exercise his skill, to have absolutely nothing to do – to be in a situation when there was nothing he *could* do . . . that was another matter. Then again, he was not well equipped to deal with solitary confinement. He loved the bustle of his workshop and the company, chatter and banter of his work-boys and apprentices; he rarely travelled anywhere without a companion. While he had the intellectual equipment to sustain himself philosophically, the company of men was a necessity to him.

The castellan had suffered sufficient embarrassment about Benvenuto's former escape not to feel under any obligation to be kind, and the prisoner himself made things worse by continually boasting about it. As usual he was completely uninterested in behaving with any tact, and took every opportunity of irritating not only Ugolini but anyone who visited him. As his friend Annibale Caro wrote to a mutual acquaintance, Luca Martini, just after his release: 'I have still some hope for Benvenuto, unless his own temper should do him mischief, for that is certainly extravagant. Since he was in prison, he has never been able to refrain from saying things in his odd way,

which, in my opinion, makes [Pierluigi] uneasy as to what he may do or utter in the future. These follies, far more than any crime he has committed in the past, now compromise his safety.'[3]

Ugolini was by now behaving in a very peculiar manner, and was clearly mentally unbalanced and unsusceptible to reason, much less persuasion. He had placed his prisoner in one of the worst cells in the castel, deprived of fresh air, noxious with fumes from the waste of the whole place, damp and unheated. With only a filthy, thin mattress – soon wringing wet – to lie on, the prisoner passed the time reading and re-reading, during the few hours when there was sufficient light, the copy of the Bible which was one of only two books allowed him (the other was a theological work too insipid to be of interest even when there was nothing else). Already in severe pain from his broken leg, Benvenuto was soon attacked by rheumatism. No friends were permitted to visit him, but enemies were freely admitted, and came to bait him – among them Alessandro Monaldo, who had commanded the Florentine troops during the siege of that city, and was not disposed to be friendly to a man he thought of as a traitor to Florence.

Perhaps because the Bible was the only form of literature available to him, but also because as with almost every man of the period a religious sense was deeply inculcated in him, Benvenuto began to see visions. One of these stayed his hand when he attempted suicide – a beautiful young man who appeared to rebuke him for thinking of destroying his body, God's own work. In the morning, he made a thin coloured liquid stained with brick-dust, tore a splinter of wood from the door with his teeth, and with it recorded the visitation in indifferent verse. He began from night to night to dream of the visits of angels (invariably beautiful, invariably male)[4] which calmed him until the next great wave of despair. With a piece of charcoal he found on the floor, he drew a religious scene on the wall, before which he regularly prayed.

His mental suffering was accompanied by increased physical suffering: his toe-nails in-grew, so that they tore at the flesh of his feet. His teeth began to give trouble. Some loosened and fell out; he pulled others. Yet he still managed to display the utmost patience

and religious resignation when the castellan visited him. This so infuriated the latter that he decided to transfer him to another cell, if anything even damper and darker – so unhealthy that it had been chosen as the room in which the Dominican friar Benedetto Tiezzi, a follower of Savonarola, had, on the order of Clement VII, been left to starve to death in for his resistance to the Medici during the siege of Florence. When they locked the door they heard Cellini singing *De profundis* and *Miserere*. This seems to have affected even the castellan, and next day Benvenuto was carried back to his original cell, allowed a proper pen and ink, some wax and a few of the instruments used to work it. He made a small image of the crucified Christ which he carried everywhere with him until his death.

He had now been in prison for four months.

It was the turn of the pope to be impressed by the prisoner's steadfastness in the face of misfortune. Cellini told the castellan of the nightly dreams and visions which comforted him, some of which were sufficiently impressive for him to remember them in great detail until he dictated them twenty years later for inclusion in his *Life*. Ugolini related them to the pope, who ordered him to transfer Benvenuto to a more comfortable apartment, and have him properly fed.

The behaviour of Paul III is extremely difficult to fathom. The most likely explanation for his vicissitudes, both in Cellini's case and in other matters, is in a combination of intemperance and passion. Though he ordered his cardinals to adopt a modest and temperate way of life, it was common knowledge that he drank too much as a matter of course (which in a man of over seventy cannot have had a good effect upon his general well-being) while the violence of his temper was equally well known. He was also, during 1538 and 1539, under considerable political strain. There was for instance the controversy in England – a protracted argument which had started in 1531, when Henry VIII declared the whole body of the clergy to be guilty of treason (in connection with the argument about his divorce from Catherine of Aragon and his subsequent marriage to Anne Boleyn). This had resulted in the pope placing the country under interdict and excommunicating the king. Then he had been worrying himself about persuading Francis I of France and the

Emperor Charles V to sign the Truce of Nice, and inducing the French king to be severe upon the Huguenots. Apart from which he was determined to reform the Church in general, and was planning an ecumenical council. Cellini may well have seemed small fry, though there really is no excuse for his being imprisoned so long and under such a harsh regime, for absolutely no sound reason.

Apart from the misery of his imprisonment, Cellini's mind was troubled by his conviction (thoroughly justified) that Pierluigi was still fulminating against him. He also heard from his keepers the rumour that Ugolini had been ordered to kill him. The latter was now more unreasonable than ever, and appeared to be dying (one suspects, of venereal disease); at one stage he actually ordered Cellini to prepare for death, then with a violent mood-swing repented of the severe treatment of a man who as far as he knew was innocent of any crime. He died on 1 December before doing Cellini any harm; but the danger was not over. In the *Life* Benvenuto states as a fact that Leone Leoni, a fine goldsmith and medallist, had been instructed to prepare powdered diamond to be mixed with his food. Leoni, a poor man, had kept the diamond (worth 100 crowns) and merely used a little harmless grit. Cellini, feeling it between his teeth, supposed it to be indeed diamond, and prepared for death, since his 'stars had determined that it should be so'.[5] This sounds a little like more paranoia, except that while he was still imprisoned he told the story to the Bishop of Pavia, Giovan Girolama de'Rossi, who was imprisoned in a neighbouring cell on suspicion of conspiracy to murder.[6] The bishop sent Benvenuto bread every day, and he lived solely on that for a while.

The former castellan was succeeded by his brother Antonio, who was somewhat more sympathetic to Cellini – and was certainly clear of mind. He told his prisoner the news that the French king was continually attempting, through ambassadors, to secure his release – but that on the other hand nineteen-year-old Alessandro Farnese,[7] Pierluigi's son, who had been made cardinal five years earlier and already had his eye on the papacy, was of the opinion that he would not be released for some time. At the end of November, Annibal Caro, the friend of Benvenuto's youth, wrote a letter in which he

complained that it was impossible to make anyone listen to sense about Cellini's imprisonment, because of the 'irascibility and toughness' of the pope.

That his release actually took place relatively soon after the attempt to poison Cellini was due to the arrival in Rome of the goldsmith's friend and patron Ippolito d'Este, Cardinal of Ferrara. Cellini tells us that after an evening of heavy eating and drinking ('a spirited debauch', he calls it)[8] during which the pope and his guest became confidential, Paul drunkenly told the cardinal that he could take Cellini home with him as soon as he liked. Though it was 4 a.m., d'Este, less intoxicated than his host, sent immediately to the prison – he realised it was important to get Cellini out before Pierluigi heard of his father's clemency – and within a few hours Benvenuto was settling into a comfortable apartment in the palace loaned to d'Este by Cardinal Gonzaga. This must have been in late November or early December of 1539, because on 5 December Caro reported to a friend that 'Benvenuto has been released from the Castel. He is in the house of the Cardinal of Ferrara, and now his affairs will take an upward turn.'[9]

D'Este was extremely generous, equipping a room with a furnace for the goldsmith's use, and commissioning works from him. His accounts for the period show payments for various pieces – a set of four silver candlesticks, a chalice and a gold-mounted rosary. Cellini spent some of his time composing a turgid devotional poem of some 150 lines about his incarceration, which he called *Capitolo*.[10]

There had not been a general outcry at his imprisonment – open opposition to the actions of the pope was not wise, especially among those seeking preferment; but most knowledgeable Romans were clearly delighted to see Cellini released, apparently not very much the worse for his imprisonment. When he had rested for a while and dealt with the many callers who came to wish him well, he decided to make a restorative excursion, and leaving the trusted Pagolo to continue work on the silver bowl, set out in the company of two attractive young Romans, a metal-worker and his friend, for Tagliacozzo and reunion with his old friend and possibly lover, Ascanio. He had no difficulty in repairing broken bridges and

persuading the young man to return with him to Rome. They spent the journey animatedly discussing future projects, and within a week or so things were very much as they had been before Cellini's imprisonment – he was working with his assistants on silver artefacts which delighted and impressed everyone who saw them. D'Este visited the workshops almost every day, bringing with him such friends as the wealthy lawyer Gabriello Maria da Cesano, a papal envoy who later became Bishop of Saluzzo. D'Este commissioned him to design his cardinal's seal, with St John preaching in the desert on one side, and St Ambrose (the patron saint of Milan) on horseback, with a whip in his hand, together with the Este arms and a cardinal's hat on the other.[11] The two scenes are presented in low relief, with the kind of attention to detail (perspective, for instance) almost entirely absent from the work of any other medallist or coin-maker of the period. The cardinal showed it off to his peers with great pride.

Cellini's good fortune in acquiring the patronage, and it might be said friendship, of Ippolito d'Este can scarcely be overestimated. He not only employed Cellini, but paid the salaries of Ascanio and another workman, Paolo Romano – the former received three gold *scudi* a month, the latter four, and both were provided with specially designed tunics and cloaks.[12]

The work they did for d'Este was varied but more or less commonplace – Cellini mounted the beads of a rosary, made four candlesticks for one of the cardinal's senior employees, found for the cardinal a little antique bronze head of the Roman Emperor Vitellius and reconditioned it. The one major commission with which he was entrusted was for a salt-cellar, which d'Este wanted to be particularly individual and unusual in design – without quite knowing what he meant by that. Two of his friends – the poet Luigi Alamanni (who knew Cellini's work well) and Gabriello Cesano – were free with their suggestions, rather tactlessly instructing Benvenuto on the sort of design he should consider: Alamanni wanted the piece to be surmounted with the figures of Venus and Cupid, with various putti and 'appropriate ornaments', while Cesano voted in favour of Amphitrite surrounded by tritons. Cellini

was not impressed by either idea (though he slightly favoured Alamanni's suggestion, because at least the poet was handsome, while Cesano was 'ugly and disagreeable [and] spoke the same way as he looked').[13]

D'Este was similarly unimpressed by either suggestion, and left the whole thing to Benvenuto, who produced a design which fascinated and impressed the cardinal and his friends. It was certainly magnificent, with Sea and Land personified as a handsome man and a beautiful woman, nude, reclining facing each other with their legs entwined (as the sea and land meet in inlets and promontories), an intricate golden ship to hold the salt and a richly ornamented temple for pepper, and with multifarious animals and sea creatures gambolling around the base. Cesano said that it would take ten men a lifetime to complete such a project; Alamanni was even more critical, suspecting that so elaborate a work might never be completed. When Cellini, typically, said that not only would he complete it, but that the finished piece would be a hundred times more elaborate than the model, d'Este suggested that it would be most practical to consider making it for Francis I of France, who would best be able to afford the considerable amount of gold which would be needed. He then announced that he was leaving for France in ten days, and Cellini had better make ready to accompany him.

Though there is no suggestion that Cellini had actually made plans to return to France, the proposition made sense. The cardinal seemed convinced that Francis would now be more at leisure to consider new art commissions, while the goldsmith himself felt under no compulsion to be loyal to a pope who had treated him so badly – nor were there any signs of new commissions from that quarter. He would be safer and very probably financially more secure in France.

On 22 March 1540 – the Monday of Holy Week – the cardinal's party left the city in two sections, the first, with himself, making for the Romagna, where d'Este wanted to pray at the shrine of Our Lady of Loreto. He would then proceed to Ferrara, where he would be joined by the second part of his company, which was to travel via Florence. It was with this second party that Cellini rode – on

Tornon, the handsome new horse allotted to him for the journey – accompanied by Pagolo and Ascanio. They paused at Viterbo, where Benvenuto called at a convent of which one of his cousins was abbess, then at Florence, where Benvenuto's sister Liperata was delighted to entertain them.

At Ferrara he and his two companions were well housed by the cardinal, and he was told that there would be plenty of material with which he could continue to work on the still incomplete silver bowl (he was given a candlestick and some coins, to be melted down). He was surprised and irritated to learn that he was expected to remain at Ferrara while d'Este went on to Paris. The excuse was that the cardinal was eager to discover precisely what would be expected of the goldsmith there, which sounds as though d'Este was perhaps beginning to have doubts about landing up in Paris with a goldsmith and two workmen for whom there was actually no work, and whom he would then have to support. At all events, there was to be no argument: d'Este rode on, and Cellini was left to his own devices.

There were two very attractive courts at Ferrara, one presided over by d'Este's brother Ercole II, Duc de Chartres, and the other surrounding the French retinue of Ercole's wife René, daughter of Louis XII. But Benvenuto scorned them – perhaps they seemed provincial after Rome – and declined to play the courtier. Then he, Ascanio and Pagolo fell ill (fever, again) – and (he claims) only a regular supply of peacock pie, produced from the birds he shot every day in the neighbourhood, gave them the strength to recover.

Meanwhile, in the intervals of working on the silver bowl, he passed the time by making a few small models, including a group of four horses and a galley, and Ercole II sent for him and commissioned a portrait medal. The duke sat for Cellini for four or five hours together. They got on well, and the goldsmith was occasionally invited to supper. However, when it came to paying for the medal – with which he professed to be delighted – Ercole excused himself from handing over the 200 *scudi* which had been agreed, and instead proposed to give Cellini a diamond ring of the same value. Unfortunately, when the ring was examined, the diamond was found to be 'a miserably thin stone, worth perhaps ten *scudi*'.[14] Benvenuto

cheekily returned it, suggesting to the duke's chamberlain that it would be more serviceable if his master would kindly provide instead the kind of copper bracelet which, in England, was said to cure rheumatism. This would at least be useful. The riposte was of course reported to the duke, who was furious, but to save face ordered the man to find a diamond really worth 200 *scudi*. What turned up in the end was one valued at 60 *scudi*, but Cellini gave up the unequal struggle and put the whole incident down to characteristic aristocratic meanness.

He seems to have worked on two other medals at this time[15] – one bearing the head of the Cardinal of Ferrara, the other that of Benedetto Accolti, Cardinal of Ravenna – one of the few men about the court he found himself able to tolerate (he also speaks of entertaining himself with a few court musicians, perhaps joining them in making music). But he did not enjoy himself in Ferrara, and determined to get away. Unfortunately, the duke, impressed with his medal, was set on keeping him – as always, his skill had been recognised and was coveted. He was instructed not to leave the court without notice and permission. However, he considered himself no man's servant, and in the *Life* claims simply to have set off without leave, delighted to be away. What actually happened was that d'Este's agent Alberto Bendedio brought him a message that King Francis had demanded his presence immediately. D'Este had procrastinated, suggesting that Cellini was still lying sick at Lyons, and Benvenuto himself was not interested in rushing to Paris at full speed. However, the excuse was welcome, and he told Bendedio that he would happily attend upon the king, but that he intended to travel in easy stages. Bendedio agreed to this, and without bidding the duke farewell, Cellini left Ferrara. The only thing he had enjoyed there, he said, was the peacock pie.

EIGHT

The Court at Fontainebleau

Cellini, accompanied by Ascanio, Pagolo and one other servant, returned to Fontainebleau in mid-September 1540. D'Este had reached the court three months earlier (on 7 June), arriving at the château during the king's customary *lever*, when as the most distinguished guest he was invited to hand Francis his shirt as he rose from bed. The monarch was clearly delighted to see him, and talked with him for two hours, only releasing him when the dishevelled traveller asked permission to change his clothes. As soon as he had done so, he called on the dauphine, Catherine de' Medici, and was taken by her to pay his respects to the king's mistress, Madame d'Étampes. He had some time, before Cellini's arrival, to talk up the goldsmith's achievements. The king was politically and militarily more at leisure than he had been in 1537 – which meant that he was giving almost all his time to the embellishment of his château, and when Cellini arrived, he was received cordially both by Francis and Madame d'Étampes.

Francis was now forty-six years old, and although he was not in the best of health was still physically an impressive figure – Edward Hall, an English visitor to the court, described him as 'a goodly prince, stately of countenance, merry of cheer, brown coloured, great eyes, high nosed, big lipped, fair breasted and shouldered, small legs and long feet'.[1] When he and Henry VIII of England had met at the Field of the Cloth of Gold, they made a magnificent pair – two of the greatest monarchs and most handsome men in Europe, though observers had noted that while Francis's buttocks and thighs were impressive, his lower legs were a little thin, and his nose perhaps a trifle large.

117

Though at first shy when introduced to strangers, once at ease his conversation was enthusiastic and interested: 'If a man speak to him first,' Sir Thomas Cheyney wrote, 'he will not likely begin to speak to him, but when he is once entered, he is as good a man to speak to as ever I saw.'[2]

As a young man he had been physically both strong and courageous: in battle, he fought long and well, and at play was equally vigorous and brave – he hunted with a zeal which was almost senseless, and once faced a wild boar in single combat, spearing and killing it as others fled from the vicinity. He hunted women with equal fervour. When he was twenty, he was married to fifteen-year-old Claude, the daughter of his cousin King Louis XII. She was not especially physically attractive – 'small in stature, plain and badly lame in both hips' – but at the same time was 'very cultivated, generous and pious',[3] and was generally agreed to be particularly sweet and amiable. She certainly did her duty to Francis and the kingdom, for by the time she died, aged twenty-four, in nine years of marriage she had borne him no fewer than seven children – three sons and four daughters.

She did not, however, come up to the mark Francis set for his own sexual satisfaction. Rumour had it that he had a mistress at the age of ten and had incestuous relations with his sister. At the time when he succeeded Louis XII as king in 1515, only a year after his marriage, he was in the middle of an affair with the wife of a prominent Parisian lawyer, and had numerous other mistresses.

When Cellini first met the king, Madame d'Étampes – Anne d'Heilly, Dame de Pisseleu – had been his established mistress for at least nine years, and was described by the Imperial ambassador at the French court as 'the real president of the King's most private and intimate council'. She was a skilled and incessant political meddler, and made many enemies at court because of her considerable influence on the king in every area of his life. A closet Lutheran, she influenced his policy in religious as well as political matters.

The daughter of Guillaume d'Heilly, Seigneur de Pisseleu, she had been introduced to Francis in March 1526, when she was a beautiful eighteen-year-old member of the entourage of Madame de Vendôme.

Within a year she was continually seen in the king's company. Sir Anthony Browne wrote to King Henry VIII describing how Francis had a sumptuous bed carried with him when he went hunting, and would repair to it for a rest, of an afternoon, 'whereunto a great number of ladies and gentlewomen used to be in his company be sent for, and there he passes his time until ten or eleven o'clock, among whom among others, as the report is, he favours a maiden of Madame de Vendôme, called Hely, whose beauty, after my mind, is not highly to be praised'.[4]

Browne was alone in denigrating the favourite's beauty, which was usually not in question. She was also extremely high-spirited, sagacious, ebullient and sexually adept. In 1533, Francis married her off to Jean de Brosses, whom he created first Comte then Duc d'Étampes and made Governor of Brittany, and who was sufficiently tactful and complaisant to spend most of his time there, leaving his wife in the king's company. Though Francis re-married in 1530 (to Eleanor, sister of the Emperor Charles V) there was absolutely no doubt who ruled court and king – as Cellini in due course was to discover.

Meanwhile, it must have seemed rather a stroke of luck that Rosso, who had attempted to restrict Cellini's access to the king on his former visit (or at least had been of no help to him) died just after Benvenuto's second arrival at Fontainebleau. Not that the goldsmith did not admire Rosso's work: 'a master of extraordinary merit', he called him, which was at least tactful – it would have been undiplomatic of him to criticise a fellow Florentine whom the king is said to have admired more than any other living artist, and whose work was to be seen everywhere.

Francis I was no less happy than any patron to see himself and his achievements celebrated by his artists, and Rosso had covered the walls at Fontainebleau with paintings – historical and allegorical – celebrating the incidents of Francis's life, each set off by a magnificent frame more splendid than the painting it contained, with stucco figures and garlands in high relief, cut leather panels and strapwork in indiscriminate profusion. Then there were innumerable magnificent tapestries, some probably designed by the Italian, in

which beautiful naked women reclined in or strolled through imaginary fairytale landscapes (something of a speciality with Rosso) with forests, rolling hills or towering mountains.

We can only regret that so little of Francis's Fontainebleau remains to be seen – the long gallery, ballroom, the suites for the queen and for Madame d'Étampes were all either demolished or much altered during later work on the château, and many of the paintings were ruined by heavy restoration during the nineteenth century. Only the north wing of the *Cour de Cheval Blanc* and the *Galerie François Ier* remain more or less in their original condition, though the latter has been much altered – the ground floor beneath it was originally a bathroom and 'sweating room', with a bath deep enough for swimming. Sir John Wallop, the English ambassador, admired it,[5] though he was almost asphyxiated by the reeking steam which condensed on the surface of some of the king's best paintings, which he kept in the 'sweating room' – presumably enjoying, in the heated atmosphere, the erotic art which he so appreciated (he had been collecting paintings of nudes since 1518, and enjoyed showing them off).

Primaticcio was still busily at work about the château, painting his own fantastic landscapes, heavily influenced by Rosso (the latter indeed designed some of the frescoes which Primaticcio painted soon after his own arrival at Fontainebleau). He was no threat to Benvenuto. Neither was another Italian, Sebastiano Serlio, known as Il Bologna, who arrived just after Benvenuto together with a number of his own workmen. He was an architect invited to France by d'Este, who later commissioned him to design an *hôtel* for him at Fontainebleau. Cellini describes him as 'an excellent master of design'. The Italian mafia ruled at the château, the artistic achievements of 'the School of Fontainebleau' sending the message of the Italian Renaissance all over northern Europe – Serlio's influence on architecture (together with that of Palladio) was for instance seen in England.

Cellini looked forward to a prolonged period of work at Fontainebleau, and his hopes were no doubt strengthened by the king's gracious acknowledgement of his thanks for his majesty's

intervention in the matter of his imprisonment by Paul III. Francis greeted Cellini in Italian, and said that he would immediately turn his attention to considering just the sort of work he could commission from him. But no commissions were forthcoming, and Cellini was left to kick his heels about the court. Not that that was without its compensations, for life at Fontainebleau was crowded and far from dull. Apart from the many servants, there was a constant procession of visitors, princes both of Church and state, ambassadors, distinguished foreign travellers, entrepreneurs who came to sell the king rugs, tapestries, works of art, and of course *filles de joie* – that was actually an official title, and the young women were more or less on the pay-roll, each New Year receiving a gift of gold.

There was also plenty of art to see and study. Francis had been collecting pictures since he was ten years old – he had even then been capable of intelligently discussing art. He had tempted the aging Leonardo da Vinci to France simply because he admired him as the greatest living artist, and spent many hours talking with him – their relationship was sufficiently close for it to be claimed, though falsely, that Leonardo had died in the king's arms. Apart from the paintings and sculptures, there was music to be enjoyed, and no doubt Cellini listened with pleasure to the singing of the chapel choir (none but the best singers: two boys had even been kidnapped from the choir-school at Rouen)[6] and to the music of the court lutenists and the less exalted orchestral music of the band of viols, hautbois and sackbuts. There is no record that he joined them, but his interest in and love of music continued until the end of his life.

He hoped continually for news that he was to be employed – but Francis was restless, and the court left Fontainebleau to trail around northern France with, apparently, no particular aim in view. The enormous train of nobles and servants – Cellini says there were 12,000 of them, but other sources suggest almost twice that number – ambled pointlessly through villages and small towns, places which seemed completely devoid of interest. The king would usually put up at some convenient abbey or inn, while the courtiers would scrabble about for what accommodation they could find. 'Sometimes,' Cellini

wrote, 'there were only a couple of houses available, and we would huddle under canvas like gypsies, often in great discomfort.'[7] This meant, of course, that he could not work, and he swiftly became discontented. D'Este told him to be patient – in due course his majesty would let his will be known. Cellini presented himself regularly at the king's table, and in due course Francis condescended to notice him, complimented him, and promised shortly to make full provision for him and enable him to get down to work.

Now there was an altercation about money. Cellini had unwisely set out for France without having made any arrangement for his financial future. He had been expecting the cardinal to send him word of the terms the king would be prepared to meet; but no firm offer had been made, and never a patient man Benvenuto had made his journey as a speculation. Now he regretted it, for the king offered him only 300 *scudi* a year, which was almost insulting. He would not, he told the cardinal, have come for twice that sum. D'Este lost his temper at this, and told Cellini to go to the devil. Cellini thought that going to the devil might on the face of it be quite as profitable as remaining in Francis's service, packed his bags, and left the court for his lodgings back at Fontainebleau. There, he gave Ascanio and Pagolo as much money as he could afford, told them he had taught them all he knew, and advised them to go back to Italy. Leaving them bemoaning their dismissal, he took off on horseback with the clothes he rode in, a couple of spare shirts, and 50 *scudi* in his pocket.

He had no firm idea whence he was bound, except that he would avoid large towns and keep himself to himself. Remembering one of the visions he had had during his imprisonment in Rome, he promised himself that his next big project should be a 4- or 5-foot high, extremely beautiful figure of Christ. It was his first idea of a really large-scale work, but how he would obtain the funds for it, and where and how he might support himself while he was executing it, was in the lap of the gods. He was once more expressing his boundless confidence in his own competence and talent.

As things turned out, the question was not to arise, for after he had ridden only 2 or 3 miles he heard the sound of pursuing

horsemen, and Ascanio appeared together with a messenger from the king ordering his immediate return. He gave a dusty answer, but the messenger was insistent, and Ascanio pleaded with him to be sensible – resistance might well mean imprisonment. The idea frightened him into obedience, and he turned once again for Fontainebleau. As the three horsemen passed d'Este's tent, the cardinal was standing in the entrance, and called out to Cellini. The king had, he said, generously decided to pay the goldsmith the same sum as had been paid to Leonardo da Vinci when he had worked at Fontainebleau over twenty years previously – 700 *scudi* as a salary, 500 *scudi* as 'expenses', and additional ad hoc payment for any work he produced.

The sudden turnabout seems extraordinary, but the explanation may be relatively simple. Apart from d'Este (who was perhaps a little tentative in his arguments in favour of Cellini, probably fearing to annoy the king by persistent advocacy) Benvenuto's chief supporter at court was another Italian, the poet Luigi Alamanni. Nothing is known of Alamanni's position at Fontainebleau. He had served Francis since 1502, when he was purchasing pictures for the ten-year-old 'little prince', as he then called him.[8] He seems merely to have been an amateur of art, but clearly had access to the king, and his artistic opinion was respected. He had first encountered Cellini in Florence in 1528, when he had been brought to the goldsmith's workshop by a mutual friend, Federigo Ginori. The two men had liked each other at first sight, and become close friends – perhaps, indeed, more.[9] When Ginori died of consumption, Alamanni inherited a medal which Cellini had designed for him (at Michelangelo's recommendation), and later showed it to Francis I – it was probably the first the king heard of the goldsmith. There seems little doubt that it was Alamanni who now reminded Francis just how talented Cellini was, how mistaken the king would be to lose his services.

The following day Cellini sought and was granted an audience, and Francis commissioned him to make twelve silver candlesticks to be set around his table, the bases of which would be formed by six gods and six goddesses. This was a more remarkable proposition

than it may seem, for the figures were to be life-sized – the same height as the king himself (who was about 6½ feet tall). It was a tremendous commission, and Cellini must have been extremely excited at the prospect – each figure would be considerably more substantial than anything he had previously done. Indeed, it is slightly surprising that the king should have thought Cellini competent to execute such an ambitious scheme – he was still, after all, mainly a miniaturist, known for his designs for jewellery, medals and coins.

Francis seems to have had the commission in mind for some time. He had previously asked Rosso to make a large statue of Hercules as a *torchére*, but was extremely dissatisfied with the result – indeed, he described it to Cellini as 'the ugliest work of art he had ever seen', and had not kept it for himself, but had presented it to Charles V. According to Benvenuto, the problem with the figure had been that the Parisian silversmiths who had made it to Rosso's design had been incompetent – they could not work out how to solder the silver properly, and had clumsily attached the arms and legs with wire.[10] Cellini assured the king that he could do a great deal better than that, and Francis, accepting his word, suggested that it would be best if the goldsmith established himself in a workshop in Paris, where additional skilled workmen were available if he needed them.

At first, he borrowed a room in d'Este's house, and set to work immediately on wax models of four of the statues – Jupiter, Juno, Apollo and Vulcan – each about 6 inches high. He showed these to the king, taking the opportunity at the same time to present Ascanio and Paolo as two men whose help would be invaluable in the execution of the commission. The king, impressed by the *maquettes*, agreed to pay the two young men a retainer of 100 *scudi* each.

A proper workshop would of course be necessary to carry out the work of making two full-sized statues, and Cellini discovered what he believed would be the ideal place – a small medieval building on the left bank of the Seine, opposite the Louvre, part of the Château de Nesle[11] and known as L'Hôtel du Petit Nesle. This had a previous association with an artist, for the sculptor Guido Mazzoni

had lived there for a time. The king agreed that since the place appeared not to be in use and its rooms would make excellent studios and workshop, it was to be given up to Cellini. It was a contentious decision. The château was the property of Jean d'Estouteville, Seigneur de Villebon, who was Grand Prévôt de Justice, and an extremely vain and self-important person. The king was warned that there would be trouble, but was not deterred, and ordered that if there was any dispute about Benvenuto's right to occupy Le Petit Nesle, force should be made available to support him.

The Prévôt was not happy – especially when some of his servants, who attempted to prevent Cellini from entering his new quarters, were forcibly restrained. The position was not made more comfortable by the fact that Nicolas de Neufville, Seigneur de Villurois, Treasurer of France, who was ordered to see that Cellini was given every assistance, was a friend of d'Estouteville. Neufville strongly advised Benvenuto to look for accommodation elsewhere, but he was not a man to be cozened, and with a foothold in the château was not disposed to move. Neufville passed the matter on to another of the king's secretaries, Jean Lallemant de Marmaignes (later condemned for peculation), who Cellini described as 'a crafty old chap, and pretty fierce'.[12] He attempted to spike Benvenuto's guns by himself occupying some of the rooms the goldsmith needed. There was a confrontation. Cellini and his servants faced Lallemant and his, and daggers were drawn. Violence was avoided – just – and when the king heard of it, he ordered his secretary out of the rooms and provided Cellini with a protector, one of his personal bodyguard, at which d'Estouteville appears to have given up the unequal contest.

It was now 1541, and Cellini – dignified by the formal title of Orfèvre du Rois, or Goldsmith to the King, settled down to work on the ambitious commission. He prepared full-scale models in terracotta for three of the silver statues – Jupiter, Vulcan and Mars[13] – and when the king came to examine them, explained how he would proceed: he must have done so in much the same language as he used in his *Treatise*:

There are many different ways of doing the thing, and each master chooses the method to which his technical excellence or his fancy guides him.

First of all you make a statue in clay of the size you want your silver statue to be, then you make a gesso mould of it in many pieces: the whole breast to the middle of the ribs at the sides, and to the juncture of the throat above and the legs at the groin below, forms one piece. The next piece comprises the back from the juncture of the neck and contains the shoulders and down to the buttocks. These are the two main pieces. In like manner must the arms, legs, and head all be formed into two pieces . . . the gesso moulds are then respectively cast in bronze. And you have your sheet of silver handy of such size as may be deemed expedient by the skilful master, and commence to hammer it over the bronze with wooden hammers, carefully rounding the silver over the various forms; by means of frequent annealing these forms come to be beautifully covered.

A discreet and cunning master in order just to connect separate pieces together applies a few extra hammer strokes to their edges . . . [then] fits the one into the other, and with nice judgement tightens them with a hammer, holding them over a round stake, or some other piece of iron as shall hinder the hammer from indenting the silver where it has nothing to back it. In this way all the pieces are done, first the body, then the legs, arms and head.[14]

Cellini had the silver statues in mind during the whole of his time in Paris, though when he left in 1545 only one of them, the Jupiter, was completed; a sketch of the companion piece, Juno, has survived – and since the Jupiter has also vanished, is the only surviving piece of evidence of the ambitious project.

It was January 1545 before the Jupiter was ready to be shown to the king. Francis had looked in on Benvenuto from time to time at the foundry, sometimes bringing his mistress with him, sometimes important guests. His visits were informal – on one occasion he entered unexpectedly, his arrival lost in the noise of the workshop, and was almost knocked over by a small French apprentice

catapulted in his direction by a hefty kick from the goldsmith, annoyed by some incompetence.

Not only the Jupiter was to be seen at the workshop: there were other projects – among them a bust of Julius Caesar, larger than life-size, in armour, and a head of a girl – a model called Caterina, who 'I also used to keep to look after me in bed' he says,[15] in a phrase perhaps significantly devoid of the complimentary terms in which he describes his young male friends.

He also finished the bowl and ewer commissioned by d'Este, which the cardinal presented to the king on 17 March 1541 at a party attended by the most notable people about the court. Cellini had gilded both bowl and ewer so well that the king was almost overwhelmed by their beauty, and was intrigued when d'Este demonstrated that one could drink only from one of its three mouths – the other two were *faux*. Madame d'Étampes amusedly followed his example, and also drank. She seems, at what must have been a very early encounter with Cellini, to have been reasonably impressed with him, but he did not pay her sufficient attention either on this or following occasions – a fatal error. Had he learned to defer to her views and tastes, his years at Fontainebleau would have taken a very different course.

Francis was impressed by Cellini's work and personality, and delighted by the occasion and the impression his goldsmith had made on his guests, acknowledged d'Este's taste and foresight in bringing him to Fontainebleau by making him a present of an abbey with an income of 7,000 *scudi* a year. The cardinal gave Benvenuto 75 *scudi* as a mark of his own esteem.

Cellini did, however, receive French citizenship as a gift from the king to '*mon ami* Benvenuto' – Cellini is pleased to record the familiarity. With the naturalisation papers came the additional gift of the freehold of Le Petit Nesle. If there was ever any doubt of the extent to which Cellini was admired by the king – and by his artistic advisers – it must be allayed by two such magnificent, and indeed unprecedented, gifts.[16]

Now with his own house in the city, Cellini was able to offer hospitality to his friends. One of them, Guido Guidi – a Florentine

Professor of Medicine and Philosophy in the service of Francis, and later of Duke Cosimo – lived with him for more than a year, and he loaned apartments at Le Petit Nesle to Monsignor de'Rosse, the Bishop of Pavia, and to Luigi Alamanni and his sons. There was also a young man from Ferrara, Bartolomeo Chioccia. They all made good use of the tennis court in the grounds. A number of craftsmen also enjoyed his hospitality: a printer worked in one of the rooms of the castle – Pierre Gauthier, who published translations of books on surgery by Hippocrates – and a maker of gunpowder in another. There was some trouble with the latter, who refused to give up one of the rooms he occupied to Cellini, who needed it for his own work. Cellini threw him out, bodily, with a display of choice Florentine invective. This turned out to be a mistake, because the man was in some way connected with Madame d'Étampe, and complained bitterly to her. Then, a few days later, he threw out another tenant, hurling his furniture out of a window on to the street. ('One of these days, that devil will sack Paris itself!' Madame d'Étampes exclaimed.)[17] This, with a later incident, paved the way to considerable trouble.

Meanwhile, the occasion on which Cellini presented the silver-gilt bowl and ewer to the king saw the genesis of another work which was to be one of the two most important achievements Cellini left to posterity. The king was so delighted with the two pieces that he remarked that he would really like a fine salt-cellar to accompany them. By coincidence, Benvenuto remarked, he already had a plan for such a thing, which he would be happy to show his majesty. This was, of course, the design he had already made, some time ago. He hurriedly fetched the wax model, which fortuitously he had brought with him from Italy, and showed it to the king, who was enormously impressed. D'Este was a little offended – he recognised the model as the one Cellini had made for him, in Rome – and remarked that he doubted whether such an ambitious piece could ever be completed. The king, however, on the spot ordered his treasurer to supply old gold coins worth 1,000 *scudi*, which when melted down would be sufficient in weight to enable the salt-cellar to be made. Rather rashly, Cellini decided to collect the coins in person, and

immediately – perhaps wondering whether the king might not think better of the project, next day.

Cellini decided to carry the coins back to Le Petit Nesle unescorted – he 'did not want to disturb' his servants. By the time the treasurer had counted out the gold it was late evening, and he did send for some servants to escort him home – but they sent a message saying that they were 'unable to come', so he placed the coins in a small wicker basket given to him by his cousin the abbess, put the basket over his arm and set out through the dark streets.

As he left the treasurer's house, he saw a little group of whispering servants; they seemed, he thought, to be watching him. He crossed the Pont au Change, and as he approached Le Petit Nesle four men came towards him with drawn swords. He drew his own sword and dagger, and fought so fiercely that they withdrew; he shouted, his servants came out, and the money was safely carried into the house. He then settled down to a good meal with Ascanio and Pagolo, who told him that he was too prone to try to face every situation alone, and that one day he would regret it. The anecdote is told with considerable *brio* in the *Life*,[18] where Cellini is certainly not reticent about his own courage and skill, and it is probably not inaccurate – Cellini was always ready for a fight careless of the odds, and his confidence that he was quite capable of protecting a very large sum of money by wit and by arms sounds just like him.

Work on the Jupiter was slow and sometimes abortive – a plan to cast the complete figure in bronze in a furnace specially constructed for the purpose came to nothing because of the incompetence of the Parisian workmen (as well as Frenchmen, he also employed some Germans and a number of Italians who had been brought to France by Rosso and Primaticcio).

Meanwhile, Madame d'Étampes persuaded the king to commission Cellini to prepare the decoration for the Porte Dorée, for which he designed the now famous Nymph. The king also invited him – again at Madame's suggestion – to make a design for a fountain, but Benvenuto made the fatal mistake of showing this to his majesty before the king's mistress had seen it. She was furious. When he heard that she had been annoyed, hoping to placate her, he

took to her house a pretty silver vase he had made for her. Told of his arrival, she sent down a message that he should wait – and he did so until after dinner (displaying an almost unprecedented degree of patience) and then went off to dine with the king's friend, Jean, Cardinal of Lorraine, and gave him the silver vase. Madame d'Étampes was even more furious; the king, when he heard the story, merely laughed, which made matters worse.

Cellini shrugged the incident off, which was a little unwise. He had friends at court – not only was he confident of the king's support, but the dauphin (Henry, who eventually succeeded his father), the dauphine (formerly Catherine de' Medici, daughter of Lorenzo de' Medici) and the king's sister, Marguerite, Queen of Navarre, were on his side. But he underestimated the influence of Madame d'Étampes, as many men have underestimated the power of a mistress. The woman sent for Primaticcio and suggested to him that he was really the proper man to design a monumental fountain for Fontainebleau, and should demand the commission of the king. Not unnaturally, he agreed. With some justice they pointed out to Francis that not only had Cellini been commissioned to prepare twelve large silver statues, but that he had not yet finished a single one. Francis could not but feel that perhaps he was overloading his goldsmith.

At the same time, Cellini had other troubles. Needing more room at his château, he had thrown out another tenant – and this man went even less quietly than the salt-petre manufacturer, and took his former landlord to court. Though he seems rather to have enjoyed the theatricality of the courtroom, Benvenuto complains bitterly at the protracted nature of the proceedings, the duplicity of the lawyers employed, and the short temper of the judge. There is no reason to suppose that justice was any more or any less rigorously applied in Paris than anywhere else in Europe, but Cellini was always impatient, and when his lawyers informed him that the case was going against him (and that he would probably have to pay damages and possibly re-house his tenant) he once more resorted to violence. 'I had recourse', he says, 'to my large dagger', pointing out[19] with some pride that this was a collectors' piece ('I have always loved

owning fine weapons'), and then relates without the slightest embarrassment how he attacked the plaintiff, stabbing him so often in the legs that he was unable to walk, and then similarly attacked one of the man's advisers. He congratulated himself upon solving the legal problem at a single stroke (or rather, several strokes) – and indeed there is no suggestion that he was ever prosecuted for his actions, or even that he was suspected of the crimes – though surely, given his reputation, there must have been suspicions. Court records, however, are silent on the matter.

Apart from this, there was a domestic crisis involving a second Pagolo, who for clarity we will call by his proper name, Paolo. Paolo Miccieri suddenly appears in the *Life* as Cellini's bookkeeper – there is no indication that he travelled with Cellini from Rome, and Benvenuto seems to have met him as the brother of a man who was in some way employed about the court and highly regarded as an accountant. Paolo was an extremely pious young man, always muttering his prayers, and Benvenuto not only trusted him with his purse, but asked him to keep an eye on his model and mistress, Caterina. For some reason he had started to mistrust the girl, believing that she might be carrying on an affair with someone else. The fact did not disturb him, but he was concerned that if she fell pregnant she would be likely to pass the child off as his. Paolo seemed grateful for this exhibition of trust, and when invited to accompany Cellini, his two assistants and his friend Chioccia to a garden party given by a fellow-artist and a lutenist, Mattio del Nazaro, pointed out that it would be unwise to leave unoccupied a house and workshop in which there was so much gold, and suggested that he should remain at home, on guard. It would give him a good day's quiet in which to meditate and pray.

For no particular reason, Cellini tired of the party by mid-afternoon, and rode home. As he entered the castle he heard Caterina's mother shout 'Pagolo, Caterina – the master's here!' Finding Paolo and the model in a suggestive state of undress, he drew his sword. While not a possessive lover, he did not relish the actual sight of infidelity. The young man fled; the girl threw herself on her knees. Cellini chased after Paolo, but at the last moment

refrained from running him through – no doubt because especially on top of his recent behaviour, to kill a man even with good excuse would probably put an end to his stay in France, if not to his own life. Miccieri slunk off, and returning to the castle Cellini beat both the girl and her mother, driving her out of doors.

They seem in the first place to have considered suing him for assault, but having consulted a lawyer decided to accuse him of sodomising Caterina. This was a very serious accusation. The law in matters of sexual deviance were less ambiguous in France than in Italy. Sodomy, here, meant anal intercourse, and there were heavy penalties (including burning to death) for those found guilty of what was regarded as both a sin and a crime. Indeed, as recently as 1534 a Florentine merchant named Antoine Mellin had been found guilty of sodomy in Lyon and condemned to be burned alive; only the fact that he was extremely wealthy and managed to bribe the magistrate in charge of criminal cases had saved him.[20]

Cellini says in his *Life* that he supposed that the women and the lawyer were colluding in a blackmail attempt, believing that he would pay rather than face such a serious charge. He never seems seriously to have contemplated doing this, but the accusation threw him into a serious state of panic – quite possibly because it was well-founded.

At first, he prepared for immediate flight; then hesitated; then sought the advice of his companions; then thought of writing to the king, pre-empting the news of the accusation and setting it down to spite; then called together his friends and some of his assistants – ten in all – and invited them to arm themselves and prepare to help him fight his way out of the city if need be. In the end, he presented himself before the court, and denied the charge with some vehemence.

When Caterina accused him of sodomy, he mendaciously replied that that sort of intercourse was not the Italian way, but presumably it was the French way, since the girl knew all about it while he was totally ignorant of the procedure. The judge, who seemed to be on the girl's side, encouraged her to relate 'openly and clearly what was the filthy practice she accused me of'.[21] She did so, whereupon

Cellini swore that he had 'had no relations of any kind with her' – a statement even more equivocal than the previous one.

The records of the court have not survived, but clearly the charge against Cellini was eventually dismissed – it may have been dropped altogether. He was extremely fortunate. The judge would have been predisposed to suspect a sexual relationship between an artist and a beautiful teenage model, and it is very possible that there were rumours about Cellini's relationship with his boy apprentices. The temptation to put two and two together must have been considerable. Even if the news of his earlier prosecutions had not reached Paris (something of which he must have been fearful) his usual sexual behaviour, on the evidence we have, was scarcely discreet.

Whether Caterina's accusation of sodomy was justified is of course another matter. Cellini's fear that she might pass off a child as his may not be unrelated to the fact that he may have known that it would be impossible for her to conceive because he had been using anal intercourse as a form of contraception – a practice by no means infrequent. We know that he enjoyed anal intercourse with his boys, and she may not have objected to satisfying him in that way. At all events, muttering imprecations against the judge – who indeed seems to have been an incompetent bully – Benvenuto and his friends went home to a cheerful meal.

NINE

Quarrels with King and Court

In February 1542 Francis I had asked Cellini to think about the possibility of designing a fountain for the grounds of Fontainebleau. Within a few days Benvenuto came to the king with a design for a fountain with a square basin, up to which swept a graceful *ménage* of steps. In the middle of the basin was to be a pedestal a little higher than the wall containing the water, and on it was to be set a huge figure of Mars, muscular, graceful and nude, poised on his right foot, his left resting upon an intricately decorated helmet, and raising a broken lance in his right hand while the left rested on a sword caught by a belt around his waist. The central figure was to stand 54 feet high, and around it were to be placed four other figures, one at each angle of the basin, representing Learning, Design, Music and Generosity (the latter no doubt conceived as a meaningful permanent hint). 'The great statue in the centre,' Cellini said ingratiatingly, 'epitomizes your Majesty himself, the god Mars, unique in valour – valour which you employ justly and devoutly, in the defence of your glory.'[1]

His flattery had no effect, however, for in January 1545 Jacques de la Fa, one of Francis I's treasurers, who was supervising the payments which passed at irregular intervals between the king and the goldsmith, came to Cellini to confirm that Francesco Primaticcio had been commanded by the king to make the huge figure of Mars which Cellini had proposed as the centrepiece for a great fountain at Fontainebleau.

Cellini was furious; despite the delay, the idea of the colossal statue had never been out of his mind. He was not surprised to hear from de la Fa that it was Madame d'Étampes who had persuaded

the king that Primaticcio was the right man to design and construct the fountain. He remained her favourite, partly perhaps because of the effort he had put, during three whole years, into the decoration of her private rooms, where he had covered the walls with framed frescoes, each flanked by carelessly draped female figures – almost anorexic, with long slim arms and legs – surrounded by a plethora of flowers and fruits. But though she certainly showed Primaticcio favouritism, one can, in this case, rather sympathise with the king's mistress: if the design of a fountain was relatively easy, the actual construction – the laying of the pipes, the provision of an adequate water supply – was complex, and Primaticcio had already, in 1541, built a successful fountain at the château in the Cour de la Fontaine, with a figure of Hercules at its centre. Cellini was none the less infuriated, and no doubt worried that if the king's mistress could deprive him of such a major commission, she might well go on to deprive him of his privileged position.

Benvenuto was not the man to sit calmly and consider what to do to counter the influence of the king's mistress. There was an easier target, and he immediately took up his sword (always the main agent of persuasion which occurred to him) and made his way to Primaticcio's rooms, where his fellow artist greeted him with the utmost courtesy, and offered him wine. Cellini declined, and accused his colleague outright of having stolen the commission for the fountain through the influence of Madame d'Étampes. Primaticcio was perfectly at ease, and in view of Cellini's volatile temper – which must have been common knowledge – faced the accusation rather bravely: everyone, he said, obtained advancement by whatever means at his command. He had got the commission, and that was that. Was there anything else?

Cellini at first managed to keep control of himself, and suggested that they should both prepare models of the Mars, so that the king could make a final choice. Primaticcio was not interested, and simply reiterated that the decision had already been made. At which Benvenuto really lost his temper. If he heard that Primaticcio spoke one more word about the Mars to the king or to anyone else, he would kill him like a dog.

He then went off to the king, and without bringing up the subject of the Mars (showing some tact for once) discussed the new coinage he had been invited to design along the lines of some rough sketches Francis had sent him. His irritation showed itself, however, when some courtiers attempted to persuade Francis that the coins should be designed in a French rather than Italianate style, tartly pointing out that he had not come all the way from Italy to conform to an outdated fashion; he would as soon go home.[2] For the time being, the subject of the fountain was dropped.

Back at the château there was a further irritation – the news that Paolo Miccieri had taken a house for Caterina and her mother, and was boasting that he always kept a sword and dagger at his side to deal with her calumniator, should the blustering Cellini trouble them.

This was the last straw in a load of aggravations. Benvenuto, accompanied by Chioccia and a servant, went straight to the house and burst in, finding Paolo sitting joking with Caterina and her mother, his arm around the model's neck. With Cellini's sword at his throat, Paolo became so terrified that, rather uncharacteristically, Cellini spared his life. A better revenge, he thought, would be to force the man to marry the little whore. And that is what he did, sending for a notary and witnesses, waiting until the marriage bond was signed, and then leaving the house in disgust.

It seems possible that he really was sexually fixated on Caterina – a rare occurrence for him, with women. She was clearly extremely beautiful, and not only did he regard her very highly as a model, but his drawings of her were much admired. Moreover, he was unable to get her out of his head even after he had humiliated her, for after a while he sent to ask whether she would continue to pose for him. Surprisingly, on receiving his message she immediately returned to his studio. It may be the case that she was glad of the fee, which was paid in advance, and perhaps of the generous meals he gave her. But more likely (for Paolo had now found a position as secretary to the Prior of Capua, and must have been earning a regular salary) she found Cellini as attractive as he found her.

On his own evidence,[3] he treated her (at least after her marriage) sadistically, forcing her to pose naked for long periods in the most

excruciating postures, and from time to time beating her without real cause (on one occasion, for simply boasting of her husband's new job). He also regularly cuckolded Paolo, an exercise to which she seems thoroughly to have agreed. Everything suggests that they were sexually compatible; she was clearly a masochist. The beatings were severe: 'I pulled her round the room by her hair, and gave her so many kicks and blows that I was exhausted . . . she was all ripped up, her limbs bruised and swollen', he wrote.[4] Why should she have put up with this treatment unless she liked it? She did not need the money – her husband now had a profitable post. Instead, she returned day after day for the same treatment. Once, after Benvenuto's elderly female servant Ruperta had had to treat Caterina's bruises with beef dripping, the two women happily sat down with him to enjoy the left-over dripping, and the girl returned on the following day, threw her arms around his neck, and after they had breakfasted joined him in bed. The very next day, he beat her again – and so it went on, the modelling and love-making sessions continuing until Paolo, perhaps not entirely happy with the scenario, took his wife away out of Paris.

Meanwhile, he had financial problems. The king had promised him 7,000 gold crowns on account of work done and work to be done, but payment had been withheld – partly no doubt because Francis was concerned about the expense of a possible battle with the advancing army of the Emperor Charles V, who had taken Luxembourg early in 1544 and was now threatening Paris.[5] He surely felt that he should harbour his resources against a possibly protracted and expensive defence of the city.

That gifts of money from the king were neither frequent nor generous is also a reflection of the continued antipathy of Madame d'Étampes, who was now nursing an almost pathological dislike of Cellini. Her antipathy seems to have been rooted in his tactless refusal to kow-tow to her and defer to her judgement, as most of the court artists did. He was not of course in general a tactful man, nor given to deferring to anyone where artistic taste was concerned – even the popes found him somewhat intractable in such matters. It is also not impossible that she might have been aware of his equivocal

sexuality, and reacted negatively to this. At all events, she continued to take every opportunity of upsetting him. For instance, much impressed by the skill of a chemist who had come to her with a selection of perfumes and unguents (including an ointment for removing wrinkles – something hitherto never seen in France), she encouraged the man to present several of his most subtle flasks of perfume to the king, and when he received them enthusiastically advised the man to ask permission to use Cellini's tennis court and some of the apartments in his château. Francis was at first reluctant, but Madame d'Étampes was no less an adept in persuasion than other mistresses, and the perfume distiller presented himself one day at Le Petit Nesle accompanied by Jean Grolier, Francis's Superintendent of Finance, and claimed a set of rooms. Benvenuto's reply was to threaten to throw the man out of the window – but he was clearly diffident about giving possible offence to the king, and eventually allowed him to move in.

Consultation with lawyers, however, resulted in his being advised that a man's château was his castle, and he, Benvenuto, had a perfect right to throw out an unwanted tenant. He was delighted to have the opportunity to try out several new weapons – pikes and arquebuses – which he had recently acquired, often for the handsome designs of the latter, and the distiller was swiftly and firmly ejected. Benvenuto then went to the king, made a clean breast of his action, and claimed that he had thrown the man out because he threatened to get in the way of his service to the monarch. The king (one assumes that Madame d'Étampes was not present) laughed, and gave Cellini a clear warrant for undisturbed occupancy of his quarters.

Meanwhile, he and his assistants were at work on the salt-cellar which had originally been designed for Cardinal d'Este – he devised a careful work schedule, setting aside so many hours of the day for that project, so many for work on the Jupiter. He started working on the smaller piece the very day after displaying the design and model to the king, and it was completed by 1543. When it was shown to the king, even he – who had been presented in his time with so many splendid artefacts – was reduced to astonished silence.

It may be that privately he had shared the opinion of others who had seen the design: that it would be impossible to craft metal into such subtle contours.

Though he was certainly impressed, there is something a little odd about his reception of the work. According to Cellini, he threw up his hands in astonishment, and was completely silent for some time, gazing at the piece. But then rather than ordering it to be placed in a position of honour, he told Cellini to take it away; in due course he would tell him where it should be sent. This is rather puzzling. Perhaps the king thought of sending the work as a present to someone he specially wanted to impress? Or perhaps he genuinely wished to think carefully about a proper setting for it – although in that case he would surely have had it kept at the palace? His hesitation may have been a hint of the trouble which was certainly to come, the fires of which were to be stoked by the irrepressible Madame d'Étampes.

At all events, Cellini had completed the only surviving genuine masterpiece among his remaining small-scale work in precious metal.[6] He took it back to his home, placed it in the centre of his table, and gave a supper party for his closest friends and assistants, who were the first to use it. He left three descriptions of the salt-cellar – two in his *Life* and one in his *Treatise*. In the former, he first describes the design as he conceived it in Rome, and then as it was when he presented it to the king. These vary, presumably because he made some improvised alterations to the design while he and his assistants were at work. His last description, in the *Treatise*, written more than two decades after he last saw the salt-cellar, is in fact the most accurate. The main scheme, however, never altered – the sea was represented as a male figure, seated opposite the woman who represented the land.

Speaking of his initial conception, the design which he originally showed d'Este, Cellini proposed that the two nude figures should sit – or rather lounge – with their legs entwined, representing the sea's embrace of the land 'in the same way as certain long branches of the sea cut into the land'. The male figure was to hold a highly ornamented ship in his hand, which would hold the salt, and by the

side of the woman (who held a horn of plenty) was to stand a temple on which she rested her other hand, to take the pepper. A plethora of sea-creatures and shells would decorate the base under her, while beneath the male figure would play a selection of land-animals.[7]

Though much of the delight of the piece is in the often minute detail, the two nude figures are themselves remarkable. Looking at a photograph of them, with no means of guessing at their scale, one might be forgiven for thinking them life-sized – the suave beauty of the woman, the musculature of the male, is as perfect as it could be in much larger figures. Their relationship to each other is well conceived; Cellini rightly rejected his original idea of having the legs entwined – in the finished work they are disposed naturally, with no attempt at effect. There is a real connection between the two beings: they regard each other with grave interest.

In the finished design the ship which was to have been held by Earth became a small barque, sailing on the right-hand side of the Sea, while the temple was turned into a triumphal arch, also simpler than Cellini originally described. It is less 'wonderfully decorated' perhaps than he had proposed, modified as the design was actually being exercised. It has been suggested that the original design must have been too difficult to execute – or to execute in a style as 'elaborately wrought' as he had first planned. Nor did the cornucopia or horn of plenty survive – again perhaps because Cellini originally intended it to be 'exquisitely wrought', and once more found it impossible to execute it with the high standard of workmanship needed to bring his vision to life. In his second description[8] there is again a suggestion that his ambition for the piece was not fully realised. Was it the case that his reach exceeded his grasp, or that he and his assistants were unable to translate into gold or silver the extraordinarily complex and elaborate designs he devised on paper? Had he been able to do so, would we have been more impressed with his surviving work, or would he have decorated his pieces to such an extent that their force would have been diminished?

That is unlikely. What remains of his work shows, as one critic has put it,[9] 'a kind of cold sobriety', which protected him from the

temptation to over-decorate for the sake of showing off his skill as a goldsmith. It is most probable that the changes to the design of the salt-cellar arose not from an inability to realise the original conception, but from the exercise of his artistic taste as the piece took shape in three dimensions.

Not that one should suggest that the salt-cellar is not an extremely elaborate piece, displaying all the skill of which Cellini and his assistants were capable. The elaboration is perhaps most keenly illustrated in the gold reliefs around the ebony base which supports the figures, where the goldsmith set a number of 'wind gods' (as he called them) and figures illustrating the times of the day – night matching day, and morning joined with evening.

The reclining figures set by Michelangelo on the Medici tombs in Florence also represent morning, evening, night and day, and Mario Scalini in his essay on Cellini[10] goes so far as to suggest that he plagiarised them. One need not go that far – and he cannot, at the time he worked on the salt-cellar, have seen the figures *in situ*, though he will also certainly have seen them as they were being carved. The two male figures on the base of the salt-cellar certainly resemble Michelangelo's in their pose, but there are considerable differences, and Cellini's figures are more human in their attitudes, less formal, than Michelangelo's. Of the female figures, Morning slightly resembles one of the tomb figures; Night, not at all. And it must be said that Cellini's female figures are infinitely better-observed and more feminine than Michelangelo's.

The salt-cellar is one of those works of art which, given a glance within its glass case, reveals only a generally pleasant effect. A closer inspection than the casual visitor will have time to give it – or than is possible when one cannot approach it closer than a glass case will allow – reveals just how delicately the figures are executed, and with what exquisite skill. The arch designed to hold the pepper, for instance, is decorated with cherubs sitting upon each corner, above delicately wrought columns, standing figures at each end – a naked woman with a cornucopia, and Jupiter with the apples of the Hesperides. When isolated in a photograph, these again might be life-sized, so perfectly proportioned are they.

The details of the piece are more astonishing the more one looks at it. The salt-bearing barque, for instance, has a bearded head at the prow, surmounted by two rams' heads, and at the stern is a masked figure, while on its sides are military insignia – arrows, shields and flags. Then there are animal figures elsewhere: Earth is actually sitting on an elephant, beneath which can be seen a dog's head; nearby the head and front paws of a lion peep out, and the emblem of Francis I, the salamander, is under the female figure's left heel. Jupiter sits on a saddle-cloth supported by four sea-horses, the scale of which has been carefully crafted, while his little barque bobs on a sea accompanied by a turtle and three dolphins. On the base are numerous miniature symbols: a pick and spade, a bow with a golden string, an arrow and a scythe, crossed oars and an anchor and two crossed tridents. Beneath Jupiter are musical instruments and a sheet of music.

Apart from the appearance of the gold in which it is made, the piece originally shone with the most beautiful and subtle enamelling, considerably damaged in the piece's present state – but one can still see traces of the green shade of the sea, the white and red of flowers and fruit, the blue cloth on which Earth sits and the gilt-edged blue of Jupiter's saddle-cloth. Cellini was obviously a master of the art of enamelling – he writes of it at some length in his *Treatise*, speaking of it as being similar to painting, the main difference being that there were certain colours which could not be used to colour gold (yellow, turquoise blue and white, for instance, though he did attempt to use white in some areas of the salt-cellar: such as on the sheet of music).

No one who has seen the salt-cellar can deny its remarkable quality, perhaps the most impressive aspect being its carefully crafted spontaneity. If it is true that its design is less elaborate than Cellini originally proposed, one cannot believe that that is any loss. Quite apart from the design, each part of the work seems to have been completed to the most meticulous standard of craftsmanship, and is a tribute not only to Benvenuto himself, but to his workmen – Ascanio and Pagolo apart, he also employed an experienced German, Peter Baudel. He had also accepted as an apprentice a boy called Jean Sollier, the ten-year-old son of one of the gardeners at Le

Petit Nesle, whose position among his employees remains somewhat equivocal. It may be that he showed real promise, as Cellini himself had at that age, or he may simply have been employed as artists so often employed young boys, to do menial work about the studio.

Meanwhile, work continued on the silver figure of Jupiter, Cellini working with four of his best artisans, and in January 1545 it was ready to be shown to the king. It was to be set up in the Grande Galerie, where it would be in the company of a number of handsome bronze casts of the most celebrated classical figures in Rome, brought to France by Primaticcio – including the *Ariadne*, *Laocoön*, *Apollo Belvedere*, and *Cnidian Venus* (Cellini suspected, perhaps with justice, that this had been done on the advice of Madame d'Étampes specifically so that his own work could be compared unfavourably to the work of the great masters).

The Jupiter, industriously polished to show it off to advantage, had been placed on a gilded bronze plinth which Cellini had enriched by scenes of the rape of Ganymede and the love of Leda and the swan. Beneath its base four hard-wood balls had been set in sockets, so that the whole figure could be rolled into place. The king announced that he wished to see the figure immediately after dinner on 29 January, and the scene at which it was displayed was recorded not only by Cellini but by a Ferraran diplomat (in a letter to the Duke of Ferrara).[11]

It was one of the triumphs of Benvenuto's career. Since the figure has not survived, we can only rely on descriptions – in particular, Cellini's own. Life-size, the god stood with a globe of the world in his left hand, his right arm raised above his head, ready to hurl a thunderbolt. By the time the king had dined, dusk had fallen and the gallery was gloomy. Cellini suggests that Madame d'Étampes had delayed the monarch by her chattering specifically in order that lack of light should divest the silver figure of some of its glamour. It may have been for this reason that a wax taper had been placed within the representation of flames coming from the thunderbolt. Hearing the king's party approaching, Cellini lit it so that it threw its light down to gleam on the naked silver body, highpoints glittering beneath a transparent black gauze shot through with gold thread.

As the king entered with the court, Madame d'Étampes at his side, accompanied by the dauphin, the dauphine, the King of Navarre and his daughter, Marguerite of Navarre, Cellini signalled to Ascanio, who pushed the statue smoothly forward on its wooden wheels. The warm light of the taper illuminating the silver flesh beneath the gauze danced so that the god seemed about to come to life, and the king immediately complimented Benvenuto: the figure was, he said, the most beautiful thing he had ever seen.

Madame d'Étampes was determined to be unimpressed. According to Alvarotti, the Ferraran diplomat, her only comment was: 'So this is what has taken four years to make, and cost us forty thousand francs.'[12] It was glamorised by the way in which it was being presented – it would look nothing in daylight. Cellini knew better than to lose his temper on such an important occasion, and simply reminded her of the other work he had done since he came to Fontainebleau. A courtier played into the mistress's hands by asking why the figure was veiled. 'Obviously to hide some imperfection,' she said. 'Not at all,' replied the artist; 'in fact, I covered it for the sake of decency.' He then signalled to Ascanio, who released the gauze cloak from behind the figure, and it fell to the ground revealing the naked statue, whose genitals had been crafted in, it seems, remarkably effective detail. 'Do you find everything as it should be?' Cellini asked Madame d'Étampes.

Cellini reports that the king carefully controlled himself in the face of his mistress's anger, simply promising him a proper reward for his achievement. Alvarotti, on the other hand, reported to the Duke of Ferrara that Francis 'exploded with laughter', and that Benvenuto said plainly to Madame d'Étampes that he was accountable for his work to the king alone. 'What would you say if you were accountable to others as well?' she asked. 'If I were made accountable to others, I would not stay here,' he replied. 'What would you say if you were accountable to me, as well?' 'If I were accountable to you,' Cellini said boldly, 'I would not stay with His Majesty.' At which point the king said 'Enough, enough!' and brought the exchange to an end.[13]

Madame d'Étampes, bested on this occasion, laid up the perceived insult for future attention – she was to be aided by Cellini's rash use

of a certain amount of silver which was left over from the Jupiter. Instead of setting it aside for use in the partner statue of Juno to which he was expected to turn his attention, he used it to make a large *braccio*, or vase, described by Alvarotti as 'a silver vase in the style of the antique with two handles all worked in relief, a work judged universally to be exceptional and singular'. He worked on it for some months, on and off, describing it in his *Treatise* as the finest he ever made. When he left Fontainebleau, the vase remained there together with several others he had made 'in the style of the ancients', including two large ones which he showed the king and which Francis wished to buy (though whether he did so is not known).

One small silver vase, also created at this time, was made at her own request for Madame d'Étampes, but by the time it was ready to be presented to her the relationship between them had deteriorated, and she declined to receive him. He offered it then to the Cardinal of Lorraine, with the request that in return the cardinal should recommend Cellini to the king as an artist worthy of continued support. The cardinal paid 100 *scudi* for it.

After the unveiling of the Jupiter, the king made Cellini an immediate and welcome present of 1,000 gold crowns. Benvenuto went back to Le Petit Nesle and held a party during which he had all his best clothes brought to him, and gave them to his workmen, apprentices and servants.

The Jupiter was clearly a triumph, and it is no less a tragedy that it did not survive than that the whole project – for twelve gods and goddesses – was not carried through. How far Cellini got with designs for the other eleven, we cannot know – though a sketch and a small wax model survive[14] of the projected statue of Juno, which would have been a partner to Jupiter.

Cellini does not seem to have been very good at organising his time – the impression from his *Life* is of a man engaged on a confusing number of projects all at the same time. He did of course have his assistants, and it would have been perfectly possible once he had made basic designs for them to carry on the work while he simply moved from one to the other, supervising. After the unveiling of the Jupiter, he turned to another major project – the colossal

145

statue of Mars which was to stand at the centre of the great Fontainebleau fountain. Undeterred by the fact that the commission had been passed on to Primaticcio, he now started work on it, set up wooden scaffolding, and began modelling the figure in plaster. Alvarotti wrote to his master on 29 January 1545 excitedly reporting that Cellini was at work on a statue which would be larger than any made even by the ancient Romans.[15]

He was determined that the work should be a masterpiece, completely overshadowing anything his rival Primaticcio might produce. Working on such a large scale presented a particular problem – he remembered the proportions of Michelangelo's statue of David, and despite his idolisation of the master may well have had in mind the fact that some elements of that masterpiece illustrate the difficulty of getting every part of so large a figure perfectly in proportion (David's hands, for instance, are rather larger than perfection of scale would demand). He completed a full-sized skeleton of the figure of Mars. It was so large that it was possible to climb inside the helmet on which the god's right foot rested, and mount through the leg and body to the head. This helped a little when he had to clothe the body in canvas on which was laid a skin of several layers of gesso – chalk mixed with glue.

After this had been done he retired to as great a distance as the size of the courtyard in which he was working would allow, and carefully compared the huge figure with the small model from which he was working – neither he nor the carefully chosen few he invited to view the Mars could see any disparity between the two.

At first, the head of the figure lay on the ground at its side – a convenience for Ascanio, who had fallen in love with a French girl who he persuaded to leave home and live with him. Her mother discovered the identity of her lover, and came one day to the Petit Nesle to recapture her. Warned of her approach, Ascanio ingeniously made up a bed for his young mistress inside the head, where she slept for several nights. Among the results of this was the Petit Nesle's reputation as a haunted house. Visitors making clandestine visits to the courtyard believed that the eyes of the figure moved, even while it was still decapitated – what they saw of course was the

movement of the girl inside. Later, when the head was set upon the statue's shoulders, it could be seen from a considerable distance, and as with the Statue of Liberty, constructed in Paris over three centuries later, Parisians climbed to their rooftops to point out the enormous figure peering out over the city.

Finally, it was time to invite Francis to view the statue. Placing the king in a corner of the courtyard, as far from the figure as possible, Benvenuto signalled to Ascanio to pull away the huge canvas curtain which had been hung to conceal the figure. Throwing up his hands, the king 'spoke in my praise the most complimentary words that human tongue ever uttered',[16] and directed one of his admirals, Claude d'Annebau, to pay Benvenuto an immediate 2,000 gold crowns, either in currency or in the form of the grant of an abbey with a revenue of that amount. There is no record of any such payment, and no record of what happened to the gigantic statue. Certainly the proposed fountain was not erected, and since the Mars was a construction of lathe and plaster, it would not have survived for long.

Deprived of the commission (though no doubt pleased at its reception, and happy that it was not to be executed by his rival) Cellini had to continue to get by with the help of the sale of various artworks (he seems to have made a considerable number of small bronze figures at this time) and occasional crumbs from the royal purse. We cannot suppose that he was happy with the situation. It was all very well to have his work approved by one of Europe's great monarchs, but he had to live – moreover, there was always the cloud of Madame d'Étampes's antipathy hanging over him. That cloud was still darkening, growing blacker and more ominous.

TEN

The Nymph of Fontainebleau

Meanwhile, Cellini was at work on another major project – a figure to be set over the main gateway of the château of Fontainebleau.

In January 1542 the king and his mistress together invited him to devise some form of decoration for the Porte Dorée, the principal entrance to the palace. This consisted of three arches, with a fairly large lunette or alcove above the central one, which embraced the door itself. Within a few days Cellini had designed a project and started work on it; within two months he was casting the figure now known as 'the Nymph of Fontainebleau', at first using Caterina as a model for the figure – then when her husband removed her from Paris finding another young woman to pose for him (when drawing or modelling the human figure, he always worked from models, whether male or female).

He cast around, and picked up a very beautiful, strong-limbed fifteen-year-old country girl called Gianna, whom he nicknamed Scorzone – a slang Italian term for the rough husk of a nut, and also for a small black venomous snake, both of which seemed to summarise her character. She not only took over as model for the nymph, but for the figures of Victory which were to stand on each side of the door. She also performed Caterina's more intimate duties, and in short order Benvenuto had got her pregnant with 'as far as I remember, the first child I ever had'.[1] He was positive that she was a virgin when he first had her, and happily acknowledged the daughter she bore him, whom he named Costanza (he carefully noted her birth-data for astrological purposes: one o'clock in the afternoon of 7 June 1544). One of the king's doctors, Guido Guidi, was her godfather,[2] and her godmother was the wife of Cellini's friend Alamanni.

There is no suggestion that he ever beat Scorzone – but on the other hand no suggestion that he found her as sexually stimulating as Caterina. In fact despite the fact she became the mother of his child, he seems to have cared for her very little, and the single reference to her in his *Life* is cursory.[3]

His references to women in the *Life* militate against the arguments of those writers who have claimed that he was chiefly heterosexual, resorting to homosexual behaviour only when women were not readily available. The extent to which he was genuinely bisexual remains an open question. He never writes as warmly about women, even the mothers of his children, as about the boys and young men who accompanied him everywhere. The impression given is that he used women as sexual objects, but that he actually loved his male companions, quite apart from his sexual interest in them.

At the time of his residence in France, the danger of being actively homosexual was more acute there than in Italy. Jean Duret, the Royal Prosecutor in the presidential court of Moulin, put it very clearly indeed: 'When Venus disguises herself, when love is sought where it cannot be found, the imperial laws demand that the laws arm themselves and rise up to punish such monsters, infamous for all time, with death.'[4] An Italian visitor might also have been more open to suspicion than a Frenchman: the fact that the crime of sodomy was referred to as 'the *buzerroni* of the Italians' was significant.

Whether or not Cellini's display of interest in his female models was to some extent calculated, there can be little doubt that during his second visit to France he behaved much as he had always done, and was as interested in boys as in women – let us say at least that had he known all, the father of Jean Sollier might have had his suspicions.

Cellini's work on the figures to decorate the Porte Dorée was delayed for a while by the king's concern about the activities of the Emperor Charles V, who had occupied Luxembourg and much of Flanders, marched into Champagne, and seemed about to advance on Paris. That city was imperfectly protected, and Francis – knowing no doubt of Cellini's reputation during the siege of the castel at Rome – consulted him about the fortifications. The two men walked about the walls together, and the king, finding Cellini's

advice sensible and practicable, instructed the marshal of France, Admiral Claude d'Annebau[5] to see that matters were placed in his hands. Madame d'Étampes, when she heard of this from a jealous d'Annebau, was furious, and ordered him to send to Dieppe for the king's chief engineer, Girolimo Bellarmati, a specialist in military architecture (he designed the harbour at Le Havre). He put to the king his own scheme for the protection of Paris. Cellini calls this 'the most tedious method of fortification' and claims that had the emperor reached Paris he would have taken the city with the greatest of ease,[6] but he was not particularly offended – though interested in fortification and the arts of war, his main concern lay elsewhere, and he went back to his work for the Porte Dorée.

He approached this with considerable pleasure. He had been late in coming to large-scale sculpture, but his work on the Jupiter and the huge Mars had pleased and excited him, and he looked forward to executing more large-scale figures. And, apart from anything else, a massive ceremonial doorway to one of the great palaces of Europe was likely to outlast pieces of jewellery, silver vases, or even magnificent golden tableware. He was perfectly aware that at times of crisis (such as the present one) such things were likely to be dismembered or melted down to supply ready cash for the raising and support of armies, and that few of them might survive to offer him the possibility of immortality.

The transition from goldsmith to sculptor seems to have been relatively easy for him. There were no doubt technical problems, but his studies of the antique, together with a certain amount of experimentation, had showed him how to resolve these; he also had his own ideas about the casting of large-scale works, which were to be well proved. It was not necessarily the case, of course, that a jeweller and goldsmith could command the technique of a sculptor working not only in silver and bronze, but later in stone. The most notable example of a goldsmith who had achieved greatness as a sculptor was from a century and a half earlier: Lorenzo Ghiberti, born in 1378, who had been trained as a goldsmith by his father, and whose masterpiece was, and remains, the 'Gates of Paradise', the doors of the Baptistry of the cathedral of Florence.

Ghiberti had worked for some years as a goldsmith before winning the commission for the bronze Baptistry doors in 1401, in competition with six other artists, one of whom was Filippo Brunelleschi, who later erected the great dome of the cathedral (Ghiberti was rumoured to have helped him in the task). It had been a surprise when in 1412 (while still working on the doors, which were not completed until 1424) he was commissioned by the Arte dei Mercanti di Calimala, the guild of merchant bankers, to make a larger than life-size bronze figure of their patron, John the Baptist, to stand outside the Or San Michele, their headquarters. This was, when it was erected, the first large bronze statue to be seen in Florence – and it had been designed and cast by a goldsmith! Though Ghiberti had died forty-five years before Cellini's birth, Benvenuto's mind must surely have turned to his predecessor's life and work as he himself progressed from small- to large-scale work.

Benvenuto had always confidently modelled figures in wax, and never seems to have doubted his ability to enlarge his talent to embrace life-size and larger than life-size figures. He must, nevertheless, have been grateful for the confidence shown in him by Francis, for there were few examples of such a metamorphosis on the part of major artists, and many people were convinced that it was impossible. In fact, five years after the king had first suggested that he work on the doorway, when Cellini was commissioned by Cosimo I to produce his figure of Perseus, his fellow-artist the sculptor Baccio Bandinelli was outraged 'that Benvenuto should have changed in a moment from a goldsmith into a sculptor, nor was he able to grasp in his mind how a man who was used to making medals and little things, could now execute colossal figures and giants'.[7]

He looked forward to making something lasting, in material which would endure – unlike the stucco in which so many Italian artists at Fontainebleau had worked. Bronze would last, and would be less likely to be wilfully destroyed than gold or silver. Happily, there was a bronze foundry at Fontainebleau, which Primaticcio had set up in order to make casts from the moulds he had brought back from Italy; and Cellini also saw to it that a smaller foundry was constructed at Le Petit Nesle. He partly used this to teach some of

his French workmen more about the art of casting bronze – they had already spoiled the casting of part of the Jupiter.

The idea for a decoration of some kind over the Porte Dorée, and the proposition that Cellini should be commissioned to prepare it, had arisen in January 1542, when Madame d'Étampes's antipathy towards him was as yet undeveloped. Visiting his studio with the king, she had suggested that he commission the Italian to 'execute something beautiful for the decoration of his favourite residence'. Francis immediately agreed, and asked Cellini to prepare a model of some work of art which would enrich the appearance and nobility of the château. Though Cellini does not specifically record that it was the king who suggested the Porte Dorée as the place where such a project would be particularly effectively displayed, it seems to have been Francis who proposed the site; it was certainly he who made the provision that whatever carving or statue was devised for the lunette, the space over the doorway, it should represent 'the genius of Fontainebleau'.

The Porte Dorée was the main ceremonial entrance to the palace of Fontainebleau, the work of Gilles le Breton, the supervisor of the architects who worked on the exterior of the palace. Completed in 1538, the doorway itself was rather elegant and restrained. Cellini, however, did not care for it – it had been designed 'in the filthy French style',[8] he said – and (not allowing the fact that he was not an architect to disturb him, and without seeking le Breton's permission) set about 'improving' it, 'correcting' the proportions, introducing projections at its sides with pediments and cornices, and proposing to demolish le Breton's rather pleasant severe columns, setting up a couple of satyrs on either side of the entrance. His design[9] shows these to be unwelcoming figures – one held up the lintel with one hand and brandished a heavy club in the other, while his companion threatened the visitor with a flail with three balls attached to its thongs. Both were 'meant to strike terror into the beholder'. Le Breton would perhaps have found the alterations unhappy, but Cellini left Fontainebleau before he had finished the satyrs (if indeed he ever got further than drawing them), and the doorway itself remained undisturbed.

However, work was completed on the figure Cellini designed for the lunette, now known as the Nymph of Fontainebleau. The design was based on the legend which explained the name of the château and the neighbourhood – a hunting dog called Bleu had found the haunt of a local nymph in the forest, with a little bubbling spring. Rosso had already painted the scene in the king's gallery, showing the nymph reclining naked in a sylvan setting, her left arm resting on an urn from which water ran (the classical symbol for a nymph), with two hounds in the background moving among tall wheat. Cellini altered the scene somewhat. The dogs are still present, of course, but so are other animals, couched among fruits of the forest, while the naked nymph reclines with her right arm about the neck of a huge stag – 'one of the King's emblems', Cellini explains.

The casting of the nymph and surrounding figures was a complicated matter, and was done in several sections. It took place in February 1543, with two Frenchmen, Pierre Villain and Galium Saligot, contracted to oversee the main body of the work, and Thomas Dambry, a former assistant to Rosso, in charge of the engraving of the nymph's drapery. The chasing of the nymph's body, head and hair was entrusted to Pierre Bontemps and Laurent Mailleu (the former had worked with Primaticcio on the stucco in the queen's rooms at Fontainebleau). Cellini of course supervised, keeping the closest watch on all the men who worked on the piece. His pride never allowed him completely to trust any assistant or even colleague.

The bronze is now in the Louvre Museum in Paris,[10] isolated and not perhaps in the best setting; but it can still be recognised as a remarkable piece of work. Cellini was clearly an admirer of the female body – unlike Michelangelo, who regarded it as inferior to that of the male, which as Vasari put it, he 'held for something divine', and always drew his female studies using male models. From the waist up the nymph's torso is traditionally attractive (the head, however, is set a little oddly, somewhat to the figure's right, upon the shoulders), and the figure is certainly somewhat distorted by the undue length of the legs. This is partly the result of Cellini having to fill the space available, but also partly due to the particular view of

women's bodies taken by the Mannerists, who, getting away from the classic tradition of the female nude, tended to give them elegant but unnaturally long limbs, making them impossibly slender, almost anorexic.

A first reaction may well be to question whether the figure was truly modelled on the body of the sensual Caterina who Cellini so often enjoyed. But then if one looks more closely, ignoring the strange posture of the head, the modelling of the body itself shows just how personal and appreciative of the model the sculptor has been: the formation of the neck, the shoulders, the breasts and the lower part of the torso are all clearly modelled from life, as are the hands, which are no courtier's hands, with fine, small elongated fingers, but those of a working girl – the left hand not merely resting on the urn from which the water flows, but gripping its rim. It is worth remembering that while Caterina was the original model, her work was taken over by Gianna – the finished figure is a tribute to them both.

Though Cellini was perfectly capable of executing more 'classical' figures (see, for instance, the Minerva and Danae in the Bargello; and to judge from his preliminary drawing in the Louvre, the silver Juno which would have been a partner to his Mars would have been entirely conventional) the nymph is, with his later Ganymede, the best example we have of the artist as a Mannerist. Later critics grouped some of the artists of the sixteenth century together under that title because while they were strongly influenced by the work of Michelangelo, their own work imitated his manner rather than his intention or the spirit of his drawings, paintings and sculpture. The Mannerists were almost the first modern artists, for they eschewed the classic idea of creating male and female bodies which were perfectly in proportion, presenting the notion of idealised, flawless beauty particularly celebrated by Raphael. They took the view that perfect beauty was in the end rather boring, and set about making the figures they portrayed more individual and personal – but also often in some way unusual or imperfect, sometimes startling, sometimes almost ugly – and thus (as in real life) perhaps more capable of arousing desire. It is also the case that they enjoyed

solving intricate artistic problems such as having to place figures in complex poses or in confined spaces, for decorative purposes.

One of the most obvious examples is Parmigianino, an almost exact contemporary of Cellini, who was so intent on producing individual work that some of his paintings caused offence – his painting of the Madonna, for instance, with a neck so long that critics likened it to that of a swan, and impossibly slender fingers. Although his vision may have been influenced by an astigmatism, El Greco (born in 1541) seemed to take the idea to its ultimate in his bold disregard for classical proportions, producing figures so apparently distorted that until comparatively recently his paintings were seen as a bad joke. Cellini's nymph does not take the Mannerist idea to such an extreme; whether or not Caterina or Gianna had legs as long as hers, she remains entirely plausible as a desirable woman.

Apart from the nymph herself, the detail of the modelling of the animals which surround her is marvellous – one critic, examining them, has called Cellini 'the finest animal sculptor of the sixteenth century'.[11] He clearly loved dogs – he seems almost always to have owned one, sometimes for hunting and sometimes just for companionship – and the greyhound and four other dogs in the piece are wonderfully lively and living creatures; he clearly studied dogs with as much loving attention as he studied the bodies of his two female models. Then there are the two wild boar, fierce enough to give even the hunting dogs pause for thought, and the two fallow deer, all in a forest setting. The scene alone, without the central figure, would make this one of Cellini's most impressive surviving works – a sheer delight to the eye, not just as a setting for the nymph, but as a study in itself.

Around the lunette for which Cellini had made his nymph was a square moulding, and to fill the upper corners of this he proposed two figures of draped angels with torches in their hands, which he called 'Victories'. The originals have vanished,[12] so we know them only from the casts which were made of them in the nineteenth century.

* * *

It was while Francis I was at Cellini's foundry at Le Petit Nesle being shown the sculptures prepared for the Porte Dorée that the storm-clouds which Madame d'Étampes had been carefully puffing in the artist's direction actually began to precipitate. When the king was preparing to leave the château she suggested that she accompany him – but then when she heard that he was to visit Cellini's foundry she made her excuses, and in fact persuaded him to cancel his visit, which took place on the following day. It seems likely that she took the opportunity to blackguard Benvenuto, for having looked over the sections which awaited assembly the king, out of the blue, began to abuse him: he should remember that he would be nowhere without patronage, and that it was his duty to be obedient and subservient to his patrons. He had been commissioned to produce twelve silver statues, and had only produced one, preferring to make a salt-cellar, various vases, a decoration for a door. He had completely ignored the king's wishes, and gone his own way. Francis was stupefied, he said, by such disobedience and self-satisfaction. 'If you think you can go on like this, you'll soon discover what I can do when things are not done as I want them to be done. Take this as a warning, and in future do precisely what you're told. If you carry on as you've been going, you'll find that you run your head up against a brick wall.'[13]

The scene was an unpleasant and even potentially violent one. Francis was frowning, gesticulating, stamping his foot – the surrounding courtiers had rarely seen him in such a fury, and when he was in a rage one stood well clear: he had once broken down a door because the key had not been immediately forthcoming. Cellini must have been surprised (even frightened, had he been the sort of man to be fearful of anything). Up to that moment, though Madame d'Étampes had blown hot and cold about his work, and criticised his behaviour, he had had nothing but admiration from the king. By now, however, he had learned to keep his cool. He went down on one knee and offered what for him was as close to an apology as he was likely to make: his one intention, night and day, he said, was to serve the king. If he had appeared to be ungrateful or disobedient, it was the fault of destiny or malignant stars. But then he began to protest,[14] reminding the king that he had been given only enough

silver for *one* statue, and the little that had been left over had been made into a vase designed in the classical style, to show his majesty how things had been done in previous ages.

As for the salt-cellar, he reminded the king that he had actually asked for it on the very first occasion he set eyes on the design, and had given Cellini the means to make it. His majesty had not seemed ungrateful when he had been shown the finished article. The work on the Porte Dorée had been firmly commissioned – he would certainly not have considered such an ambitious project unless it had been specifically requested of him. He had, it was true, on his own account made a few busts in bronze – but this had been strictly necessary, for he needed to be sure of his technique before going on to make major figures in that material.

Then came a flourish all his own: 'I made Mars, my great Colossus, entirely at my own expense. An insignificant artist like myself should in my view put himself out to pay tribute to a great king; the resulting work will be not only for your glory, but by reflection for my own – a homage more complete than the ancients ever saw.'[15]

He suggested then that it was clear that God was unwilling to make him worthy of the honour of serving his majesty. Any reward the king had thought of giving him would be amply replaced by his kind permission for the artist to take his leave of Fontainebleau and return to Italy, where for the rest of his life he would be grateful for the happy time he had spent in his majesty's service.

Though clearly furious, Cellini managed to restrain himself. Even considering the life-and-death power of the king it must have been extremely difficult for him to deliver all that sycophancy in a suitably servile tone of voice, but on the occasion he succeeded. Francis put out his hand, raised Cellini to his feet, addressed him as '*mon ami*', and admitting that all his work had been excellent turned to the courtiers around him and praised the nymph as suitable for the doors of paradise. Of course the artist must continue to serve him.

But Cellini was not prepared to forgive the king – if forgiveness is a word to be used of monarchs. He thanked Francis for the

compliment, but firmly repeated his request for leave to go. The king went into another rage, ordered him to be quiet, said that he would drown him in gold if that was what he wanted, and – calming down a little – promised that he would be allowed free rein to make whatever he wanted to make (provided he also made what the king asked him to make). Francis then glanced at the statue of Mars, ordered his secretary to disburse whatever sum Cellini claimed in respect of it, and took his leave without allowing further discussion. He was never to see the Mars in a finished state, though in 1546, when Cellini was back in Florence, the king ordered the figure to be covered and sheltered from the weather in the belief that the artist would return to France and finish it.

On his way back to the château Francis had time to think over the scene, and by the time he arrived was again in a temper. He found Madame d'Étampes closeted with François de Bourbon, Comte de Saint-Paul and Duke of Estouteville, a close friend and confidant of his own (he had shared his imprisonment after the battle of Pavia). The king started complaining to them about Cellini, and also about d'Este, who had been so impertinent as to introduce such a rebellious spirit to the court. This was meat and drink to his mistress, and de Bourbon, whom Benvenuto had taken for a friend, immediately volunteered to see what he could do to bring the artist under control; he would see to it in one way or another that he stayed contentedly in France, serviceable to the king and causing no further trouble. Madame d'Étampes looked sour at this – but when the king asked how de Bourbon thought of keeping Cellini in France, and the nobleman said that hanging him up by the neck might possibly do the trick, she went into peals of laughter. The king also laughed, and said that de Bourbon was welcome to hang Benvenuto provided he could provide someone equally talented to take his place.

Francis's sudden antipathy is difficult to explain except by reference to the influence of Madame d'Étampes – but he was under considerable pressure elsewhere, for though a peace had been concluded with the emperor, his forces were still skirmishing with the English (Admiral d'Annebaut set off from Le Havre in July 1545 to confront the English off the Isle of Wight – on which he actually

at one point established a landing). These circumstances cannot have made for a tranquil frame of mind.

Just how serious the situation now was for Cellini is difficult to calculate. He had not considered de Bourbon to be an enemy, but the demands of kings had been known to sever friendships, and while the threat of hanging was perhaps not significant, there was no promise that his situation at Fontainebleau would improve. And indeed it did not: shortly after the scene at the foundry, the allowance which had enabled Cellini to run it was cancelled, and he was forced to lay off his bronze casters. This seems to have been a direct and mean-spirited attempt to teach him his place, and was the reason why neither the satyrs designed for the portals nor the huge figure of Mars were ever cast.

His last confrontation with the king took place at Argentan, north of Alençon, and was far from satisfactory. Cellini had arrived with two splendid vases he had made, with the help of two Italian workmen, using his own silver.[16] But the king pleaded illness and declined to receive him for several days. When he was shown the vases he was apparently delighted, and Cellini took the opportunity to renew his request to be allowed to return to Italy. He would be happy, he said, to forgo – at least for the moment – the seven months' salary due to him, and after all the times were far more suited to warfare than to art. The king at this became extremely cold, and simply said to him, in Italian: 'Benvenuto, you are a great fool.'[17]

D'Este was present at the interview, and when Benvenuto appealed to him advised him to go to Paris for a week, during which time he, d'Este, would make a further appeal to the king and would, he was sure, obtain permission for the journey back to Florence. Indeed, if there was no word from him within that time, he could start for Italy without apprehension.

Cellini waited longer than a week – indeed, for twenty days. During this time he made three strong packing-cases for the silver vases, which he had taken back to Paris and gilded. He left some work behind him, but took these away with him together with some other small pieces – and, if Vasari is to be trusted,[18] some original drawings by Michelangelo which had been left at Fontainebleau,

and that he had somehow acquired. Since the king had shown no sign of wanting the vases, and since they had been made with his own silver, he considered that they were his property, and he would take them with him to d'Este's abbey at Lyons. Not having heard a word from d'Este, he loaded the cases on the mule which had been loaned to him by the Bishop of Pavia (who was staying with him at Le Petit Nesle) and set off with one servant, 'a little French lad',[19] and two companions – Ippolito Gonzaga and Lionardo Tedaldi (nothing is known of them, but they may have been servants of Galeotto Pico, the Count of Mirandola, who himself was a servant of the king).

Ascanio and Pagolo were left in charge of the château and of what belongings Cellini left behind him, including his furniture and some smaller silver vases and other pieces on which he and they had been working, and which he ordered them to finish. He clearly regretted parting from Ascanio, and gave him a lecture: the boy was now a man, should guard his property and his honour, and if there was any trouble with the beastly French he was to send Benvenuto a message, and he would return like an avenging angel and smite them. Ascanio burst into tears and called him 'father'.

No sooner had Cellini left Paris than some of the king's men arrived at Le Petit Nesle and accused him of stealing the king's silver. They threatened the Bishop of Pavia and Guido Guidi, who were seriously frightened – as was Ascanio, who immediately rode after Benvenuto, caught him up, and told him that the bishop and Guido were in grave danger of arrest, and that he should send the vases back. He did so – rather unjustly railing at Ascanio as a 'traitor'. This is the last we hear in the *Life* of a young man who had been one of Cellini's most constant companions and assistants. Ascanio lived on in France, and may have died there – the last record of him dates from fourteen years later when, in 1563, he became involved in a street brawl in Paris, and disappeared to Flanders.[20] He and some fellow workmen clearly continued to run Cellini's workshop for some years – records have survived for ten months between 1548 and 1549, during which there were considerable sales.[21] Francis I did not give up hope of Cellini returning to France, and appointed

Jacque de la Fa, his treasurer, to see to it that the workshops and foundry at Le Petit Nesle were maintained. In March of the following year, 1546, de la Fa was still referring to Benvenuto as head of the workshops.

Francis's irritation at his departure, Benvenuto writes (in his *Treatise on Sculpture*),[22] was exacerbated when he heard a rumour that he had settled in Florence and accepted a major commission from the duke. He told d'Este that he would never employ Benvenuto again – and insisted that his decision should be conveyed to the sculptor in writing. After almost two years, the king had second thoughts and provoked a quarrel with d'Este, accusing him of being responsible for Cellini's departure – then ordering one of his treasurers to send the sculptor 6,000 *scudi* and to instruct him to return to France and finish his colossal Mars. Cellini got a letter invoking his return – but no money. By the time he had replied assenting – provided the cash arrived – the king had died.[23]

'Thus', Cellini writes, 'was I deprived of the glory of my great work, the reward of all my labours, and of everything that I had left behind me.' If he had equivocal memories of his time at Fontainebleau, he was grateful to the mercurial king for one thing in particular: Francis I had, he believed, set him on the road to immortality by turning him from a goldsmith into a sculptor. Though the Mars might have been a splendid work, there was a stroke of luck in all this, for within the next two years Cellini was to make the single work of art which would establish him in the pantheon of Italian sculptors, and the piece by which he is still best known.

ELEVEN

The Medici Patron

Cellini could not remotely be described as a family man. He never seems to have been especially close either to his brother or sisters – which is not to say that he was not protective of them, or cared nothing for them. While in France, he had one sister particularly in mind – Liperata, who now had six children, all of them girls, the oldest of marriageable age, the youngest still at the breast. Hearing that the family was in difficulties – Liperata's husband Rafaello Tassi was for some mysterious reason unable to work (Cellini seems to hint that there were political problems) – he sent her 4 *scudi* a month from Paris, and sometimes jewellery, which Tassi, an extremely honest man, was reduced to pawning in order to keep the family fed. Now, back in Florence, Benvenuto pledged himself to provide for the daughters, and gave four of them generous dowries – the other two eventually joined the convent of Sant' Orsolo and relieved him of further expense.

Having deserted the French court and one wealthy if parsimonious patron, he must now seek another, hopefully more generous – and it would be far better to have a single major benefactor than a number of less wealthy ones. The obvious candidate was the Duke of Florence, Cosimo I de' Medici, who had now ruled the city for eight years with somewhat surprising success. Not a great deal had been expected of him: Benedetto Varchi, a distinguished historian, supposed that the young man, who was considered 'of slow judgement', would 'with the twelve thousand ducats granted him as his private income, devote himself to enjoyment and employ himself in hunting, fowling and angling (things wherein he greatly delighted) while [others] would govern and, as the phrase is, suck the state dry. . . .'[1]

On the contrary, however, he very quickly proved himself an able and shrewd administrator and tactician who would stand no nonsense from anyone. He struck terror into the hearts of his enemies when after the defeat of an army of anti-Medici exiles he had many of them publicly beheaded in the courtyard of the Bargello in a series of bloody ceremonies which lasted for four days – at the end of which public outcry against the cruelty and debasement of his prisoners forced him to put an end to the carnage. He was, and remained, a man it was unwise to oppose.

Cosimo was an imposing figure: 'his hair yellow and curly, his face in youth most fair (while he throughout his life was of an admirable dignity) of bright colouring, his mouth somewhat full . . . his eyes large and keen, his forehead wide, his beard thick . . . his hands most delicate, his step rapid'.[2] At his side sat his duchess, Eleanora, one of the daughters of Don Pedro de Toledo. He had married her in 1538, and she was to give him several children. She occasionally acted as regent when he was from home, and was as formidable as her husband when it came to matters of argument.

When Cellini went out to the duke's villa at Poggio a Caiano to approach him, he must have thought the court showed substantial promise as a possible haven for an artist. Cosimo was at some pains, in the first place, to make all his villas outwardly handsome: he was especially interested in the design of gardens, and those of Cerreto, Lecceto, Montelupo, Il Trebbio and Poggio a Caiano (originally built for Lorenzo the Magnificent, and now with gardens designed by Giuliano da San Gallo) were justly celebrated. It was clear too that he was not entirely preoccupied with state business, and gave considerable time to pleasure – for instance to hunting and killing song-birds, happily recording one morning the death of sixty, including thrushes, blackbirds and twenty-five robins. The same afternoon the indefatigable hunter slaughtered five boars and two roebucks – 'one of which boars killed the Duchess's favourite hound and wounded and mauled many more. The chase ended, towards evening, their excellencies in the best spirits in the world.'[3]

The duke and duchess seemed also to take considerable interest in appearances. One of their major preoccupations was fashion.

The duchess was always commissioning new clothes and complaining at their quality when they were delivered, and the duke seemed to share her interest: there are records of his own commissions of bright doublets of red and crimson satin and scarlet hose, and he too was always criticising the quality of the material used to make his clothes – the cloth was too thick, or badly woven, or not soft enough. The duchess on at least one occasion (on 13 August 1543) ordered her tailor, Messer Carlo Pheo, 'to have made for his Excellency two pair of leathern hose, but not miserably short and tight like the others, which his Excellency has not been able to wear'.[4] Cosimo also paid marked attention to the dress of his sons (velvet doublets were *de rigueur* for the eldest) and his courtiers, even laying down standards for his pages' caps (which 'should be of purple velvet, for the scarlet caps are not convenient for the summer').

Five years before Cellini returned to Florence, Cosimo had moved his court from the family house in Via Larga across the river to the Palazzo della Signoria (now known as the Palazzo Vecchio) – incidentally clearing away the butchers' shops which had always displayed their wares on the Ponte Vecchio, and encouraging jewellers to take their place. Though Michelangelo's *David* stood on the steps of the Palazzo, further aggrandisement of the square would be no bad thing, and this was probably already under consideration when in August 1545 Benvenuto made his first approach to Cosimo.

The duke might have been expected to regard Cellini with suspicion. The court of Francis I was hospitable to a considerable number of anti-Medici exiles – those who had not been enthusiastically executed some years earlier – and Benvenuto might for all Cosimo knew have been one. On the other hand he admired Benvenuto's ostensible reason for returning to Italy: 'He came back to this country', he wrote to Catherine de' Medici, 'in order that his nieces might benefit by his talents and assistance; and I am no less pleased by this mark of dutiful regard for his family than by the beauty of his works.'[5]

So he greeted his visitor courteously, and he and his duchess both seemed interested to hear about his work at Fontainebleau. Cellini initially spoke well of Francis, though he was frank about the

financial problems which had forced him to leave Fontainebleau, and did not demur when the duke criticised the poor rewards given to the artist and promised that he would treat Benvenuto far more generously if he cared to make something for him. Playing one putative patron off against another was a skill artists were wise to learn, and Cellini, not disposed to be unduly friendly to the French and the French court, did not go so far as to claim that Francis had been an ideal patron.

Perhaps somewhat unwisely he did emphasise the king's personal friendship towards him, pointing out how hard Francis had worked to have him freed when he was imprisoned in the Castel Sant' Angelo. The duke shifted uneasily in his seat – but the point had been made; he must show himself as great a friend and a rather more generous patron. He insisted that if Cellini cared to produce a notable work of art for the city of Florence, he would be astonished at the generosity with which he would be rewarded.[6]

He and Cellini seem at that first meeting to have agreed together on the subject of the work and where it should be placed. The proposed site was the most prestigious in the city: right outside the Palazzo della Signoria, in the Piazza della Signoria, where already two masterpieces stood – the *David*, on the palace steps, and Donatello's *Judith and Holofernes*, in the Loggia dei Lanzi. A splendid new statue to stand in the loggia at the end near the palace, in counterpoint to Donatello's work, would further enhance the square and confirm it as the ceremonial centre of the city.

Cosimo, although he was taking something of a gamble in commissioning such a major work from an artist who was not known as a sculptor, was not as rash as might appear. He would no doubt have preferred to ask Michelangelo to consider a new project for the square – but finding Alessandro de' Medici a despot he had no desire to serve, the older artist had left the city a dozen years earlier, and was now working at the Vatican in Rome. Who else was available? The work Michelangelo had planned for the Medici Chapel in Florence had been carried out by Giovanni Angelo Montorsoli, who had completed several other pieces for the city, but had then left for Genoa, and was now at Messina. The architect of

the Duomo, Francesco da Sangallo, was also a sculptor, but not one in whom the duke had such confidence that he wished to commission a really major project from him. The main candidate was Bartolomeo Bandinelli, who had done a considerable amount of work for Cosimo, and might indeed have been thought of as the court sculptor. The duke had already seriously contemplated asking him for a sizeable statue, but was hesitating – there had been considerable criticism of some of Bandinelli's work.

The thought of producing a statue for the piazza must have stricken Cellini equally with pride and apprehension. He was always confident of his own powers, but to produce a work which could stand comparison with one of the greatest achievements of his hero Michelangelo – the sublime *David*, which he had known and admired since he was a child – was a challenge indeed. There were certain dangers, too – he had envious enemies in the city, where men jealously took sides, praising their favourite artists and attempting to denigrate competitors. Even the statue of David had been stoned on its first appearance, so that for several days a guard had to be set around it. On the other hand, what a compliment, and what a chance finally to establish himself as a real artist rather than a mere artisan – for there were still people (especially in Florence, where his recent work was unknown) who thought of him, if they thought of him at all, as just a goldsmith, producing delightful but more or less insignificant work. He seemed not to hesitate for a moment in accepting the duke's commission: he would be happy to attempt such a work. Should it be in bronze or marble? And had the duke a subject in mind?

Cosimo suggested – or commanded – a figure of Perseus, the Greek hero. In myth, he was the son of Jupiter and Danaë. King Polydectes of Seriphos, fearing that he would influence Danaë to reject his offered love, persuaded him to undertake the dangerous task of obtaining the head of the gorgon Medusa. Unexpectedly, he was victorious, and the statue should show him standing triumphantly over the body of the slain Medusa holding aloft her head with its hair composed of poisonous snakes.

Within a few weeks Cellini had produced a wax model of the statue as he envisioned it: Perseus stood, nude but for his winged

helmet and sandals, over the headless body of the gorgon Medusa, the sword given him by Mercury in one hand, the severed head held aloft in the other. The hero had a slim, sinewy body, more triumphalist than that of David, who Michelangelo had shown preparing to meet Goliath rather than after his victory. Neither was there a parallel with Donatello's *Judith and Holofernes*, which had been dedicated to the people of Florence – 'the invincible and constant spirit of the citizens', as the inscription on the base had it. Cellini rightly inferred that Cosimo wanted the *Perseus* to be dedicated to himself – Perseus victorious symbolising Cosimo victorious, and the victory and power of the Medicis.[7]

The fact that the model was produced fairly quickly does not mean that considerable thought was not given to its conception. The duke had envisaged a fairly simple statue of the hero; Cellini planned something more ambitious, eager to show his skill and vision. His *Perseus* was to stand on the body of Medusa which itself was to be carefully related to an elaborate base. He made several more models in wax, some in terracotta, and one at least in bronze (which with one of the wax models, can be seen in the Bargello). In the course of re-thinking his conception, Cellini made several changes from model to model – the body of Medusa for instance was originally draped, but finally was naked. Benvenuto obviously carefully studied Donatello's *Judith*, with which his own statue would inevitably be compared, and with which it must form a relationship. So, as Judith grasps the hair of the dead Holofernes with her left hand, Perseus holds up the head of Medusa in his; while the body of Holofernes rests on a wineskin, the body of Medusa rests on a padded drapery. Cellini was careful, too, to make his figure genuinely three-dimensional – pedestrians walking in the loggia would pay as much attention to the back of the statue as to the front.

He had come to very firm conclusions about the rules for making a good sculptural group, and outlined them in a letter to his friend, the philosopher Bendetto Varchi, written in January 1547. The sculptor, he said, should look at his work initially from eight different standpoints, and each view should offer a prospect of equal quality. If one aspect of the work failed to please, it must be

moderated; then the sculptor would have to consider how the modification affected other views. The result in the end must be a compromise, some of the sculptor's ambitions for a particular aspect sacrificed to enliven or modify another. Thus while one would begin to look from one aspect only, in the end one would consider the work from a hundred or more viewpoints, and these should reveal as few defects as possible. The demands made upon a sculptor, he inferred, were considerably greater than those made upon a painter.

The eventual work differs very little from Cellini's early sketch – *Perseus* was envisaged in one genuine moment of creation; what came afterwards was the exercise of technique – indeed to some extent the invention of technique, for the sculptor had never previously worked on anything like the figure which he was now contemplating, and its casting was to present him with problems which a lesser craftsman would have failed to solve.

When Cosimo returned to Florence from the country, Cellini took the model to the Palazzo della Signoria to show him, setting it up in the *guardaroba*, a small room in which Cosimo kept many of the smaller works of art he had commissioned and near which he had already set up a fully equipped goldsmith's workroom in which he could watch Benvenuto at work. One of the first works he created there was a little bronze relief of a Saluki hound, standing in a lozenge-shaped plaque some 28 centimetres long, its intelligent head slightly inclined towards the observer. It would surely have delighted Cosimo's children, who often interrupted the goldsmith in his studio: Don Garzia, the fourth of the duke's five sons, trailing around after him holding on to his cloak, and the others – Francesco, the elder son Don Giovanni, and Ferdinando (known as Don Arnando) – always fooling around in the workshop. One day when Don Garzia was busy poking the goldsmith in the back while he was trying to finish a tricky piece of work, Benvenuto lost his temper and told them to leave him alone. 'We can't!' they said. 'Well, then, if you can't you'll have to carry on annoying me!' Cellini said (perhaps catching sight out of the corner of his eye of the duke who was passing by).[8]

For a few days Cellini wondered whether he had dreamed the visit to Poggio a Caiano, for Cosimo simply ignored him. But eventually

one evening after dinner the duke brought the duchess and some of his closest associates to see the model, praised it, and encouragingly said he thought that, executed at full-size, it would be the most beautiful statue in the piazza.

Some men would have found his fulsome praise encouraging, but on reflection almost too flattering: Cellini, once committed to the work, accepted the duke's praise as an accurate forecast – merely his due. He had no fear, he said, of comparison with Michelangelo and Donatello, though they were the two greatest masters known to man. He would produce a full-scale work three times as effective as the wax model which now stood before the court, and it would hold its ground. If the duke was ready to accept this, some of his courtiers were more doubtful, and there was some dissension – or at least discussion. But Cellini held firm, and at length the duke encouraged him to list everything he needed for his work – he would see that it was provided.

One would have thought that after his experience with Francis I, Benvenuto would have made some effort to tie the duke down to his promise by suggesting a formal contract of some kind. He did not. Indeed, he made an unsolicited commitment to Cosimo, addressing him as 'my exceptional patron'. 'True petitions and agreements between us should not rely on statements or agreements,' he said, 'but on what accomplishment I can achieve.' As he wrote in a cancelled passage of his *Life*, he treated Cosimo 'as a Duke, not as a shopkeeper', and he was to regret it.

He was nevertheless quick to mention a house in the city which would be suitable both as a home and a working space: it was in the Via del Rosaio[9] and was spacious enough to contain both comfortable rooms in which he could live, and others which could be used as workshops in which he could produce models in clay or wax, and work in gold, silver or bronze. It would be a relief to be able to work without the continual interruptions of the duke and his children. There was also a small apple-orchard in which a furnace-room could be built for firing the large bronze statue he was about to create. He showed the duke two beautifully set jewels he had brought back with him from France, and volunteered to exchange

them for the house. The duke immediately offered to give him the house (perhaps Benvenuto had gambled on this) and had a deed made out – a *rescritto*[10] which ordered the discovery of the house's owner, an examination of the premises, and a record of the price for which it might be bought. 'We wish to please Benvenuto', he wrote, making no real promise at all – though Cellini scribbled on the bottom of the paper a note that the *rescritto* was so encouraging that he would prefer to live in Florence under such a duke than to return to France.[11]

Cosimo put the ordering of the affair in the hands of his secretary and major-domo Pier Francesco Riccio, and at a meeting with Riccio Cellini described his requirements, and everything seemed to be agreed. Cellini had the apple trees cut down and marked out the foundations of the furnace-house, and an official government purveyor, one Lattanzio Gorini, was ordered to provide the building materials. He was either inefficient or simply careless: after a considerable delay, he delivered enough stone, lime and sand to build a small pigeon-coop (some of the materials arrived in a cart pulled by a lame donkey led by a blind boy). Fuming, Benvenuto got on with other preparations as best he could. At least he had an excellent carpenter, Giambattista Tasso[12] – the same Tasso with whom he had started to walk to Rome all those years ago – who cheerfully sang (if in a rather unpleasant, shrill falsetto) as he started work on the wooden scaffolding within which the full-size model of Perseus would be set up.

A more serious problem now arose. Cellini suddenly received a summons to the Palazzo della Signoria. This was, then as now, magnificent enough to be awe-inspiring to anyone less self-assured than he: the apartments in which the duke lived and where he held court (sitting in splendour on the Udienza, a formal platform at the end of the grandiose Salone dei Cinquecento) had been splendidly decorated – indeed, work was still being done on them. He was received by Riccio after dinner in the Sala del Oriolo, in which the passing minutes were marked by the cosmographic clock set up there in 1484 for Lorenzo de' Medici. To his astonishment, the secretary asked what he thought he was doing, occupying a house in

which he had no permission to live, and ordering building work there for which he had no authority.

Cellini replied that nothing had been done except on the orders of Riccio himself, acting on the instructions of the duke. Riccio accused him of lying, whereupon Benvenuto replied that he was not inclined to take that from a man who was merely a servant, the equivalent of a schoolmaster.[13] The two then descended to name-calling, each man managed bitterly to insult and offend the other, and Cellini announced that if he was to be treated in this way he was going back to France.

He actually meant it, made arrangements for the support of his sister and her family, and began packing for Fontainebleau. But in a few days' time he was summoned again, less peremptorily, and Riccio made a long and flowery speech, disguising as best he might the fact that he was actually making an apology, and asked the artist to name the salary which would keep him in the duke's employ. Bandinelli, he said, received 200 *scudi*. Would he consider staying for the same stipend? Savouring the moment, Cellini agreed. He could do little else, for in the meantime he had heard from Guido Guidi in France that Francis I no longer counted on ever seeing him again. This was not particularly good news, for while he did not especially wish to return to the king's service, the situation at Fontainebleau was an excellent fall-back position, especially since he had French nationality and a château of his own in Paris. It seemed that Ascanio, while writing to him telling him to enjoy himself in Italy and not trouble about the situation in Paris, had at the same time been telling the king that he had no intention of returning. Well, there was nothing to be done about that. He got on with his work, with the sketches for the *Perseus*.

He had found two young boys to help him, and used one of them as a model – the very handsome Vincenzo, or Cencio, as he called him – the son of a Florentine prostitute with the impressive name of Margherita di Maria di Iacopo da Bologna. He was a slim but muscular adolescent youth with narrow hips; we know this because we have his portrait – he modelled for the Mercury on the base of the *Perseus*. Benvenuto could have done with more assistants, but the experienced workers he approached – and they were thin on the

ground in Florence – were bribed by Bartolommeo Bandinelli to refuse to work for him.

Bandinelli, having heard of the commission of the *Perseus*, was extremely and increasingly jealous. Usually known as Baccio, he was twelve years older than Cellini. Their families had always known each other – as a young boy, Benvenuto had briefly worked for Baccio's father Michelangelo de' Brandini, a blacksmith's son who had become a dependable and not unskilled goldsmith. Baccio had changed his name to Bandinelli in 1530, when Charles V had proposed to knight him, and to facilitate the compliment had claimed to be a member of a patrician family from Siena.

From childhood, Bandinelli had been far more interested in sculpture than in making jewellery or small ornaments, and as a boy entered the workshop of the Florentine sculptor Giovan Francesco Rustici, a colleague and friend of Leonardo, who recognised a certain talent. From the first he was violently jealous of any competitor – including even Michelangelo, whose work he closely studied. His expertise as a sculptor, such as it was, was chiefly the result of two years' work with Andrea Sansoverino on some reliefs at Loreto, and in 1519 an *Orpheus* he carved for the Medici palace was compared to the *Apollo Belvedere* (on which it was clearly modelled). The *Laocoön* he produced for the King of France was so admired that the Medici kept it for themselves, and in 1525 he was given a large block of marble which had been intended for Michelangelo, who being busily engaged on the tombs for the Medici chapel had only gone so far as to sketch a possible group of Samson and two Philistines. Bandinelli used it to produce the figures of *Hercules and Cacus* which was set up in the Piazza della Signoria (where it still stands) and was greeted with almost universal scorn. Bandinelli sent a spy to the piazza to report what the public was saying about the statue, and when he heard nothing but criticism 'concealed his vexation – it was always his custom to act thus, pretending not to care for the censure that any man laid on his works'.[14] The criticism did, however, considerably upset the duke, who actually imprisoned some of the critics who took the opportunity to make political points by criticising the work.

Michelangelo's absence from Florence left the field clear, and Bandinelli did not allow public criticism to deter him from following what seemed to be a rising star. Cosimo I continued to support him, asking him to design a monument to his father Giovanni (in whose service Benvenuto's brother Cecchino had fought). This is a not unsuccessful piece, more vigorous and better composed than many of Bandinelli's works, though it was considered unsuitable to the church for which it was intended and was set up in the piazza outside. Later the duke commissioned (at Bandinelli's suggestion) a series of statues of other members of the Medici family for the dais of the huge audience chamber of the Palazzo della Signoria – attracting more public criticism. Nevertheless, the duke proudly showed off in his private apartments a botched *Bacchus* which Bandinelli had started as an *Adam* to be set in the Duomo, but which had somehow turned into the god of wine. His support of Bandinelli was at least partly for a practical reason: order a work from him, and though it might not be good, you would at least get it – whereas other sculptors (in particular, Michelangelo) were extremely cavalier and unreliable when it came to actually delivering the work commissioned from them.

Giorgio Vasari, in his book on the artists of the time, was not complimentary: Bandinelli, he said, 'was not able to endure a colleague or an equal, and had little praise for the work of others'.[15] The fact that he was 'always decrying and maligning the works of others brought it about that no one could endure him, and whenever another was able to pay him back in his own coin, it was returned to him with interest; and before the magistrates he spoke all manner of evil without scruple about the other citizens, and received from them as good as he gave'.[16]

Cellini knew Bandinelli's work, and had no great opinion of it: indeed, he thought him a sculptor of quite astonishing lack of talent – a blockhead, he called him, a man whose work disfigured the public places of Florence. Bandinelli, in turn, became increasingly jealous of Cellini and increasingly malignant towards him – to the extent of spreading the rumour that when he could get hold of young workmen, he took them out with him on nightly tours of the

more degenerate houses of the city. Benvenuto denied this – and indeed there is evidence in the *Life* that he was more usually entertaining women, or at least one woman, during this period of his life. If his autobiography is to be believed, an unknown woman bore him a son within a year of his return to Florence. Nevertheless, Bandinelli's libellous gossip may have been perfectly true: his view that great art and vice were incompatible was not a theory to which Cellini subscribed, and after some time in France, where he had to keep his homosexual proclivities very much under wraps, he seems to have enjoyed revisiting his old haunts around the Old Market and the archbishop's palace, and may well have introduced his two handsome young assistants to the pleasures of the Chaisso de' Buoi.

If this was the case, it was more than a little foolhardy. Cosimo was on record as regarding homosexuality as 'odious'[17] and in 1542 had promulgated a much more severe law against sodomy than had been in force since the days of Savonarola – though this seems to have been inspired less by the duke's personal feelings than by the occurrence of an earthquake and a number of lightning strikes damaging the Duomo which the clergy insisted were the signs of divine discontent at the frightful displays of homosexuality in the city. As a result of the insistence of his bishops, Cosimo 'supported by the clergy, created two very severe laws, one against blasphemy and the other against sodomy, imposing very harsh penalties on delinquents, even death'.[18] Though the rigour with which this law was at first imposed had faded a little, sodomy was still regarded as a personal affront to the duke, and Cellini would have been well advised to exercise a little caution.

However, he seems not to have moderated his behaviour, and though it was some time before Bandinelli actually publicly accused him of being a homosexual, their public skirmishes began almost with their first meeting. To say that they were incompatible is to understate the position, and they were soon providing the duke and his court with a continuing cabaret of vocal pyrotechnics. Cellini was never a man to suffer fools gladly, and apart from his other problems was under additional tension because of the sudden death of his brother-in-law, leaving his sister with six daughters to care for,

and himself with – he felt – additional financial responsibility for them. Vasari reports that he

> expressed his thoughts freely, and found a man able to answer them; for Baccio saying many of his biting words to Benvenuto in the presence of the duke, Benvenuto, who was no less proud than himself, took pains to be even with him. And thus, arguing often on the matters of art and their own works, and pointing out each other's defects, they would utter the most slanderous words of one another in the presence of the duke, who, because he took pleasure in this and recognised the true genius and acuteness in their biting phrases, had given them full liberty and licence to say whatever they pleased about one another before him, provided that they did not remember their quarrel elsewhere.[19]

In the end, their exchanges became rather too heated for the court:

> One day, among others, that they were railing against each other as usual and laying bare many of each other's actions, Benvenuto, glaring at Baccio and threatening him, said: 'Prepare yourself for another world, Baccio, for I mean to send you out of this one.' And Baccio answered, 'Let me know a day beforehand, so that I may confess and make my will, and not die like the sort of beast that you are.' By reason of which the Duke, who for many months had found amusement in their quarrels, bade them be silent, fearing some evil ending, and caused them to make a portrait-bust of himself from the girdle upwards, both to be cast in bronze, to the end that he who should succeed best should carry off the honours.[20]

Cellini was still trying to get his workshops in some kind of order – the razed orchard was still a space littered with miscellaneous builders' rubbish, and getting reliable workmen was still a problem. He was sent a couple of day-labourers, one of whom was eighteen, the other sixty. The latter was useless, but the former – Bernardino Manelli – was willing enough, looked after Cellini's horse, became his personal servant, and gradually learned to be of use in the

workshop, in the end turning into perhaps his most experienced assistant. It is likely that he modelled for the hero, *Perseus*.

We have as much information about the actual making of the *Perseus* as about any work of art of the time, and a great deal more than most. The account in Cellini's *Life* is supported by additional material in his *Treatise on Sculpture*, while in an account book which has survived[21] he recorded all the expenses of creating the group. The main note at first is of frustration – not because of any difficulty with the design of the work itself, but because of seemingly endless bureaucratic bungling. During the hours and days when he was held up and because he was suffering from back pain (there seems to have been some trouble with his kidneys) Cellini turned to other work – a little gold drinking bowl and an ornamented girdle for the duchess, for instance – but mainly (in October 1546, though it was not finished until spring of the following year) the larger than life-size portrait bust of the duke.

Cosimo posed for the bust, which in the first place was modelled in clay. He was genuinely interested in the process, and suggested that Cellini should set up a whole suite of workshops in the Palazzo della Signoria – much more ambitious and better furnished than the single room he already had there. Then his patron could drop in from time to time and watch the work going forward. Benvenuto made an excuse – to entertain so important a visitor, and one with whom it would be a pleasure to discuss art, would be to hold the work up too much, he suggested. In fact, of course, the prospect of his patron appearing suddenly at any hour of the day and belabouring him with questions, suggestions and proposals was appalling.

Cellini used the creation of the bust as an opportunity to experiment in casting a major figure – a sort of rehearsal for the much larger figure of Perseus. He wanted[22] to try out the various kinds of clay suitable for bronze casting, for he saw or believed he saw faults in some of Donatello's bronzes which were the result of using the wrong kind of clay. Since his own furnaces were not yet ready, he borrowed one from a colleague – a bell-founder – in which to fire the head of the duke.

This was a triumphant success. The giant bust resembles the great classic busts of the Roman emperors (while he was in Paris, Cellini

had made a larger-than-life bust of the head of Julius Caesar, which in retrospect was a dress rehearsal for the head of Cosimo). The brilliantly executed cuirass with its detailed figuring and a strikingly vigorous mask on its shoulder, a winged head of Medusa at the centre of the breastplate, and a pair of eagle's heads, one on each side, is a magnificent achievement, and must in its original form have been dazzling, wonderfully gilded with no less than 300 parcels of gold. The portrait head itself – the intent steady eyes, the stern expression, the living quality of the beard and the hair – to the detail of the mole on the left cheek – is wonderfully alive and vivid, the epitome of a firm, noble, trustworthy, just ruler beneath whose armour beats a heart as adamant and determined as the steel itself, whose lofty gaze, calm and assured, passes just above the head of the onlooker.

Cellini thought well of the piece: he always took a proper pride in his work, and in this case was perfectly confident of his powers. As far as workmanship was concerned, he took more pride in the bust than in the *Perseus*, he once told Cosimo;[23] it had, he believed, 'all the audacious movement of life'. He may have been encouraged to make such a statement because the duke himself seemed to undervalue the achievement. It may be, as has been suggested,[24] that the portrait was a little too belligerent in its appearance – that Cosimo wished to present himself as the guardian of peace rather than as a ruler ready for war. At all events, he seems to have been more than a little embarrassed. Rather than being given a place of honour in the palazzo or elsewhere, the bust was hidden away in the *guardaroba*, where only those invited by the duke could see it.

After a few months, the bust was actually banished from the city, and never took the prominent place there which Cellini hoped for it. Instead, it was sent off to the island of Elba, where the duke had constructed some forts, and placed over the main entrance of the fortress of Stella at Portoferraio, the island's capital. To add insult to injury, Cosimo showed considerable reluctance in paying for it: Cellini received only 300 *scudi* when it was completed, and it was a decade before another 300 were handed over, while a final payment of 150 *scudi* reached him only a few months before his death.

TWELVE

Myths in Marble

From its conception in 1545 to the moment in 1554 when it was placed before the public, the statue of *Perseus* and its base occupied Cellini for almost nine years, though with periods when he turned his attention to other work. As the trouble with his kidneys subsided, Cellini – probably while at the same time completing work on the bust of Cosimo I (as so often, the chronology is confused) – supervised the setting up of a large framework of iron within which the figure of Perseus could begin to take shape. Work on both projects came to an abrupt halt one evening early in 1546 when Margherita, the mother of the boy Cencio, dragged the lad to the studio, confronted Benvenuto and accused him of sodomy.

Benvenuto was not convinced that she would go so far as to denounce him to the police (he suspected that she was attempting blackmail, which indeed seems to have been the case). But 'I considered that it would be best to allow a little time for the fiendish accusation to blow over',[1] he says in the *Life* – blaming his misfortune again on the malignance of the stars. Packing away his valuables and money and handing them over to his sister, within twelve hours he was on the road to Venice accompanied by his other young work-boy and model, Bernardino.

The woman never went to the police, and Cellini suspected that Riccio had taken advantage of her greed, and was probably at the bottom of the accusation. If this is the case, the duke's major-domo did not go about things very cleverly. Benvenuto's sexual orientation was known to many of his friends and enemies in the city, and anyone sufficiently determined to do so would have had little difficulty in getting together enough evidence to succeed in convicting him. Riccio, if it was he, made a mistake in involving

Cencio's disreputable mother; a careful watch on Cellini's movements might well have had more success – and there were still a number of boxes about the city expressly placed to receive anonymous complaints about the citizens' sexual behaviour, in which information could be posted. So perhaps after all the incident can be laid entirely at Margherita's door.

At all events, Cellini was probably wise to leave Florence for a while. From Ferrara he wrote to the duke assuring him that he had left the city only temporarily, and would shortly return. Riding on to Venice, he called on Titian, who was living and working there, and on an old acquaintance, the sculptor Iacopo del Sansovino, who he had known many years previously in Florence and Rome. Then, in the street, he bumped into none other than Alessandro's assassin, Lorenzino de' Medici, and in a display of breathtaking audacity actually invited him – on whose head Cosimo had placed a considerable price – to stay with him in the house where he was lodging!

This is one of the strangest incidents in Cellini's life. He had of course known Lorenzino in the days when he was still accompanying Alessandro on his various nocturnal adventures in Florence, and had come across him again in Paris, moving among the various anti-Medici exiles there. But they were never familiar, and why he should have decided to be so overtly friendly towards him when he must have known that the news would get back to Cosimo in Florence, is a mystery. It may of course be the case that he decided to attempt to discover Lorenzino's plans for the future, and those of other anti-Medici exiles, in order to report them to the duke – indeed, this is perhaps the most credible explanation, for though Lorenzino attempted to persuade him to remain in Venice rather than returning to the service of the duke, a decision which would (he said) bring him nothing but trouble, he did go back to Florence, and immediately called on Cosimo. He seems, in the *Life*, somewhat guarded about their conversation; they spoke mostly 'about Venice', he says. Then the duke told him to get back to work. If there was an attempt at espionage on Cosimo's behalf, it was not a very successful one.

Work meant, of course, *Perseus*. But there were distractions, caused at least to some extent by rivals and enemies. There was the case of Baldini and the diamond, for instance. Barnardone Baldini, who was employed by the duke to buy precious stones on his behalf, had found a huge diamond (over 35 carats) in the possession of a Venetian merchant called Antonio di Vittorio Landi. Making Landi an offer, he hoped to sell the diamond on to Cosimo at a considerable profit. The diamond had been damaged by a previous owner, who had had it cut to a point, then disappointed with the result had chipped the point off. The result was that the stone did not look particularly attractive. Landi, who knew Cellini, met him in the market one morning, told him about the diamond, said he was sure the duke would consult Benvenuto about it, and that he would be prepared to sell it for 17,000 *scudi*, cutting out Baldini.

A few days later the duke came to Cellini's workshop one evening with the diamond and asked his opinion. Benvenuto was unimpressed by the stone, and showed it. It was worth only about 15,000 *scudi*, he thought – but told Cosimo (who was clearly more impressed with it) that it might perhaps be worth 18,000. Red in the face, Cosimo said that he had just paid more than 25,000 *scudi* for the jewel, and that Cellini was showing his ignorance of precious stones by under-valuing it to such an extent. Swallowing his pride, Benvenuto said nothing, but he and his friends marvelled at Baldini's achievement in exacting such a price.

A little later the duke commissioned a gold setting for the diamond, which Cellini reluctantly executed. Noticing his hesitation, Cosimo told him he had better watch himself – and it turned out that Baldini had been accusing him of the theft of some of his property. Cellini, irritated, revealed the fact that he could have bought the diamond from Landi for 17,000 *scudi*. As a result, Baldini left Florence quickly, under a considerable cloud, and 'the affair went up in smoke', as Benvenuto put it.[2] He finished setting the diamond and took it to the duchess, who was so impressed that she gave him the honour of attaching it to the bosom of her dress with a golden pin.

Both the duke and the duchess were continually demanding jewellery and small *objets* from Cellini and frustrating his work on

the *Perseus*, so that in the end he protested that while everyone knew he was a good goldsmith, he had yet to prove himself as a sculptor. Could he please be allowed to settle to work on the statue? He took care to ingratiate himself with Eleanora by commissioning the best of his assistants to make a large number of intricately designed small silver vases for her, and subsequently made use of her good offices to combat the irritating niggling of Bandinelli, who was continually spreading the rumour that he was having difficulties with the statue, and passing on libellous (if very possibly accurate) stories about his private life. The duchess was sympathetic, but told him he should really ignore the rival sculptor, whose work her husband recognised as being worthless.

Cellini's requests to be given time to concentrate wholly on *Perseus* were somewhat perverse, however, for even when left to himself he was not concentrating single-mindedly on that project. It is likely that it was in 1546 that he began work on a bust of the 55-year-old banker Bindo Altoviti, the head of the powerful bank which bore his name and had branches in Marseilles and Lyon. He had been born in Rome, and through his mother, a niece of Pope Innocent VIII, he had the *entrée* to the Vatican, and subsequently became acquainted with two more Medici popes, as well as with Pope Paul III. He had become a Florentine by residence, though his main home was in Rome. Cellini kept some of his own money at Altoviti's (1,200 *scudi*, to which he added the 50 *scudi* Altoviti sent him as an advance payment for the bust).

Altoviti spent a great deal of his significant fortune on patronage. A great collector of antiques, he had as a young man commissioned a portrait from Raphael, and later gave him other commissions; he was a patron of Vasari and of Andrea Sansovino, the sculptor of, among other works, the enormous tombs of Cardinal Ascanio Sforza and Cardinal Girolamo della Rovere in Santa Maria del Popolo in Rome. He was also a friend of Michelangelo. As a firm republican he was no friend of the Medici family – despite which Alessandro de' Medici (doubtless because of his economic influence) appointed him Consul in Rome and a member of the Consiglio de' Duecento in Florence, appointments which Cosimo confirmed for

the very simple reason that he owed the bank a considerable amount of money.[3] (Later, there were attempts to extradite Altoviti from Rome and bring him to Florence to be charged with working secretly against Cosimo; Pope Julius III refused to let him go, but his and his wife's property in Florence was confiscated).

There is a certain amount of mystery about the fact that Cellini agreed to make a bust of Altoviti. Why did he take the chance of alienating Cosimo by agreeing to associate with one of the duke's enemies? Then, when did the sittings take place? – for the bust was obviously modelled from life. The most likely date for the commission is 1546, when Altoviti was made senator – but Cellini does not seem to have visited Rome at that time, while it is unlikely that Altoviti would have come to Florence. The commission might have seemed likely to be profitable, but Cellini knew enough by now not to count on being generously rewarded for his work, while the chance of alienating the duke might have seemed to outweigh any short-term financial benefit.

At all events, the bust was completed by 1551, and set up in Altoviti's study in his magnificent palace overlooking the Tiber near the Ponte Sant' Angelo, where it commanded the admiration of all who saw it – as it still does.[4] It is rather larger than life, and even more impressive than the bust of Cosimo – partly because it has never been exposed to the elements, has always been carefully kept, and is therefore in pristine condition. If any work can be called 'a speaking likeness', the bust of Altoviti deserves the description: here is the strong, opinionated face of a man who can keep his own counsel, glancing slightly over the right shoulder of the onlooker from under thick eyebrows. Once again, as with the bust of Cosimo, the detail is astounding – the modelling of the moustache and beard in particular, and of the partly embroidered thin cotton cap which Altoviti wears, the material so thin that the curls of the hair can be seen underneath it. The great appreciator of Cellini's work, John Pope-Hennessy, has written[5] that 'seen at close quarters, the modelling of the cheeks beneath the eyes, the pockets of flesh above the eyelids, and the domed forehead have no equivalent in High Renaissance portrait sculpture'. One might say in addition that few

busts of the period give so vital and immediate an idea of the nature and personality of the sitter.

Altoviti was, as he might well have been, delighted with the bust and proudly showed it off to his friends and acquaintances, giving it pride of place in a row of niches facing the windows of his study each of which held a bust, many of them ancient masterpieces. One of his visitors was no less a person than Michelangelo, who immediately appreciated the quality of Cellini's work, and asked the identity of the artist, for (he said) 'you must know that the bust pleases me as much, or even more, than those antiques, though there are many fine things to be seen among them'. He suggested, however, that it might have been better placed: the light should come from above, to show the bust off to its best advantage, rather than from directly ahead.

A little later Benvenuto himself received a letter from Michelangelo:

My dear Benvenuto – I have known for years that you were the greatest goldsmith we have ever heard of, and now I know that you have an equal talent as a sculptor. Messer Bindo Altoviti took me to see the bronze bust of himself which you executed, and I liked it very much – though I was sorry that it was placed in such bad light. If it had been properly lit everyone would see what a beautiful work it is.[6]

It must have been a great moment in Cellini's life, receiving such a letter from the man who he revered above all as the greatest living artist. The financial satisfaction he received was less generous: though he had cast the bust at his own expense, Altoviti proposed no fee, simply suggesting that the bust be given to him in exchange for exceptional interest of 15 per cent on the capital Cellini had invested in his bank. A formal contract was made to that effect; but Cellini had been outwitted – the profit he made on his investments was nothing like a decent fee for the astonishing work of art he had created. Altoviti was as astute as Cellini's bust suggests.

Lesser works continued to take up a considerable amount of Cellini's time. One day the duke simply handed him some chunks of

silver and said 'Make me an elegant vase'. Then there were several pieces for the duchess, including a fine golden belt studded with a number of gems commissioned as a present from the duke (for which the artist was never paid, though it took him a considerable amount of time). He very wisely did his best to stay on the right side of the duchess. She had a mercurial disposition, and always seemed to have the potential to turn round, like Madame d'Étampes at Versailles, and become an implacable enemy – at one time she took exception to Cellini taking a short cut through some of her rooms to reach his workroom at the Palazzo della Signoria, and began locking all her doors against him though it had been her husband who showed Benvenuto the route.

He assuaged the tension which all these problems exacerbated by riding out to Fiesole to visit an illegitimate infant son – characteristically, he neither identifies the mother nor so much as mentions her in his *Life*. He had placed the boy with a wet-nurse – the wife of one of his workmen – and found that an hour or two spent with the infant recovered his spirits. But one day he left the child feeling less lighthearted than usual – the little boy had been fractious, and howled with distress when his father left, and just after he reached home a messenger arrived from Fiesole: his little son was dead, accidentally smothered by the wet-nurse.

A few days later he was surprised to receive what seemed to be a peace offering from Bandinelli: the offer of a prime piece of marble. He received the offer less than gracefully, replying that he would hope to use it as the donor's tombstone. A few days later he sat down – on 23 June 1546 – and wrote formally requesting that his rival should send him the marble, ironically adding that he recognised only one master in sculpture, the great Bandinelli, and that he hoped to use his kind gift to outdo even that instructor.

Two months later the duke took to sharing Cellini's workshop in the Palazzo della Signoria, donning an apron to chip rust and wash earth from some antique bronzes which had been excavated at Arezzo, and watching as Benvenuto restored some of them, replacing a missing head here, a missing limb there. Sometimes more extensive work was required, such as the modelling of a horse on

which an antique riding figure could be mounted. This often unremarked bronze is well worth notice[7] – it bears its rider (several hundred years older than itself) with complete and genuine confidence, its rearing body full of animated spirit. Another, more familiar Arezzan discovery was the fifth-century bronze Etruscan chimera – a mythical animal with a lion's head, a goat's body and a dragon's tail – which was found later, in November 1553, and immediately recognised as a very considerable work of art. It has always been assumed that Cellini restored the piece – replacing the missing tail and two of the feet – though it should be said that he nowhere claims to have done this, merely mentioning the fact of the discovery.

One day on his way to his workroom, Cellini was passing through the Clock Room of the palace and was called by the duke into his wardrobe, where a packing-case was being broken open. It contained a present from Stefano Colonna, a trusted servant of Cosimo who was later to become his lieutenant-general, and it turned out to be a damaged Greek statue of a young boy. Cellini immediately found it appealing – and more than appealing: he didn't remember, he said, ever seeing such a beautiful work, and immediately offered to restore it and by adding an eagle made it into a representation of Ganymede, the lovely boy so admired by Zeus that in the guise of an eagle he carried him off to Elysium.

The duke was about to agree when Bandinelli happened by, and glancing at the marble commented on it, uninvited: it showed, he said, how little the ancients knew about anatomy. When Cosimo pointed out this difference of opinion to Benvenuto (who had heard but ignored it) the latter merely remarked that Bandinelli, being composed solely of malice, could see nothing but ill in anything. The two men immediately began the most bitter argument, during which Benvenuto criticised Bandinelli's statue of Hercules and Cacus with a vigour that went perhaps further than art criticism might be expected to go: if you cut Hercules' hair off, he said, his head would be too small to contain a brain; it was so badly attached to his neck that you couldn't find anything less graceful; the shoulders looked like the pommels on the saddle of an ass; the muscles of the chest

seemed to have been copied from an old sack full of melons, and those of the back from a sack full of courgettes. How the legs were connected to the body it was impossible to conjecture, since you couldn't tell which leg the figure was supposed to be standing on. Surely Bandinelli could never have seen a naked man . . .

Driven to distraction, Bandinelli hit out with the most telling accusation he could think of: 'Shut up, you filthy sodomite!'

The duke and the courtiers, who had been rather enjoying the scene, fell suddenly silent. Cellini scarcely paused to consider his answer.

'You're a madman!' he said. 'All the same, I wish to God I know how to commit the act you mention. After all, we hear that Zeus played that game with Ganymede in Elysium, and here on earth the act is practised by the greatest emperors and kings. I am simply a lowly, humble man who could never comprehend how to go about taking such marvellous pleasure.'[8] There was another pause, and then a great roar of laughter from the duke and his friends. Cellini pretended to laugh with them – but was boiling with anger inside (and no doubt somewhat apprehensive: the accusation was a serious one, if anyone cared to take it seriously).

Bandinelli, at a loss to continue, mumbled something about how Cellini had been bragging that he owed him a block of marble. Benvenuto replied that he had evidence that the offer had been made, and he would now be obliged to receive the stone. Never, replied Bandinelli. Then prepare to die, said Cellini. At which point the duke felt he should intervene, elicited an admission that Bandinelli had indeed offered Benvenuto the marble, and ordered him to deliver it – which indeed he did. Though it was damaged, Cellini produced from it a study of Apollo and Hyacinth. The duke supplied a rather better block of Greek marble, brought from Rome as material for the restoration of the ancient statue as a Ganymede. It seemed a shame to use it piecemeal in that way, so Benvenuto employed other material in the restoration, and used the block to make a Narcissus. These three major works[9] repay study not only as works of art but (it can be argued) as revelations of Cellini's character and nature.

The repair of the ancient Greek statue was highly effectively carried out; the work was finished by March 1550, when the statue was trundled on a hand-cart from Cellini's studio to the Palazzo della Signoria. It had been more difficult to complete than he had at first thought – more difficult, he told the duke, than producing an entirely new and original work.

Other artists had produced representations of the beautiful boy being carried to the skies by a powerful eagle – in some cases riding on his back, in other cases clutching the eagle's talons. But the legs of the original Greek statue were too close together for him to be shown astride the bird, while the vestigial remains of the left arm showed that it had been hanging down, and it would be impossible to reconstruct it so that the boy could convincingly cling to the bird. Cellini therefore placed the eagle – a small eagle which might have had some difficulty in flying off with the boy – at Ganymede's left side, and produced a left arm which hangs down so that the knuckles just rest against the nape of the bird's neck, one finger tenderly ruffling the feathers. The couple are clearly still on earth (Ganymede's shepherd's sack still lies behind him) and the boy's right arm is raised to the side of his head, that hand holding a second, small bird. The duke was delighted, and placed it in his apartments next to Michelangelo's unfinished *Apollo*.

The work was much admired from the first, and during the following century many copies were made of it. Few people seem to have remarked, at least in public, on the construction which could be put on it. The myth of the most beautiful boy alive, abducted by Zeus to be his cup-bearer and paramour (to the fury of Hera, his sister and wife), had been popular in both Greece and Rome as offering religious justification for a man's love of a boy, and of sodomy – previously tolerated only in goddess-worship. There is an added reference in the case of the little bird in the boy's right hand: in Greece a small bird would often be presented by an *erastes*, or adult man, to his *eremenos*, the boy he was courting. The Ganymede story was still, in the sixteenth century, specifically a homosexual myth, and Cellini knew this perfectly well – indeed, he had thought of the story precisely when courting his first, fourteen-year-old

assistant in Rome, and in two poems he was to write years later, when in prison for sodomy, refers to the fact that he is imprisoned 'because of Ganymede' and because 'Ganymede still pleased me'.[10]

Cellini's *Apollo and Hyacinthus* is much sexier than it appears in illustrations. Apollo, cool and self-contained, has a rather curious unclassical appearance, giving – it is perhaps something to do with his pose, the head lifted on a rather long neck, and a curl of his long hair (which seems dressed in a romantic rather than an antique style) hanging over his right shoulder – the strange impression of being an eighteenth-century dandy. His right arm falls at his side, his fingers on Hyacinthus's head as though encouraging the boy to lean back against the calf of his right leg. His left arm is bent, the knuckles of the hand (which holds the remains of the broken discus) resting on his hip. It is a rather camp gesture, and Apollo's body itself seems remarkably devoid of solidity, as though there is no bone or muscle in it. It is entirely uncharacteristic of its period.

Hyacinthus on the other hand is unquestionably in the antique tradition – a chubby little boy lying back almost against Apollo's leg, his right arm stretched over his head so that his hand joins the god's, the index finger caressing Apollo's naked right hip (or it would do so if the finger hadn't at some time been lost). The juxtaposition of the figures is blatantly erotic, and Cellini clearly felt very strongly about the subject and his vision of it. He says that at first he began, as usual, to make a wax model, but then lacked the patience to complete it, falling immediately on the marble block itself, releasing the figures from it almost without hesitation.

While little has been said by critics about its relationship to Cellini's homosexuality, the composition seems highly suggestive from this point of view, as one walks around it. From one angle of sight the boy almost completely disappears, as though being concealed – and more, the caress which Apollo gives Hyacinthus, seeming slightly to push his head backward, could be construed as a persuasion to remain out of sight. The fact that the work was actually left unfinished may suggest that Cellini became aware of the interpretation that could be put upon it, though the more common suggestion is that he simply became discouraged and neglected it –

carefully keeping it in his studio, however, where it remained until his death.

The third work of this period, the *Narcissus*, was troublesome to execute because the marble block originally ordered for the *Ganymede* was faulty: it had in it two holes two fingers in breadth and 5 or 6 inches deep, which made the design of the figure difficult – Cellini had to contrive a composition with which they would not interfere. Then, when the figure was almost completed, the River Arno overflowed, the water rising over 2 feet in Cellini's workshop; the *Narcissus* was standing on a wooden base which was destabilised, and fell over, breaking in two just above the figure's chest. Benvenuto rejoined the pieces, disguising the break by placing a garland over the breast. This (it was probably made of bronze) is missing, and the join can clearly be seen.

Cellini's *Narcissus* sits on a broken wall gazing down to his right. He is clearly caught in movement, his left arm raised and bent over his head as he leans towards the surface of the pool in which his face is reflected, the musculature of the left side of his body wonderfully modelled. His face is magnificently carved, the eyes lowered and the lips parted in wonder at the vision he sees. The characterisation is unmistakably personal, and one cannot doubt that the work was done from a model.

Of the three works which stand together in the Bargello, it may be possible to carp at the androgynous pose of the Apollo (though surely not at the figure of Hyacinthus), and the objectivity of at least some critics has clearly been affected by the almost too frank daintiness of the *Ganymede*; but at least the *Narcissus* must surely be accepted as a masterpiece.

It was while he was working on these figures that Cellini bought, in October 1548, a life interest in two farms – one at Prati, near Tresolle, and one at Trespiano – for some 800 *scudi*. He had decided that for better or for worse his future lay in and around Florence, and presumably in producing work after work for the duke – upon the most important of which, the *Perseus*, he must, from then on, concentrate all his powers. His masterpiece, he believed, still waited to be brought to life.

THIRTEEN

Perseus

Cellini seemed fated never to be able to get quietly on with his work without the interruptions and interference of the duke and the niggling criticism of Bandinelli. He had then – in 1547 – reached the stage at which he could cast the head of Medusa, in his own furnace in what had been the apple orchard. He had made several miniature sketch models in wax, which have a vivid force and character altogether disproportionate to their size,[1] and the final, full-size head, with the hand of Perseus buried in its poisonous curls, was a *tour de force*. It came out so cleanly that his friends told him there was no need to put any finishing touches to it. Cellini, however, knew otherwise – bronze, once cast, always in his view had to be reworked to make it perfect, and he did this, often in the presence of the duke, who came almost daily to his house to watch him at work. Cosimo was delighted with the Medusa head – but was nonetheless susceptible to the gossip of Bandinelli, who swore that it would be impossible for such a complex design as the *Perseus* statue to be successfully assembled from its various parts. The duke was so impressed by the rival's argument that he actually reduced the subsidy he allowed Cellini for the payment of his workmen.

This so infuriated the sculptor that he for once gave full rein to the fire of Scorpio, forgot precedence and tact, and gave the duke his opinion of the way in which he was being treated. Florence, he said, was all very well as a city in which to make a reputation; but once that reputation had been made it was clearly just as well to get out, as Donatello, Michelangelo and Leonardo had done. He would be grateful for permission to leave the city – the duke could retain the services of the great Bandinelli (indeed, it would be good for art if he

did so, because the rest of the world would then be spared that artist's presumptuous advertisements of his non-existent talent).

The duke backed away just a little, resuming payment for the workmen – though not to the former extent – and, of course, Cellini remained in Florence. There was nowhere else he could go with any assurance of major patronage – and in any event, he was not about to stop work on the project which, with good fortune, would absolutely establish his reputation as a sculptor.

We have as much information about the making of Cellini's *Perseus* as about any work of art of its time – not only from the *Life*, but from the *Treatise on Sculpture* and from an account book in the Biblioteca Riccardiana[2] in Florence, which itemises all payments made by the duke, and the additional expenses Cellini himself bore. He had to make various payments to workmen and for materials, not just because of the duke's meanness but because Florentine civil servants were incapable of processing paperwork at a reasonable speed. When Lattanzio Gorini sent in a bill for materials, Benvenuto could not pay it (he may actually have been rather pleased to have an excuse to disappoint the dilatory workman). Time and again he put in bills for wood, clay, nails and tools for immediate payment and in the end was forced to spend money himself because the court bureaucrats were so inefficient. Then, the civil servants insisted that accounts be provided in what seemed quite unnecessary detail: for instance, ludicrously, each wall of the workshop he constructed in the Via del Rosario had to be invoiced separately – there are records[3] showing separate payments of 32, 25, 25, and 38 florins for the four walls, on various dates. This must have been as infuriating as the insistence on 'proper procedure' – it was as much as the secretaries' jobs were worth not to seek the duke's signature on a requisition note for marble for the statue's base, or for the recasting of one of Perseus's feet, flawed by the flames.

Bandinelli's efforts to prevent Benvenuto acquiring experienced workmen had been successful, and his workshop was seriously under-staffed, though he had the help of Bernardino, who was not only sufficiently personable to model for the hero but had proved so

skilful and easily schooled in various tasks about the studio that he was now Cellini's principal assistant.

On 20 May 1548 Cellini was able to report to the duke that the Medusa (*'la mia femina'*) was fully modelled in clay, and that the main body of *Perseus* was also finished. The duke was enormously impressed when he saw the statue clad in its wax coating, but firmly told the sculptor that it would be impossible to cast it in bronze – the rules of art would not permit it. Cellini says that he strongly resented the statement; understandably – how much did Cosimo know of 'the rules of art'? – one cannot imagine Benvenuto hearing the comment from anyone else without bring provoked to violence. He did go so far as to suggest that the duke might not fully understand the procedure – and when the duke persisted, wondered aloud whether his patron might offer a little encouragement rather than continual criticism.

The duke was unaffected by the argument, and changing the subject suggested that it would be next to impossible to set the head of Medusa so high in the raised hand of Perseus. Cellini said that if Cosimo really understood the problems of the piece, he would be concerned not about Medusa's head but about Perseus's right foot. The duke turned to a courtier: 'The man contradicts everything anyone says to him – such conceit!'

Cellini explained to his patron the special design of the furnace he would construct for the casting – every piece of work, he said, demanded a particular type of furnace, and he had designed one whose special characteristics would force the heat of the fire downwards, so that both the head and lower parts of the figure would be perfectly cast – although he had some fears that the right foot, in particular, might not come out cleanly. The duke listened, shook his head, and left.

The figure of Medusa was cast in July 1548, with the help of Zanobi di Pagno Portigiani, the bell-founder, and his brother Alessandro. The pages of Cellini's *Life* in which he describes the casting of the *Perseus*[4] itself are justly famous, and the scene so dramatic that it is little wonder that Berlioz chose to write an opera[5] which focused on it – though even that genius was unable to do full

justice to the drama of the occasion. (Later, Oscar Wilde was to hold a large audience of American miners in Leadville fascinated by a lecture on Cellini's method of casting.) The actual work took place in December 1549. Cellini first sent for supplies of pinewood from a forest 25 kilometres from Florence – wood that would burn slowly and evenly – and while waiting for it to be delivered clothed the *Perseus* in clay. When the wood arrived, it was gradually fed into the fire lit within the furnace, so as to build the heat very gradually.

He had continued to engage assistants when he could get them – some more and some less skilled. These came and went during the long process of preparation and casting; and included goldsmiths and several sculptors, among them Gianpaolo Paggini and his brother Domenico, goldsmiths who had worked with Benvenuto on jewellery for the duchess (Domenico was Master of the Mint to Pope Sixtus V, and Gianpaolo was to die in the service of Philip of Spain). Then there was Giambattista Tasso, who had set out sluggishly for Rome with Benvenuto in 1519, the Lorenzi brothers – Battista, Antonio and Stoldo – the latter only sixteen, the sculptor Guglielmo Fiammingo (who had a useful knowledge of bronze casting), Francesco del Tadda, who seems to have worked exclusively on the base of the *Perseus*) and the goldsmith Fazio del Tavolaccino. Others are listed as assistants in Cellini's accounts, and are no more than names: Giovanni Tassini, Antonio del Pollaiuolo and others. It was probably at this time, also, that he employed a youth called Ferrando di Giovanni da Montepulciao, who became a favourite. Benvenuto's relationship with him would cause a great deal of trouble five or six years later.

Cellini had carefully trained his workmen in his own theory of casting, which was a modified and individualised version of the 'lost wax' method, by which the hollow clay mould clothed the vital, carefully crafted inner skin of wax. When the hot metal entered the mould through carefully placed holes, it took the place of the escaped, melted wax, and when cold formed the exterior of the finished work.

After 48 hours of even heat all the wax had melted and been extracted, and the clay mould was well baked. The mould was lowered into a trench and covered with earth, numerous tubes of

terracotta inserted to act as air vents; the furnace, gradually heated by the burning pinewood, melted quantities of copper and bronze. Then in a moment of drama a random spark set the workshop roof on fire, and there was some fear that it would collapse. However, fortuitously, there was heavy rain and wind which helped to extinguish the flames – though they also began to cool the furnace.

Anxiety at trying to cope with all these problems together with the expenditure of nervous energy over two hectic days manifested themselves in a return of the fever which had previously attacked Benvenuto, and he was forced to take to his bed, leaving the work to the supervision of a number of workmen (several of them experienced in casting bronze) under the control of Bernardino Mannellini.

The fever was as intense as any illness he had ever had; devotedly nursed by a young female servant he felt that he was dying – and just as the fever was at its height, one of the workmen came to his bedside and announced that things had gone seriously wrong. Benvenuto leaped out of bed and threw on his clothes, cursing and kicking anyone who came near him, and went down to the workshop where everyone was standing around in depressed silence. The men feeding the furnace had not made allowance for the driving rain and wind, it had been allowed to cool, and the metal had congealed into an unwieldy mass.

Cellini sent his men across the road to fetch oak wood from a pile he had noticed stored behind a butcher's shop, and began feeding the furnace with it. The seasoned oak produced a vigorous flame, and gradually the metal began to move again, to glow, even to sparkle. The heat grew – Cellini had to send men up to the roof to dampen the boards lest they again caught fire. Then

All of a sudden an explosion took place, attended by a tremendous flash of flame, as though a thunder-bolt had formed and been discharged among us. Unwonted and appalling terror astonished every one, and me more even than the rest. When the din was over and the dazzling light extinguished, we began to look each other in the face. Then I discovered that the cap of the furnace had blown up, and the bronze was bubbling over from its

source beneath. So I had the mouths of my mould immediately opened, and at the same time drove in the two plugs which kept back the molten metal. But I noticed that it did not flow as rapidly as usual, the reason being probably that the fierce heat of the fire we kindled had consumed its base alloy. Accordingly I sent for all my pewter platters, porringers, and dishes, to the number of some two hundred pieces, and had a portion of them cast, one by one, into the channels, the rest into the furnace. This expedient succeeded, and every one could now perceive that my bronze was in perfect liquefaction, and my mould was filling; whereupon they all with heartiness and happy cheer assisted and obeyed my bidding. . . . All my poor household, relieved in like measure from anxiety and overwhelming labour, went at once to buy earthen vessels in order to replace the pewter I had cast away. Then we dined together joyfully; nay, I cannot remember a day in my whole life when I dined with greater gladness or a better appetite.[6]

Pier Francesco Riccio, the duke's major-domo, had been sniffing around trying to discover what was going on; two workmen, who turned out to be in his pay, reported to him that they believed Cellini had been able to complete the work only by the use of magic – his powers were clearly supernatural. What Riccio made of this when reporting back to the duke we cannot know, but it can only have been a preliminary report, for the mould had to cool for two days before it could be broken away to reveal the work beneath. The figure emerged triumphantly, only the right foot being slightly incomplete (it was re-cast in March 1550). Even Cellini was surprised at the perfection of the casting (though claiming to have been a little disappointed that the right foot was not more imperfect, since he had made a point of telling Cosimo of the difficulty of casting it).

A marble block for the base of the statue had been brought to the studio in June 1549, and work had continued on the bronze figures which were to stand around it; two of these – Mercury and Danaë – were cast in April 1552 and two more – Jupiter and Minerva – in the following June.

It took several years of work to finish the main figure to perfection – the surface must be made perfect, small holes (made by bubbles) filled by small pieces of bronze and smoothed by the use of hammer and chisel so that no water could possibly find its way into the body of the statue and corrode it; then the whole must be polished by abrasives, some intricate parts of the figure gilded with gold foil (the wings of the helmet, for instance), and finally a patina applied to prevent surface damage from rain or air pollution.

All this while Cellini had to continue to execute petty commissions from the duke and duchess for jewellery and geegaws. It was on 27 April 1554 that *Perseus* was unveiled to the public, set up in the Loggia dei Lanzi. The duke admired it but – perhaps worn down by the unending drip of criticism from Bandinelli, who without having seen the statue continually heaped scorn on it, told all and sundry that Cellini should not be too confident about the public reception of his work. However, the auguries were good: the Bishop of Arezzo, Bernardetto Minerbetti, saw the piece in the garden of Cellini's studio, and in a letter to his friend Vasari was full of admiration – of the expression on the hero's face, the movement of the arm raising Medusa's head aloft, the wonderful expression of death on Medusa's head . . . and as for the reality of the group, one almost stepped aside for fear of being splashed by the blood pouring from the severed head![7]

And indeed, when the statue was revealed for the first time in public, a great shout of praise went up from the public, and the duke, smiling and waving from a balcony high above the crowd, was gratified by the public's acceptance of the work of 'his' sculptor. Even Bandinelli, at first silent, had in the end to venture a faint-hearted compliment. Poets, professional and amateur, wrote sonnets in praise of the figure and (as the custom was) pinned them to the scaffolding which still lay about its base. Cellini's admired friend, the painter Bronzino, was among them, sending his servant to place two sonnets with the rest – Benvenuto later published them in his *Trattati*. He did not publish one of the few critical poems, by Alfonzo de' Pazzi, suggesting that the torso of an old man had been placed on the legs of a young girl. But in general, he need not have

feared unfavourable comparison with Michelangelo's *David*. On the contrary, his *Perseus* was seen as a worthy companion piece – and few critics would suggest otherwise.

Relieved and perhaps overwhelmed by even more praise than he expected, Cellini, with the leave of the duke, went to the monasteries of Vallambrosa, Camaldoli and La Vernia, on the slopes of the Apennines north-east of Florence, to give thanks for the successful completion of the work.

The *Perseus* is by far the best known of Cellini's works: the salt-cellar is renowned, but there can surely be no visitor to Florence who has not given at least a cursory glance at the figure which still stands in the loggia where it was first placed. And it is, of course, worth far more than a cursory glance.

Not unnaturally, Cellini paid enormous attention to the modelling of the figure itself. The wax model, which has survived and can be seen at the Bargello, is wonderfully vigorous, and whether or not it was Bernardino who posed for it was clearly done from life. The pose had to be slightly modified in the final, full-scale version; in this first sketch the young man leans forward slightly, in a tentative almost questioning pose – there is nothing of the hero here; this is a natural youth, all humanity – and there is no mistaking Cellini's engagement with him and admiration of his body. If some of the almost naive freedom of the figure is lacking in the finished work, it is replaced by a nobility of carriage enriched by the trappings of heroism – by such details as the grotesque animal mask on the hilt of the sword, and the wonderful helmet, on top of which crouches a small, bizarre, snarling animal which, in a strange quirk of the artist's skill, becomes at the back of the helmet a weird human head which is tangled in the hero's hair – there is a tradition that this is a caricatured self-portrait of Benvenuto. Perseus's hair is modelled with spectacular skill, the curls escaping from beneath the helmet and a band above the brow with carefully controlled freedom. The feathers on the winged helmet and foot are marvellously and sensitively executed.

Perseus's pose is masterly; the slightly leaning posture of the wax model has been corrected, and the result is the imposition of a

certain heroic distance from humanity. Yet the musculature of the body is still marked and real, especially on the left-hand side, beneath the raised arm; this is the warm, living body of a youth caught just a moment before completely realising his victory. He looks down gravely, brows slightly knit, not so much at the spectator regarding him from below as at the blood spurting from the Medusa's neck. If the gushing blood is not completely convincing, that which pours from the severed head is quite as vividly real as the Bishop of Arezzo suggested.

The figure of the Medusa is no less remarkable. The model was Dorotea, a sixteen-year-old girl from Doccia, who sat not only for Medusa but for the two female figures – Danaë and Minerva – on the base of the statue. She was clearly a very beautiful young woman, and one for whom Cellini felt considerable affection, not only as a model but as his mistress and (on 27 November 1553) the mother of a son, who he acknowledged and legitimised.[8] She shared the studio, the base of the statue, and Benvenuto's bed with Cencio, who modelled the figure of Mercury. It is interesting to speculate that this prancing, lively figure may suggest Benvenuto's real taste in boys; he had to make Perseus a hero – Mercury could be a scamp.

The Medusa may be a more realistic portrait bust of Dorotea than critics have supposed. The face is not that of an evil monster, but – despite the curling snakes into which Perseus's hand is thrust – that of a real woman (in mythology, she is the only human gorgon). Cellini took great care with the portrait – there are bronze sketches for it in the Victoria and Albert Museum in London which are clearly done from life. They are astonishingly powerful, individual pieces of art. In the finished work Medusa has perhaps too placid an expression for the victim of decapitation. Her dead body is clearly still warm – it is easy to believe that the blood still moves in her veins, even as it flows from the severed neck.

At first Cellini had planned a draped Medusa – a wax model of this exists – but perhaps fired by his admiration for his model, he decided on a nude figure, no less finely modelled, and clearly a portrait in every detail (the working of the figure's arm and right hand as it hangs down at the side of the base is fastidious, every finger meticulously

articulated). Sitting, or rather lying, for the modelling of the Medusa cannot have been altogether a comfortable experience: the pose is an awkward one, the body twisted, the back arched unnaturally, the left leg drawn up with the ankle grasped by the left hand. It appears entirely natural as part of the whole work, but must have been painful for Dorotea to hold for any length of time.

Below the base Cellini set a bronze plaque showing in relief another scene from the Perseus myth: the rescue of Andromeda, chained to a rock as a sacrifice to a sea-monster which the hero turned to stone by showing it the severed head of Medusa. It is in some ways a strange, though beautiful, piece of work, the narrative somewhat muddled. At the centre of the plaque the naked Andromeda sits on a rock, a single chain hanging at her side, which does not appear to be attached to any part of her body (it passes behind rather than around her wrist). She raises her right arm over her head, appearing to hold her hair over her face to conceal it (Ovid, writing the story, says that she modestly tried to hide her face from the hero). A stranger pose is that of Perseus, who appears to be furious, standing with his arm raised in anger, clearly shouting at Andromeda. Above her is a second Perseus, literally flying at the sea-monster, sword in hand (Cellini ignores the traditional weapon of the myth, Medusa's fatal head of snake-hair). On the right a group of Andromeda's friends and relations, including her mother, stands thankfully marvelling, a number of soldiers with spears in the background, and a group of horsemen, one of which appears to be Perseus, in the sky above them.

Modelling for the figures on the base was easier. Cellini must have been very conscious that the *Perseus* was to be set up only a matter of feet from his great master's *David*; and it is perhaps for this reason that he planned an impressive base – an added feature in which he could show his skill. He may also have wanted to out-do Bandinelli, whose *Orpheus* (at the Palazzo Medici) stood on a highly decorated base, though not executed by the artist himself. Benvenuto planned four bronze figures to stand in niches at each corner of the marble base of his statue, each linked to the Perseus story. Danaë was the hero's mother, imprisoned by her father so that

no man could know her, but impregnated by Jupiter in the shape of a shower of gold. She should obviously have her place; but most prominent is Jupiter himself, with the promise that the god would avenge any harm done to his son.[9]

At the back of the base Danaë stands in a characteristic Cellini pose, the left arm raised behind her head, the child Perseus at her side, kneeling with his left leg on the plinth and the right hanging down before him. In another niche stands Mercury, ready to fly to the heavens as messenger of Perseus's triumph, and on a third Minerva, presenting Perseus with a triumphal shield. Jupiter and Minerva stand in the other two niches.

Cellini prepared a wooden model of the base in 1547, and in November 1548 received a large block of Greek marble from which it was to be made. This was moved into his studio eight or nine months later, out of the heat of the summer sun, and the carving began. It is at least as fine as the working of the bronze, though it has suffered more from weathering.

With his interest in astrology, Benvenuto placed a goat's head (Cosimo's sun-sign was Capricorn) at each corner, surrounded by trumpets, grotesque masks and garlands. We do not know to what extent he worked simultaneously on the marble and the bronze – he often did work at the same time on various projects; but there is a record of a fairly large sum of money paid to another marble sculptor, Francesco del Tadda, for work on the base, and at least two other sculptors were also employed, though it cannot be doubted that the design of the base was Cellini's, and it is generally believed that the most sensitive carving is his own.

Each of the four bronze figures is individual and has a personality of its own – that of Dorotea particularly marked in the Danaë and the Minerva (nobler and more commanding than her companion – Dorotea in another mood). The figure of Jupiter is wonderfully poised and assured, the head turned to the left, the raised hand holding a thunderbolt, a firm, muscular body revealed on the left side, where the toga is drawn aside. It seems probable that the young man who posed for Perseus was also the model for Jupiter. Whoever this was, it was clearly not Cencio – for the Mercury is by

contrast mischievous and alert, in a dancing pose, the left foot planted on a lion mask, drawn up, the knee bent as though he is about to leap, both arms raised and the head turned up and to the side – the hair and winged helmet again splendidly wrought, meticulously and precisely finished, in contrast to the freer modelling of the muscles of the slim, almost anorexic body – an anonymous shop-boy immortalised.

These figures have their personal interest as part of the life of their creator; but quite apart from that, they are magnificent works of art in their own right. No contemporary of Cellini produced any bronzes to compare to them. He was pleased with the four figures, and as soon as they were completed he showed them off to the duke and duchess. This was a mistake. The duchess was so delighted with them that she declared that it would be a waste to place them around the base of a statue – besides which, vandals might damage them. Why should they not be set up in one of her apartments, where they could be carefully prepared and admired? Benvenuto was aghast, and next day while the noble pair were out riding, had the figures carried away and fixed them very firmly indeed in place around the base of his statue.[10] He received one tangible reward, however – and for once the duke conferred it in a rather graceful way: he took a beautiful branch from a pear tree, and handed it to the artist, saying that he should plant it in the garden of his house – the garden of the house which was *his*, he repeated. Cellini took it, rightly, that he had been made a gift (at last) of the house in which he had set up his studio.

FOURTEEN

Imprisonment and the Crucifix

Cellini returned to Florence after a pleasant and relaxing few weeks on pilgrimage to the monasteries of Camaldoni and La Verna in the company of one of his young workmen, Cesare,[1] with whose family he stayed in Bagni. As he rode into the city he happened to meet the duke, who greeted him cordially and told him that he had his affairs very much in mind, and that they would soon be settled. Not unnaturally, Benvenuto took this to mean that he would now be paid for *Perseus*, set up in its place in the loggia of the main square of Florence and generally admired both by the public, his colleagues, and the duke and duchess.

He was more than a little surprised to be summoned by Jacopo Guidi, one of the duke's secretaries, who enquired not very gracefully how much he expected to be paid. He replied that it was not his habit to place a price on his work, and that the duke had given the impression that he had come to his own decision in the matter. The duke, on the following day, hoped that Cellini was not going to ask an offensively high price, and when the artist threatened to leave Florence, forbade it. In the end, he offered a paltry 3,500 *scudi*, to be paid in instalments of 100 *scudi* a month – though he did have the grace to suggest that it was 'on account' until a decision could be made about the price of the work.

The payments turned out to be paltry – the duke's treasurer, Antonio de'Nobili, sometimes sent him 50 *scudi*, then 25; occasionally a monthly payment was entirely neglected. When Benvenuto brought the matter up, de'Nobili said that the duke had many expenses and little money. This was nonsense: Cosimo was one of the richest men in Italy. Twelve years after the completion of the *Perseus* 500 *scudi* were still due, and no regular payments had

been made for three years. In 1566, when the duke became ill and was perhaps in fear of death, he at least went as far as to pay the back instalments of the gratuity, though Cellini never received the full amount. (An interesting footnote is that at one stage the duke asked Bandinelli to value the statue, and was told that it was a work of outstanding beauty and that 15,000 *scudi* would not be too great a price to pay for it.)

Money, however, was the least of Cellini's problems during 1556–7. He fails to mention in his *Life* two unpleasant brushes with the law. In August 1556 he suddenly struck a fellow goldsmith, Giovanni di Lorenzo Papi, with his stick, seriously injuring him. What Papi had done to upset him is a mystery, but he ended up lying in the dust in the street with his head split open. Cellini was immediately arrested and thrown into the Stinche, perhaps the most unpleasant prison in Florence. He endured over ten weeks in stinking darkness, no doubt haunted by the fear that, as in Rome seventeen years previously, he might be confined not for weeks but months or even years; then wrote to the duke not so much apologising as regretting the loss of time which he might be spending on a new masterpiece in marble which would be an ornament to Cosimo's court.

It was just the sort of argument to appeal to the duke, who immediately sent a message to the Eight; Benvenuto was released on 26 October on bail of 1,000 *scudi* (two friends[2] guaranteed the sum), fined 300 *libbri*,[3] and warned not to reoffend. Once out of the Stinche, he obviously thought he was safe – and was even cavalier in ignoring the summons of the Eight to appear before them to hear his sentence ratified.

A more serious charge was made against him just over a month later, when on 27 February 1557 he was suddenly accused 'that for about five years he had held as his apprentice a youth, Ferrando di Giovanni da Montepulciao, with whom he had had carnal intercourse very many times and committed the crime of sodomy, sleeping in the same bed with him as though he was a wife'.[4]

Where this accusation came from is not much of a mystery: it was the familiar case of a lover scorned. Benvenuto had clearly cared more

for the young man than for the others with whom he had casual affairs – even for instance than Cencio, who he had immortalised in bronze. In August 1555, four years after meeting Ferrando for the first time, he included him in his will, leaving him 30 gold florins and a quantity of grain. There have even been suggestions that in a secret will made in May 1556, after the death of Benvenuto's son Jacopo Giovanni, Ferrando had been named as his heir. But some kind of trouble arose between them, and not quite a year later – on 26 June 1556 – the boy was dismissed with harsh words: 'I deprive him of everything I have done for him. I do not wish him to receive anything of mine. Any bequest in my Will shall be annulled.'[5] There can be little doubt that perhaps encouraged by his family Ferrando went off and laid information with the authorities – and just at a time when it would have had the strongest effect.

The duke might have taken the matter very seriously. Formerly, the duchess had been more sober and pious than he, but as Cosimo grew older sickness began to concentrate his mind on death and possible salvation through a more attentive concentration not only on his own sins but those of the people he governed. In 1550 he had ordered the burning of occult and astrological books and begun to take an active role in Church affairs. Braccio Baldini, his personal physician, said in his biography of his master that 'the Grand Duke's religious zeal was truly very great'.[6] He must have heard of the accusation to be made against Cellini before action was taken, but did nothing to prevent it.

Someone clearly tipped Benvenuto off, for on 17 February, ten days before the warrant was issued for his arrest, he suddenly left Florence for Lucca (where the writ of the Florentine court did not run). But the authorities were ahead of him. They suspected that he might be given advance news of the accusation and try to escape, and had the roads watched. Twenty-five kilometres outside the city, at Scarperia, an official, Leonardo Busini, recognised and arrested him. He wrote to the duke: 'It is about twenty-two hours, and Benvenuto the sculptor has arrived here and crossed the moat of the fortifications, taking the road towards Lucca. I, being on the rampart of the Mercatore, recognised him and sent after him four

soldiers, a horseman, and two *villani*,[7] who overtook him a mile and a half from here. I have confined him in the palace, and shall continue to hold him there until I have other orders from your Excellency.'[8]

Cellini was returned to Florence, and on 17 February charged and brought to trial. He pleaded guilty.[9] There was little else he could do. The facts were clear, and well substantiated – Ferrando must either have given evidence against him or offered to do so. Moreover, had he chosen to contest the charge, evidence would show that he had been found guilty of a similar charge before – and the penalty for a second offence was not only a fine of 100 *scudi*, but condemnation to the galleys for life.

He was sentenced as a first offender, fined 50 *scudi*, deprived of his civil rights for life, and sentenced to four years' imprisonment in the vile cells of the Stinche. He wondered whether he had really been sentenced for sodomy or for merely being an irritant to authority: in a poem he wrote in prison, he made the point: 'Some say I am here because of Ganymede,[10] others because my tongue is too fierce.' No doubt there was something in both suppositions.

He was only confined for a few weeks. He went to prison on 2 March – on the 22nd his friend Giovanni Girolama dei Rossi di San Secondo, Bishop of Pavia, who had shared his imprisonment in Rome and been his guest in Paris, wrote an appeal to the duke, hoping that Cosimo would 'deign to remember that poor man Benvenuto, freeing him from prison and sending him to his own home on those conditions which the Duke's humanity and incomparable courtesy might determine'.[11] The duke would have found it difficult if not impossible to have the verdict set aside and hesitated to intervene, but as usual made an exception in the case of 'his' sculptor. On 27 March the Eight moderated the sentence, allowing Cellini to return to his own house in the Via del Rosaio, where he would be detained under house arrest.

A year later, he was permitted to leave the house and go to that of Monsignor de' Serristori in Borgo Santa Croce, where he took minor religious orders, the *prima tonsoro*. The suspicious mind might suppose that he was equivocating – with the new pious tone of the

court in mind, was preparing to ingratiate himself anew with the duke and duchess. But if there may be an element of truth in that proposition, it is always worth remembering that Cellini had a strongly religious side to his nature. One may make a public demonstration of holiness without necessarily invoking God's name in a considerable number of religious sonnets, or treasuring for years a crucifix made in time of trouble. He made a number of religious artefacts less as a demonstration of skill than as genuine votive offerings (the greatest of them still to come) and if like many godly people he was most urgent in his supplications when ill, imprisoned, or otherwise unfortunate, there is no reason to suppose that those supplications were hypocritical. On the other hand there is no evidence to support the proposition, advanced by some of his editors,[12] that Book Two of his *Life* was specifically written to show him as a reformed character, turned from belief in astrology to belief in Christ. The two beliefs were not, in the sixteenth century, mutually exclusive.

He did not remain long in holy orders, renouncing them after only two years in order to beget more (legitimate) children – another son, recognised and christened Giovanni,[13] whose mother was an anonymous servant, and later several children by his last mistress, his former servant and model Piera de' Salvatore Parigi, who bore him a daughter, Elizabetta, in 1562. After he had secretly married her later that year she gave him a second daughter, Reparata, in 1564, a third, Maddalena, in 1566. He acknowledged his marriage openly in 1567 (and seems to have gone through a second ceremony of some sort). Their son, and Benvenuto's last child, Andrea Simone was born in March 1569.

Meanwhile Dorotea, to whom he had never offered his hand, had married one Domenico Parigi, sometimes known as Sputasenni. They produced a son, Antonio, and Cellini generously adopted him and renamed him Benvenutino. The boy was, however, congenitally stupid, and when after some years it was clear that nothing could be made of him in any profession which required skill or intelligence, he was enrolled as a postulant, and supported by Benvenuto until his death.

Finding himself confined to his house and with little to occupy his time, Cellini turned to an art of which he had previously had little experience: literary composition. He had certainly written poetry, but no major work in prose, so he decided to try his hand at writing his memoirs, on the grounds (he says in the opening paragraph of the *Life*) that everyone who had done anything remarkable in their life should seize the opportunity to record it. He had always been a reader – he knew the classics reasonably well, as is clear from various allusions in the *Life* – and may well have read that most popular of fourteenth-century works the *Decameron* of Boccaccio. One of his friends, Anton Francesco Grazzini, had written a rather pale imitation of that work: a collection of short stories published in 1549 as *Le cene* (*The Suppers*). In its style and anecdotal form Cellini's *Life* is not unlike these, though it has the form of conventional autobiography.

It may be that his motive for starting the book was the fact that his name was virtually omitted from Giorgio Vasari's *Lives of the Artists*, which had come out in 1549–50. Benvenuto had always had an uneasy relationship with Vasari, and had been highly irritated when the latter supported Ammanati in the contest to design the Neptune fountain for Cosimo. He began to write in his own hand, and then, finding that this was a tedious process, engaged a sickly fourteen-year-old boy, the son of Michele di Goro from the Arno valley, as an amanuensis. He found he very much enjoyed talking his way through his life, and while he did so at dictation speed managed to retain the freedom, informality and gusto of his ordinary speech – a quality which contributes enormously to the success of the book. When he had got a good way into the narrative, he gave the manuscript to his friend, the historian Benedetto Varchi, asking him whether he thought it was too informal in style. Varchi admired it greatly, and, happily, told him to carry on in the way in which he had started.

Begun in 1558, the *Life* was written spasmodically over the next nine or ten years (it was clearly more or less finished by 1568, though when Vasari, publishing his own collection of short biographies of contemporary artists, said that the shortness of his sketch of Cellini's

life was due to the fact that the artist had already 'described his life and works',[14] he was referring to the technical treatises rather than the autobiography. It is doubtful that Benvenuto meant to publish the *Life* in his own time (though a fair copy of part of it exists which looks as though it was made for the printers). Even though he carefully equivocates where, for instance, his true feelings about Cosimo are concerned, the vigour of his opinion of various courtiers and his comments on the court itself would have made publication if not positively dangerous, then certainly unpopular enough to have caused him considerable trouble.

While writing his memoirs, recalling various episodes in his life seems to have brought home to him the fact that he had made a great many enemies, and he began surreptitiously to collect weapons – pistols, a sword and dagger, a Turkish knife and a spear – and carry them, illegally. Later he was to regularise the position by formally requesting leave to go armed.

In the meantime the last great project of his life was constantly stirring in his mind – the commissioning of a great marble crucifix to hang over his grave. He still carried with him the small cross he had made of wax during his imprisonment in the Castel Sant' Angelo, and in August 1555, not long after the *Perseus* had been unveiled, he wrote a will in which he pledged himself to commission a life-size, or larger, version of it. Should he die before doing so, his son Jacopo Giovanni was instructed to spend up to 500 *scudi* having the crucifix executed in marble by a chosen master, the best that could be found (but *not*, he stressed, anyone who was in any way related to Baccio Bandinelli).

At that time he made an agreement with the Dominican friars of Santa Maria Novella that given the marble crucifix they would set it up before a pillar opposite the wooden crucifix dedicated by the great Brunelleschi, and that he could be buried beneath it. He would also provide the funds for a marble tondo, or circular plaque, bearing a relief carving of the Virgin and Child, with a representation of the crucifix on one side and St Peter and Christ with an attendant angel on the other. The original wax crucifix would be permanently exhibited elsewhere in the church.

Luca Martini, an old friend (to whom Cellini had dedicated the long religious poem he wrote during his imprisonment in Rome), negotiated the purchase of a fine block of white marble from Carrara, and in November 1557 a stonemason employed to do rough work started shaping it. Meanwhile, Cellini had himself bought some fine black marble, and another workman began carving the cross upon which the crucifix would eventually hang.

Cellini had decided in the first place to place the commission for the crucifix in the hands of a sculptor whose taste and expertise he trusted, one Antonio di Gino Lorenzi. But now, unable to stir from his house, his time only partly occupied in dictating his memoirs, he reconsidered: why should he not make the crucifix himself?

He set himself a task no less daunting than that of casting the *Perseus*. It is another example of his courage: he proposed to produce a work on a monumental scale which would require the skill of a Michelangelo – especially since he meant to carve the figure from a single block of marble, something very rarely attempted and even more rarely accomplished.

The name of Michelangelo was not carelessly invoked. As an admirer of that genius, Cellini followed the rules the master had set – rather than starting work immediately on the full-sized figure, he made first a small model, and then a full-scale one; from the latter, the figure could be sketched on the rough marble block. In his *Treatise on Sculpture* Benvenuto sets out the procedure to be followed: having sketched the main shape of the figure on the marble, you worked on it with fine-pointed chisels, as though you were going to produce the work in half-relief. Then you cut away the superfluous material, using drills to undercut where necessary (drapery, or particular parts of a figure, might require that). It was important to remember to be bold, and that a lightweight chisel, properly applied, would never crack the marble, but merely chip off whatever needed to be removed. When this work was completed and the surface had been smoothed with a rasp, it must be polished with a fine-grained pumice stone.

Cellini produced, in this crucifix, another indisputable master-work. Very different in tone from his other pieces – except in the

manifest love and regard of the male body – the figure of Christ is exquisitely finished, every detail of muscle and hair, every articulation of limb depicted with astonishing, attentive detail. As a contemporary poet[15] put it: 'I clearly see the last breath leaving His sacred lips. And whether He is flesh or stone I cannot tell, enthralled by so beautiful a work.'

The ribs, the scar on the right side of the chest, the curling of the fingers around the driven nails, and the face of Christ all bear the mark of a fine technician working at the height of his powers, of an artist translating into form a deeply felt vision which had occupied his mind for many years. The figure is in the true sense of the word god-like. If from the point of view of Christian iconography Cellini fails to portray Christ either in the harrowing extreme of physical suffering or with the sentimental pathos of religiosity, his is a conception which speaks clearly of the nobility of self-sacrifice and the peace of its accomplishment.

While the carving of the crucifix was untroubled and went remarkably smoothly, there were difficulties with the Dominicans, who after some time informed Cellini that, alas, there would be no room to bury him beneath it. He then suggested to the Servites at the church of the Annunziata, where his son Jacopo Giovanni was buried, that they might care to accept it, and with it the responsibility of providing his tomb. They agreed with pleasure – and then he heard that his great enemy Bandinelli had already reserved a place in that church. That was the end of that plan – he could not bear the thought of being buried anywhere near his enemy, nor the thought that their names might be associated, even by so tenuous a connection.

The collapse of the idea that the crucifix should mark his own grave turned his thoughts toward selling the work, and having put the finishing touches to it he set it up to public view at his house. The duke and the duchess brought the court and two visiting ambassadors, and so admired the work that Benvenuto immediately offered it to them as a present. He did not, of course, intend to give it away – nor did the duke mean to accept it; that would have placed him under far too great an obligation. However, in 1565 Cosimo

decided that the crucifix would make a suitable focal point in his private chapel at the Palazzo Pitti, and it was moved there – though never in fact removed from its packing case. A year later Cellini submitted an invoice for 1,500 *scudi*, which – in line with the duke's previous treatment of his artist – was never paid. Cosimo finally agreed on less than half the sum. Two years after Cosimo's death his successor, Francesco I, gave it to King Philip of Spain, and it arrived in Madrid in October 1576. Philip[16] sent it straight on to the Escorial, which less than a decade earlier had been completed as the monastic home of the tombs of all the Spanish kings. It was set up in a chapel in the upper choir of the church at the Escorial, where it may still be seen.

During all this time, Cellini's feud with Bandinelli had lost none of its enjoyable zest. The latter had received a huge commission to refurbish the choir of the cathedral at Florence, and was at work on two enormous marble sculptures. As these emerged, it became clear even to the general public that they were unworthy of such a prominent position – his carving of *Adam and Eve*, it was suggested, should be expelled from the Duomo as firmly as the originals had been from Eden. Not unnaturally, such criticism indicated to Cellini that he might profitably interfere, and he seems to have put the story about that he himself had been invited to take a hand in the decoration of the chapel. Bandinelli was furious, but conceded that Benvenuto might be offered the opportunity to work on some reliefs (though he had no confidence that the result would be anything other than incompetent, for it was common knowledge that Cellini had no idea at all of the rules of design).

Whether or not Benvenuto actually wanted to be involved in work at the cathedral, the duke was clearly in favour, for in the early 1550s Lilio Torello, his first secretary, sent for Benvenuto and commanded him to execute Biblical scenes in low relief in the choir. 'I had no desire to dignify Bandinelli's ugly work by adding my own,' he says succinctly; but it would not do to refuse the duke's command outright, and he agreed to meet with the administrators of the work. At first appearing to fall in with Cosimo's idea, he then pointed out that bronze reliefs on the planned scale would be

inordinately expensive – and put the question in their minds whether the choir, as planned, could actually support such work. It had not, after all, been very well designed; the reliefs would have to be placed very low, so that they would not be properly seen, and the dogs who made the cathedral their home would piss all over them.

Since, however, the duke was pleased to suggest that he might contribute some work to the building, perhaps he might design a massive bronze main door for the West End? (Doubtless he was excited at the notion of competing with the great doors of the Baptistry.) The administrators were equally excited – but the duke was merely irritated: Cellini, he said, always wanted to do the opposite of what was suggested to him. He rejected the idea out of hand. Benvenuto did his best to placate Cosimo, and in the end was rewarded with a commission for two pulpits for the cathedral. He made two models, and proposed that the pulpits should feature bronze reliefs showing scenes from the Old Testament – though one would also bear four capricorns – an allusion to the duke's horoscope. But the completion of *Perseus* and then work on the great crucifix resulted in Cellini almost forgetting the work for the cathedral, though correspondence suggests that at one stage he was working on the scene showing the creation of Adam – no doubt he wished to produce a figure which would be favourably compared to Bandinelli's botched one.

The feud which had preoccupied both men for over a decade bubbled up anew in the late 1550s, when Bandinelli presented to the duke designs for a splendid fountain for the Piazza della Signoria: it would be, he promised, the wonder of all Italy. The duke rather raised his eyebrows at the notion, but Bandinelli had the ear and sympathy of the duchess, and she ordered him to prepare a model based on his design. The plan was slow in developing, but in 1559 a large block of marble intended for the fountain was brought to Florence, purchased by the duke.

Cellini heard of its arrival, and racked (he says) with pity for the poor piece of marble, destined to be ruined by Bandinelli,[17] roughed out an idea of his own for which it could be used. He persuaded the duke that a public competition would be by far the best way of

choosing an artist to design the fountain: 'everyone' – by which he clearly meant himself and Bandinelli – should produce a model of a figure of Neptune as the centre of a grand fountain to stand in the Piazza della Signoria. His highness, with his impeccable artistic taste, could then commission the design he thought most suited to the site.

Cosimo was won over, and told Benvenuto to go away and produce a model. A few days later he called unexpectedly at Cellini's house, and was shown two small models of a Neptune fountain. The duke was impressed but non-committal – but a few days later Benvenuto heard that he had told a visitor to Florence, the Cardinal of Santa Fiore, that he had recently purchased a handsome block of marble which was to be used by the sculptor Benvenuto Cellini, who had produced the most beautiful model of the work he intended to produce from it. Did the story get back to Bandinelli? That bitter, jealous and contentious man died a few weeks later, on 7 February 1560, and was buried in a side chapel of the church of SS Annunziata in Florence, beneath a pietà he himself had carved.

If death removed Cellini's most potent rival, it did not immediately clear the way to the disputed block of marble, because hearing of the competition – it may be that the duchess put the news abroad – five other sculptors had entered the lists. While Benvenuto was busily producing a life-size plaster model of Neptune – the figure he intended to set at the centre of the fountain – in the loggia next to his *Perseus*, only a few feet away Bartolomeo di Antonio Ammanati, a student of Michelangelo, was at work on his own model. He was a strong contender for the prize, not only as the favourite of the duchess, but because he had already completed several excellent projects, including the design of the courtyard of the Palazzo Pitti and of the Boboli Gardens and the rebuilding of the Ponte a Santa Trinità, a bridge designed by Michelangelo but wrecked during the flood of 1557. He had also more recently executed a massive Hercules, at Padua. Then, in the cloisters of the Franciscan church of Santa Croce, Giovanni Bologne, or Giovanni the Fleming, as Cellini called him, was at work on the same project, while at the house of Ottaviano de' Medini, Vincenzio Danti, of

Perugia, was making another model, as was Francesco di Simone Mosca della Pecore, known as Il Moschino, an inexperienced outsider.

The duke was now seriously interested in the competition, and eager to follow its course. Having inspected Ammanati's model he demanded to see Cellini's, and according to the latter was very impressed by it. But in October 1560 the sculptor Leone Leoni wrote to Michelangelo:

> Ammanati has had the marble carried into his shop, and Benvenuto is flaring up and spitting out venom, flashing fire from his eyes and flouting the Duke with his tongue. . . . Ammanati says he has done best; but I have not seen his model, which is covered up in readiness for the transport of the marble to the place where it will be carved. Benvenuto has shown me his, over which I am sorry to say that in his old age he should be so ill-served by the clay and rags. The man from Perugia has done very well for one so young, but has no influence. The Fleming was turned down on grounds of expense, but worked his clay very cleanly. So much for this giant contest.[18]

Ammanati's Neptune was first shown to the public in 1565, as part of the celebrations of the wedding of Francesco de' Medici and Giovanna of Austria, and stands in the Piazza della Signoria today. No trace has been found of Cellini's design; he never had the opportunity of bringing to life what would have been his last major project.

FIFTEEN

Death and Immortality

Cellini resisted the idea that he was growing old; but this did not mean that he was not conscious of his immortality. When the idea of his being buried beneath his great marble crucifix came to nothing, he turned his attention to the Accademia del Disegno, formed in 1562 to replace the old Compagnia di San Luca, formerly the chief organisation of Florentine artists and sculptors.

This new body was to supervise the training of artists and arrange competitions among them, and to organise funeral services for colleagues. The first great occasion of that sort followed the death in Rome, in February 1564, of the greatest of them all, Michelangelo. The duke, who had approved the setting-up of the new body, had recently been widowed and had lost two of his sons, so was too preoccupied to pay much attention to the accademia's plans. He was not present when the academicians greeted the great man's coffin as it entered the city. Cellini, however, was certainly present – though he was himself far from well, having suffered recently from what appears to have been a severe, even dangerous, bout of food poisoning. He was included in the small committee of four – himself, Ammanati, and two painters, Bronzino and Vasari – which was set up to organise the funeral itself.

He took the initiative, suggesting in a long letter to Borghini, the prior of the Innocenti, that the service should take place in Michelangelo's Laurenziana Library, part of the monastery of St Lorenzo, and one of his architectural masterpieces. There would be too little room in the Medici chapel, which was the more obvious choice, while Easter ceremonies would make it difficult to hold the funeral at San Lorenzo. He proposed that he and certain other sculptors should execute six tall figures, four of them representing

Sculpture, Painting, Architecture and Philosophy weeping over the loss of the great man. A fifth figure, of an old woman weeping, would bear symbols of the four elements – a salamander for fire, a chameleon for air, a dolphin for water and a mole for earth. At the foot of the bier would stand a figure representing the River Arno, by which Michelangelo was born, and at its head the skeleton, Death – but 'bold and proud, not languid and afflicted'. Death would bear a vine, made 'with all that grace of which our art is capable, denoting that this great man, with his admirable virtues, has imparted more life through his death than he did in life, and having lived for ninety years will live for ninety times ninety years to come'.[1]

As is not unusual in such bodies, war immediately broke out among members of the accademia over the proposal. Not only did many members favour a much larger-scale funeral than could have been held at the library – or even the Chapter House, which was another proposal of Benvenuto's – but although Ammanati supported Cellini's view that sculpture having been Michelangelo's most towering talent, sculptors should take centre stage at the funeral, the painters fought bitterly against his vision. Cellini defended his position, arguing that while Michelangelo had produced many more paintings than pieces of sculpture, this was because sculpture was the more difficult art. But the painters won. Cellini did not attend the funeral, sending his excuses on account of illness.

During the last five years of his life, one gets the impression that, apart from being in poor health, Cellini had exhausted himself and his talent. He could not settle to work – he had no commissions, and only occasionally played at designing small pieces of jewellery. He designed a seal for the accademia, spasmodically continued to write his *Life*, and in addition wrote and published (in 1568) his treatises on sculpture and goldsmithing and a *Discourse on Architecture*. There were signs of renewed interest in life when he began seriously to think, in his late sixties, of returning to Paris. Disillusioned by the failure of the Neptune project, he heard from a friend, Baccio del Bene, who had come from the court of the widowed Catherine de' Medici, that she was eager to complete the tomb of her dead husband Henry II. Cellini's castle in Paris was still available to

him – why, suggested del Bene, did he not return and complete a magnificent monument to the late king? The idea was for kneeling statues of the king and queen, together with four bronze figures of the Virtues, and lesser bronzes in relief. Cellini could produce a new masterpiece.

He was strongly tempted, not only because of Cosimo's neglect, but perhaps because he was now increasingly concerned for his safety – for whatever reason, in 1562 he had petitioned the duke to be allowed to wear armour and carry a sword, and still kept a number of weapons about his houses.

He encouraged del Bene to take the matter of his leaving Florence up with Cosimo on his behalf. The duke was seriously unwell, having suffered a cerebral haemorrhage in 1568, which had had the effect of making him even more tetchy and unreliable than before. He tossed the idea aside: Benvenuto, he said, was no longer interested in working. Cellini was furious, and through del Bene made a point of telling the duke that on the contrary his regret was that he had not received any new commissions after his failure to win the competition for the Neptune fountain. The capricious duke once again turned the matter aside with the comment that, anyway, he wanted to keep Benvenuto for himself, and then promptly himself left Florence.

For Cellini to leave Florence without permission would not only have been unwise, but would probably have made it impossible for him ever to return. With no commissions from the duke or anyone else, he blamed the dying fall of his life on the planets and on the general capriciousness of princes. He began as part of his autobiography to write the truth about his relationship with Cosimo – and then reminded himself how little good was done by telling the truth about powerful princes, and tearfully burned the sheets he had written.[2]

His melancholy was mainly the result of not having any great work on hand. He was financially relatively prosperous. He had a share in land left him by his father at Poggio al Zeta, had investments in land and property elsewhere, and lived in some comfort with his wife, children and at least three servants in the

house in Via del Rosaio which had been given to him. It was decently rather than elegantly furnished – and the same might be said of the artist himself, though he could dress well when occasion demanded; he had wardrobes full of elegant and well-made clothes.

Almost as a hobby, he associated himself with two other goldsmiths in running a workshop in the Calimera. A contract made in 1568 shows that he supplied the capital (400 *scudi*) to set up the firm, and his partners, Antonio and Guido Gregori, would devote themselves entirely to making and selling jewellery. Cellini did not contract himself to make work for the shop, but if he produced designs they would not be charged to the firm. The business seems to have flourished, though at the time of Benvenuto's death his contract with his partners still had five months to run, and no complete records are available (he had anticipated making 50 per cent profit).

At the end of 1570 Cellini was in ill health. In December, he wrote to Francesco de' Medici apologising for not having cast a bronze figure for him – he had been so ill with pleurisy that he could not manage the walk from his bed to the nearby foundry. At the same time he made his final will, instructing that he should be buried in a tomb in the Annunziata – despite the presence there of the body of Bandinelli. He made something of a recovery after that, and there are records of a transaction between himself and a jeweller, Lorenzo di Zanobi Bartolini, to whom he advanced money and precious stones; he was prosecuting various minor legal cases, and added codicils to his will, settling money on his two surviving daughters and bequeathing the contents of his workshop to Francesco de' Medici, on condition that the latter saw to the welfare of his wards – including the dim Benvenutino – and the orphans in whom he had interested himself (there are no details of the personalities). On 15 February 1571 his lawyer called on him – but found him '*in extremis*', unable to talk. Later in the day, he died.

The Accademia del Disegno organised the funeral, and four academicians bore the coffin to the Annunziata, bright with blazing torches and guttering candles. Then Cellini was carried out of the main body of the church, away from the proximity of Bandinelli's

body lying beneath his crucifix, and into the Cappella di San Luca. Hundreds of people 'fought to gain entrance to the chapel to see and bless Messer Benvenuto and to hear the tribute to his great qualities'.[3] Finally, the coffin was lowered into a recently constructed vault containing eight niches. In one of these Cellini sits, surrounded by the seated bodies of seven other artists.

The chapel is a little out of the way – one must leave the church itself, and enter the *Chiostro dei morti*, the cloister of the dead, where is the entrance to St Luke's chapel, known also as 'the painters' chapel'. Beneath a portrait of St Luke by Vasari which hangs above the altar is a marble slab marking Benvenuto's final resting place.

When the contents of his property were noted, it was naturally in his workshop that his artistic remains were found, all in a jumble – a relief of the Adam and Eve he had planned for the Duomo, wax models of the aborted Neptune statue and of the fountain itself, two or three rough models for the cathedral pulpits, and a great number of other miscellaneous sketches and models including crucifixes, a head of the grand duke and the full-sized *Narcissus* and *Apollo and Hyacinthus* now in the Bargello. The history of these objects immediately after Cellini's death is obscure, nor do we know in what circumstances he left his widow and family, or what happened to them. No direct descendants have been traced.

The reputation of a painter, sculptor or designer usually resides in his or her own work. Benvenuto Cellini is an exception. Certainly, while he was not a natural writer he contrived almost by accident (no doubt he would have said through the good offices of the stars) to write a unique literary masterpiece which not only shows us the life of a Renaissance artist much more vividly and comprehensively than any other contemporary documents, including the splendid biographies of Vasari, but affords distinctive sidelights on the technique of jewellery-making, goldsmithing and the making and firing of bronzes, and is the most brilliant and complete account of life in Italy and France during the first half of the sixteenth century.

But as a result of his book, Cellini's personality has marched down the centuries side by side with his artistic creations, and in

reputation has frequently outpaced them – because of all the world's great visual artists he relies for his immortality on a very small amount of extant work. Until he started to produce large-scale sculpture – the most important examples of which have survived, although not always in pristine state – and indeed for the whole of his working life, he designed and made an enormous amount of jewellery, ecclesiastical seals, church plate and vessels, small ornaments, belt-buckles and other decorations for clothing, medals and coins, hats, sword-belts and so on. By the general consent of his contemporaries, even those who were jealous or those who for one reason or another positively disliked him, he was a master jeweller. Their opinion was matched by the admiration of his patrons who, however miserly, were concerned to 'possess' him as their personal performer of fine feats of draftsmanship and virtuosity in the making of such exquisite works as the Francis I salt-cellar, which in itself strongly suggests the beauty and accomplishment of the multitudinous objects which have vanished, some melted down, most lost, almost all unidentified and now if they exist probably unidentifiable.

Cellini as a human being defies categorisation: he was the servant of his patrons, but also a buccaneer; a lover of the human body but in anger or mere irritation a butcher who did not hesitate to stab and hack at those who offended him; a man fascinated by the occult and by astrology, but also intensely practical; an idoliser of the artists he admired, but splendidly and inventively splenetic in his condemnation of those whose work he despised; a man who had a proper pride in his accomplishments but also overweening arrogance. He appears to have had no close friends apart from his young apprentices and workmen, and his relationship to his family was no warmer than convention might demand. That he was 'difficult' in almost every aspect of his personality is unquestionable. The one irrefutable fact about him is that whatever the fate of his work or the opinions expressed about it, his personality will always fascinate. More than most men, he could have said, with Shakespeare's Parolles, 'Simply the thing I am shall make me live.' And he would have been right.

Notes

Where I have directly quoted from Cellini's *Life*, I have consulted all the available English translations listed in the bibliography, and with the help of Italian friends have prepared my own version. For context, the notes below refer to page numbers in the most recent English translation by Julia Conaway and Peter Bondanella, first published in 2002 and currently available in paperback from the Oxford University Press in its Oxford World Classics series. Early editions of the *Life* divided it into two books and a number of short chapters. This and several other modern editions of English translations of the *Life* (and indeed many editions in Italian) have followed this convention. For convenience, I have added these references in brackets to the page references, which will enable readers to go to the original in such editions as that by John Addington Symons, and easily find the relevant pages.

There have been a number of thoughtful translations of the *Life* during the past century, the most recent replete with generous notes identifying characters in the story. None of them perhaps equals Symons's 1906 translation as a work of literature, and those who wish to taste the greatness of the book will do well to turn to this, despite the occasional obfuscation and dissembling necessary a century ago.

Introduction

1. Manilius, *Astronomica*, trans. Goold, G.P., Harvard and London, 1977, 4, ll. 218–29. The book was first published in *c.* 10–20 BC.
2. Ptolemy, *Tetrabiblos*, ed. Robbins, F.E., London, 1940, III.14.171.
3. The Bondanellas, in their 2002 translation, say that Cancer is rising. This is incorrect.
4. *Life*, p. 27 (I, 17).
5. *The Life of Benvenuto Cellini Written by Himself*, New York, 1906, p. 13.
6. Vasari, Giorgio, *Lives of the most Eminent Painters, Sculptors and Architects*, trans. Gaston du C. de Vere, 10 vols, London 1912–15, vol. x, p. 22.
7. *Life*, pp. 34–5 (I, 23).
8. Cited in Christopher F. Black, *Early Modern Italy*, London and New York, 2001, p. 80.

9. Thornton, P., *The Italian Renaissance Interior, 1000–1600*, London, 1991, p. 11.
10. Rocke, Michael, *Forbidden Friendships: homosexuality and male culture in Renaissance Florence*, New York and Oxford, 1996, p. 10.

Chapter One

1. Cellini, *Life*, p. 6 (I, 2).
2. Stevens, Anthony, *Ariadne's Clue*, London, 1998, p. 350.
3. *Life*, p. 13 (I, 7).
4. Rocke, *Forbidden Friendships*.
5. *Ibid.*, p. 158.
6. Shakespeare, *Romeo and Juliet*, I.1.
7. And indeed did so, becoming a mercenary under Giovanni de' Medici, a famous *condottiere* who led the Bande Nere, or Black Band, so called because of the black ensigns carried by its members (see pp 63 & 87).
8. *Life*, p. 15 (I, 9).
9. The Italian phrase is '*e dua anni in circa praticammo insieme*'. John Addington Symonds, in his 1889 edition, translates it as: 'for two years or thereabouts we lived in intimacy' (vol. i, p. 99). Both translations, and certainly the original, seem suggestive of something more than casual friendship.

Chapter Two

1. The Pantheon: a great Roman monument built in AD 118–25, which was converted into a Christian church in 608, and still stands.
2. Like the great majority of Cellini's smaller work, this salt-cellar has disappeared altogether. But he was clearly a master of minute decoration. Similar pieces by other, and perhaps lesser, artists reveal such perfection of small detail as cannot be properly examined without the use of magnifying glasses not available in the sixteenth century. As one of the best workmen in the genre, Cellini must have had extraordinarily keen eyesight and astonishing digital dexterity.
3. St Eligius, or St Eloi (*c*. 588–660), Bishop of Noyon, was a goldsmith and preacher who became the patron saint of goldsmiths, blacksmiths and farriers. His principal emblem is the horseshoe, and he is credited with having removed a horse's leg, shod it, and then replaced it on the animal (to what purpose we are not told). His feast day is 1 December.
4. Cellini, *Life*, p. 24 (I, 15).
5. Pope-Hennessy, John, *Cellini*, London, 1985, p. 28.
6. Greci, L., 'Benvenuto Cellini nei delitti e nei processi fiorentini ricostruiti attraverso le leggi del tempo', *Quaderni dell'archivio di antropologia criminale e medicina legale*, fasc. 2 (1930), pp. 16–24.

7. *Buco* = 'hole', and a codeword for anus.
8. Rocke, *Forbidden Friendships*, p. 231.
9. *Life*, p. 28 (I, 18).
10. Greci, L., 'Benvenuto Cellini nei delitti e nei processi fiorentini', *Quaderni dell'archivio di antropologia e medicina legale*, fasc. 2 (1930).
11. *Life*, p. 26. The Italian reads: '*che domattina te lo mandremo in villa con i lanciotti*'.
12. *Ibid.*, pp. 34–5 (I, 23).
13. *Ibid.*, p. 35 (I, 23).
14. He was said once to have held a banquet in the loggia of his villa by the Tiber, and after each course ordered his servants to throw the silver plates on which the food had been served into the river. He had, however, arranged for a net to be spread beneath the water, to catch them. His villa, now called La Farnesina, is in the Via della Lungara.
15. *Life*, p. 31 (I, 19).
16. *Ibid.*, p. 39 (I, 24).
17. Cardinal Francesco Cornaro, Cardinal Niccolò Ridolfi and Cardinal Salviati.
18. The disease was named by the physician Gerolamo Frascatoro (1478–1553), who in 1530 published a poem, *Syphilis sive morbus Gallicus*, in which a rich and beautiful young shepherd, Syphilis, insulted Apollo and was stricken by a terrible sickness during which he lost all his teeth and his limbs were stripped of their flesh, exposing the bare bones – all this graphically described in elegant and polished verse.
19. Castiglione, Arturo, *A History of Medicine*, New York, 1947, p. 456.
20. *Life*, p. 46 (I, 29).
21. *Ibid.*, p. 46 (I, 29).

Chapter Three

1. *A passing good little book necessary and behooveful against the pestilence*, London, 1485.
2. *Chirurgia*, II, ch. 5, quoted in Castiglione, Arturo, *History of Medicine*, New York, 1947, at p. 358.
3. Transvestism is not mentioned elsewhere in the *Life*, and Cellini seems simply to have taken advantage of this particular model's feminine looks. There is no reason to regard his relation with Diego as especially innocent, however. Time and again there is the strongest suggestion that his admiration for physical beauty was inevitably accompanied by sexual interest and action.
4. Arquebus – a small hand-gun.
5. Alas, this was not the case; Bourbon was killed by a cannonball, and not by a shot from an arquebus.
6. *Life*, p. 61 (I, 34).
7. Falconet – light cannon.

8. *Life*, p. 61 (I, 34).
9. Martines, L. (ed.), *Violence and Civil Disorder in Italian Cities, 1200–1500*, Los Angeles and London, 1972, p. 127.
10. *Life*, p. 66 (I, 37).
11. *Ibid.*, p. 66 (I, 37).
12. In the next century it was to lose half its population to the plague.
13. Ferdinand, Schevill, *The Medici*, London, 1950, p. 204.
14. Longinus – the Roman soldier said to have pierced Christ's side with his lance.
15. Cellini, *The Treatises on Goldsmithing and Sculpture*, trans. Ashbee, C.R., London, 1888, p. 61.
16. *Ibid.*, p. 65.
17. *Ibid.*, p. 48.

Chapter Four

1. The three drawings are in the British Museum, in a volume of ecclesiastical treasures from the papal treasury. The text can be found in the *Burlington Magazine*, no. 8 (1905–6, pp. 37–43) in an article by Herbert Thurston entitled 'Two lost masterpieces of the goldsmith's art'.
2. *Life*, p. 97 (I, 56).
3. Cellini seems to have been particularly fond of dogs, though he does not say so in his *Life*. He always kept one or more, and made delightful models of several as part of his designs.
4. In the *Life* (pp. 87–8; I, 49) the impression is given that though Cecchino had only been struck in the leg, both he and Cellini were convinced that the wound was mortal. It may be that an artery had been severed and the bleeding was severe enough to give that impression – which indeed was proved to be correct.
5. *Life* (Symonds trans.), vol. i, p. 215.
6. *Ibid.*, pp. 213–14 (I, 49).
7. He was actually twenty-seven.
8. *Life*, p. 89 (I, 51).
9. Now known as the Palazzo Madama.
10. *Life*, p. 83 (I, 46).
11. Cellini, *Treatises*, p. 65.
12. *Ibid.*, p. 107.
13. *Ibid.*
14. Cellini, *Life*, p. 96 (I, 56).
15. *Ibid.*
16. Bibliothèque Nationale, Paris. Quoted at length in chapter XXXV of vol. iii of Thorndike, Lynn, *A History of Magic and Experimental Science*, New York, 1943. Antonius de Montulmo or Monteulmo or Monte Ulmi flourished at Bologna between 1384 and 1390.

17. *Ibid.*, p. 603.
18. *Life*, p. 110 (I, 64).
19. Thorndike, *History of Magic*, p. 606.
20. The Italian is '*fece una istrombazzata di correge con tanta abundanzia di merda*'.
21. Ippolito was the illegitimate son of the Duke of Nemours (the dedicatee of Machiavelli's *The Prince*) and had been made cardinal by Clement VII when he was eighteen. An enthusiastic supporter of the arts, he admired Cellini's work and was his friend as well as his patron.
22. Cellini, *Treatises*, p. 73.
23. *Life*, p. 120 (I, 71).
24. Exodus: XVII.
25. *Life* (Symonds trans.), vol. i, p. 273 (I, 72).

Chapter Five

1. *Life*, p. 123 (I, 73).
2. Pierluigi became Duke of Parma, Piacenza and Castro, married Girolama Orsini and was murdered in 1547. Ranuccio died in 1509, and Constanza married Bosio II of the house of Sforza.
3. Pope Paul III's nepotism set new records, even at the Vatican, and was criticised both by Catholics and the newly formed Protestant groups. It was so marked that when Titian visited Rome in 1545/6 and began a painting of the pope and his Farnese relatives, the group was so obviously a critical depiction of a sycophantic family that the picture was never finished.
4. Recalcati was eventually dismissed for scandalous corruption, and imprisoned in the Castel Sant' Angelo.
5. *Life*, p. 125 (I, 74).
6. He actually designed one coin for the new pope while in hiding – a gold *scudo* with the Farnese coat of arms and Paul III's title on the front, and a figure of St Paul on the back.
7. '*Maravigliose caresse*', *Life*, p. 133 (I, 79).
8. '*Io ho in culo loro e il duco!*', *Life*, p. 145 (I, 85).
9. *Life*, p. 132 (I, 79).
10. The coins were commonly called *ricci* – in slang, 'curly heads'.
11. His real name was Pietropaolo Galeotto.
12. Lorenzo was always referred to as Lorenzino because of his small stature.
13. '*Lo trovo nel letto perche dicevano che gli disordinato*' in the original (I, 80), to which the editor adds '*alle dissolutezze*'.
14. *Life* (Symonds trans.), vol. i, p. 303. The Italian reads: '*ardito e bellissimo di corpo*'.
15. *Life*, p. 143 (I, 84).

16. The building is now the official residence of the President of Italy.
17. *Life*, p. 146 (I, 85).
18. Bradstock, C.W.A., 'Speculations in Renaissance Biography: Cellini's Worm', in *Historical Medicine*, Minnesota, 1998, vol. iv, p. 353.
19. It sounds almost as though a rape took place, for the boy left Cellini's shop swearing that he would kill Vasari. Though no boy in such a position would have been likely to climb into bed with a man without knowing that some advance was going to be made, he might have objected to the extent of the liberties the guest attempted to take.
20. *Life*, p. 149 (I, 87).
21. *Ibid.*, p. 151 (I, 89).
22. See William Roscoe, *The Life of Lorenzo de' Medici*, London, 1797, vol. ii, Appendix.
23. Like so much of Cellini's work, the book has disappeared.
24. *Life*, p. 155 (I, 91).
25. Cellini, *Treatises*, p. 37.
26. *Ibid.*, p. 38.
27. *Life*, p. 159 (I, 93).

Chapter Six

1. Caro, Annibale, *Lettere familiare*, ed. A. Greco, Rome, 1957–61, vol. i, p. 294.
2. Then in his late sixties, he had been a papal secretary under Leo X, and was later made cardinal by Paul III.
3. He had already had at least two medals made, bearing his likeness – one in 1532 by Valerio Belli and one at about the same time by Leone Leoni.
4. Tassi, F. ed., *Vita di Benvenuto Cellini . . . arricchita d'illustrazione e documenti inediti*, Florence, 1829, vol. 3, pp. 313–14, n. 1.
5. It can be seen, in silver, at the Bargello in Florence.
6. In France, he was known as 'Maitre Roux de Rouse'.
7. du Cerceau, J.A., *Les plus excellents bastiments de France 1576–1607*, Farnborough, 1972, ii, p. 262.
8. The Gallery, originally called the Grande Gallerie, but now known as the Galerie Francis I, is the only room in the château which today recalls the decor of Fontainebleau as Cellini knew it. Stucco figures – monks, satyrs, nudes (some of them given wings and promoted to the status of angels) – gambol exuberantly, while frescoes show mythological scenes: the death of Adonis, the tutelage of Achilles, and so on. Rosso originally, as an early traveller put it, 'meant by the various histories and subjects of his paintings to represent the principal actions of the great King Francis'.
9. Not to be confused with Cardinal Ippolito de' Medici.
10. *Life*, p. 172 (I, 100).

11. '*questo pazzerellino*'.
12. The inventory was published in *Artisti lombardi a Roma nei secoli XV, XVI e XVII*, Milan, 1881.
13. *Life*, p. 178 (I, 103).
14. *Ibid.*, p. 179 (I, 104).
15. *Ibid.*, p. 180 (I, 105).
16. *Ibid.*

Chapter Seven

1. Cellini uses the term 'handsome' and 'boy' when describing his friend. When I use such terms to describe his friends, I do so because he employs them, and not because of any speculation about the relationship between them.
2. He had worked, in the past, for her parents.
3. Quoted from *Life* (Symonds trans.), vol. 1, p. 17.
4. The religious paintings and sculpture of the Renaissance, with their extraordinary bias towards the naked male figure, suggest a real fixation which can only be explained by a strong homophile tendency not only among artists but within the Church. But Cellini's own sexual proclivities surely played a part. The fact that he does not record one visit by a female angelic figure (while Casanova, in similar circumstances, recorded several) should not entirely be dismissed.
5. *Life*, p. 213 (I, 125).
6. He later became Governor of Rome, and wrote a sonnet praising Cellini's *Perseus*.
7. Alessandro Farnese, confusingly, had been patron and something of a friend to Cellini, despite his father's almost pathological antipathy to the artist. This may have something to do with a son's natural tendency to oppose his father, but perhaps more to do with Cellini's skill as an artist, and almost every man's desire to own something designed or made by him.
8. *Life*, p. 215 (I, 127).
9. Quoted in Pope-Hennessy, *Benvenuto Cellini*, pp. 84–5.
10. The title is rather strange, for a *capitolo* was more generally an obscene lampoon; but in any case is not especially revealing.
11. There is a lead version of the seal in the Lyons Musée des Beaux–Arts.
12. The cardinal's accounts record that the uniforms cost 24 gold *scudi* (G. Campori, ed., *La Vita di Benvenuto Cellini . . . intorno alle relazione col Cardinale Ippolito d'Este*, Milan, 1873, p. 407).
13. *Life*, p. 224 (II, 2).
14. *Ibid.*
15. See Pope-Hennessy, *Benvenuto Cellini*, pp. 87–8.

Chapter Eight

1. Hall, E., *Henry VIII*, ed. C. Whibley, London, 1904.
2. *Letters and Papers, Foreign and Domestic, of the reign of Henry VIII*, ed. J.S. Brewer and others, 21 vols, London, 1862–1910, iii, 2050.
3. *Travel Journal of Antonio de Beatis*, ed. Hale, London, 1905, p. 107.
4. Browne, Sir Anthony, *Le journal d'un bourgeois de Paris &c*, Paris, 1910.
5. *State Papers of Henry VIII*, 11 vols, London, 1830–52, viii (pt v), pp. 482–4.
6. Cazeaux, Isabelle, *French Music in the 15th and 16th Centuries*, Oxford, 1975.
7. *Life*, p. 238 (II, 10).
8. Smith, H.M., 'François Ier, l'Italie et le château de Blois', in *Bulletin monumental*, 147, Paris, 1989, 307.
9. Cellini refers to him as '*molto* domestico *amico*'.
10. Cellini, *Treatises*, p. 164.
11. The château was on the site of the present Hôtel de la Monnaie.
12. Cellini, *Treatises*, p. 163.
13. None of these have survived.
14. Cellini, *Treatises*, p. 95.
15. *Life*, p. 265 (II, 29).
16. The two sets of documents, the naturalisation papers and the confirmation of the gift of Le Petit Nesle, are in the Biblioteca Nazionale.
17. *Life*, p. 260 (II, 26).
18. *Ibid.*, pp. 247–9 (II, 16–17).
19. *Ibid.*, p. 262 (II, 27).
20. *Journal d'un bourgeois de Paris sous le règne de François premier (1515–1536)*, ed. Ludovic Lalanne, Paris, 1854, pp. 435–6.
21. *Life*, p. 267 (II, 30).

Chapter Nine

1. *Life*, p. 256 (II, 22).
2. A lead medal bearing Francis's portrait, in the Fitzwilliam Museum in Cambridge, is perhaps an example of the rough proposals for the coins which Cellini produced at this time.
3. *Life*, pp. 273–4 (II, 35).
4. *Ibid.*, p. 273 (II, 34).
5. Peace with France was to be made at Crécy in September 1544.
6. The salt-cellar remained at Fontainebleau until 1562, when it was taken to the Bastille with other pieces in gold and silver to be melted down as part of a money-raising campaign. Reprieved at the last minute, it was presented in 1570 by Charles IV to Archduke Ferdinand of the Tyrol, and was kept at Schloss Ambras until, identified as the work described in Cellini's *Life*, it was

transferred to the Kunsthistorisches Museum in Vienna, where it can still be seen.

7. *Life*, p. 225 (II, 2).
8. *Ibid.*, pp. 274–5 (II, 36).
9. Scalini, Mario, *Cellini*, Florence, 1995, p. 14.
10. *Ibid.*
11. Dimier, L., 'Une pièce inédite sur le séjour de Benvenuto Cellini à la cour de France', *Revue archéologique* 32, 1902, 85–95.
12. *Ibid.*
13. Pope-Hennessy, *Benvenuto Cellini*, p. 105.
14. In the Louvre.
15. Campori, G. ed., *La vita di Benvenuto Cellini scritta da lui medesimo ridotta alla lezzione originale del codice Laurenziano . . . intorno alle relazione del Cellini col Cardinale Ippolito d'Este ed a'suoi allievi Paolo Romano ed Ascanio da Tagliacozzo*, Milan, 1873, pp. 4098–110.
16. *Trattato della Scultura*, viii.

Chapter Ten

1. *Life*, p. 276 (II, 37).
2. The baptism was registered in the records of the parish of St André des Arts. The child appears to have died in infancy.
3. However, he was persuaded by her aunt and guardian to give her a generous dowry.
4. Duret, Jean, *Traité des peines et amends tant pour les matières criminelles que civiles*, Lyon, 1573, p. 41.
5. The title 'admiral' was more or less honorary, and did not denote any connection with the sea.
6. *Life*, p. 285 (II, 44). In 1540 Charles did come to Paris, marching through triumphal arches designed by Primaticcio and Rosso Fiorentino.
7. Vasari, Giorgio, *Lives*, vol. vi, p. 93.
8. '*di quella lor mala maniera François*', *Life*, p. 270.
9. Cellini's design for the doorway is in the Ian Woodener Family Collection in New York. In brown ink and wash it is one of the most handsome of his drawings to come down to us.
10. It had a chequered history. After the death of Francis I it was taken from Fontainebleau to Anet, where Henri II set up his court with Diane de Poitiers. There, set over the main entrance, it was known as a tribute to Diana. At some stage it was vandalised, and on its removal to the Louvre it was further damaged and later to some extent restored (the horns of the stag for instance were replaced in the nineteenth century). A plaster cast of the figure can be seen in the court of casts at the Victoria and Albert Museum in London.

11. Pope-Hennessy, *Benvenuto Cellini*, p. 140.
12. They, like the nymph, were taken to Anet, but were carried to Paris during the Revolution. Later they were returned to the Duchess of Orleans, and were set up in a chapel at Neuilly dedicated to the memory of Diane de Poitiers. They disappeared sometime in the middle of the nineteenth century.
13. *Life*, p. 286 (II, 45).
14. *Ibid.*, pp. 287–8 (II, 45).
15. *Ibid.*
16. There is some question about this. Cellini said he was given 300lb of silver to make the Jupiter statue; whether the word 'given' meant that what was left over actually belonged to him is perhaps a moot point.
17. '*Benvenuto, voi sete un gran matto!*' *Life*, p. 307.
18. Vasari, *Lives*, vol. viii, p. 128.
19. '*un piccolo ragazzetto franzese*', *Life*, p. 309.
20. Alexandre Dumas *père* wrote a novel, *Ascanio*, about his adventures.
21. Campori, G., ed., *La vita di Benvenuto Cellini*, pp. 409–10.
22. Cellini, *Trattato della Scultura*, viii.
23. On 31 March 1547.

Chapter Eleven

1. Varchi, Benedetto, *Opere*, Milan, 1882, vol. viii, p. 340.
2. *Ricordi intorno ai costumi, azione e governo del Serenissimo Gran Duca Cosimo I scritta da Domenico Mellini*, ed. D. Moreni, Florence, 1820.
3. Pagni, Lorenzo, *Lettere*, Milan, 1889, p. 156.
4. Pagni, Lorenzo *Lettere*, Rome, 1890, p. 167.
5. Quoted in *Life* (Symonds trans.), Introduction, p. 35.
6. *Life*, p. 296 (II, 53).
7. Much has been made by some critics of this point, and no doubt both the duke and Cellini intended the figure to be a triumphant symbol of the power of the Medici – at least to the extent that the subject was chosen with that in mind. But it is perhaps supererogatory to emphasise the point unduly. The statue is firstly a work of art, secondarily, and much less importantly, a political statement.
8. *Life*, p. 344 (II, 88).
9. Now the Via della Colonna.
10. Cellini's term for the 'agreement', which was formal but not legally binding.
11. *Life*, p. 298 (II, 53).
12. Indeed Tasso was more than a carpenter: he worked as a woodcarver with Michelangelo, and designed the loggia of the New Market in Florence.
13. *Life*, p. 300 (II, 55). He also, in the *Life*, remarks that he thought Riccio was actually going mad, 'in advance of the time the stars had determined' – a reference to the fact that the secretary lost his mind some years later.

14. Vasari, *Lives*, p. 76.
15. *Ibid.*, p. 62.
16. *Ibid.*, p. 105.
17. '*Questa peccato era molto in odio al Duca*': quoted, P.L. Rossi, in 'Il caso Cellini', in *Crime, Society and the Law in Renaissance Italy*, ed. T. Dean and K.J.P. Loew, Cambridge, 1994, p. 176.
18. Bernardo Segni, *Storie fiorentine di messer Bernardo Segni*, Florence, 1835, 2:298.
19. *Ibid.*, p. 93.
20. *Ibid.*
21. It is in the Biblioteca Riccardiana in Florence.
22. *Life*, p. 310 (II, 63).
23. Milanesi, C., *I trattati dell'oreficeria e della scultura di Benvenuto Cellini*, Florence, 1857, p. 2774.
24. Pope-Hennessy, *Benvenuto Cellini*, p. 217.

Chapter Twelve

1. *Life*, p. 308 (II, 62).
2. *Ibid.*, p. 313 (II, 64).
3. At least 5,000 *scudi*.
4. It is in the Isabella Stewart Gardner Museum in Boston.
5. Pope-Hennessy, *Benvenuto Cellini*, p. 220.
6. *Life*, p. 333 (II, 80).
7. It is to be seen at the Bargello.
8. *Life*, p. 321 (II, 71).
9. To be seen at the Bargello.
10. Pope-Hennessy, *Benvenuto Cellini*, p. 228.

Chapter Thirteen

1. One may be seen in the Victoria and Albert Museum, London.
2. Biblioteca Riccardiana, cod. Ricc. 2787.
3. Archivio de Stato, Florence, Guardaroba Medici, 10, Libro Creditori e Debitori, c. 59.
4. See *Life*, pp. 325–30 (II, 74–7).
5. Hector Berlioz's *Benvenuto Cellini*, with a libretto by de Wally and Barbier, was first performed at the Grand Opera, Paris, on 10 September 1838. The third act shows the casting of the *Perseus*, in the presence of Pope Clement VII!
6 *Life*, pp. 266–7 (II 77).
7. Quoted in Pope-Hennessy, *Benvenuto Cellini*, p. 184.

8. He was born on 27 November 1553 and christened Jacopo Giovanni, but died in 1555.
9. '*Te fili si quis laeserit ultor era*'.
10. Ironically, the ravages of time made their removal inevitable, and in 1975 the original figures were carried to the Bargello and replaced by excellent replicas.

Chapter Fourteen

1. His full name was Cesare di Niccolò di Mariano dei Federighi, and he had worked with Cellini on the base of the *Perseus*.
2. His guarantors were Luca Mini and Zanobi di Francesco Buonagrazia.
3. The sum is interesting: a blow which caused a fracture above the eyebrows attracted a fine of 1,000 *libbre*, while one merely causing blood to flow cost the offender 200 *libbre*. Cellini's blow had certainly injured Papi, but not actually broken his head.
4. '*tenendolo in letto come sua moglie*'.
5. F. Tassi, *Vita di Benvenuto Cellini* . . . Florence, 1829, vol. iii, pp. 67–74.
6. Braccio Baldini, *Vita di Cosimo Medici primo Granduca di Toscana*, Florence, 1578, pp. 75–6.
7. Peasants.
8. Florence, Archivio di Stato, Spogli Milanese, Manoscritti 811, f. 418, c. 565.
9. *Ibid.*, '*Confessa di essere vero di havere soddomitato decto Ferdinando*'.
10. The love of a boy.
11. *Libro delle suppliche degli anni 1556 e 1557*, Florence, Archivio di Stato, c. 302.
12. Ashbee (1867), Cust (1910).
13. He died in 1563/4.
14. *Le vite de' pui eccellenti pittore, scultori ed architettori, critte da Giorgio Vasari pittore aretino*, ed. G. Milanesi, Florence, 1906, p. 623.
15. Vincenzo Danti, quoted by Pope-Hennessy in *Benvenuto Cellini*, p. 259.
16. A well-substantiated report has it that Philip was so scandalised by the meticulous carving of the genitals that he had a scarf draped over the figure, to conceal them.
17. *Life*, p. 360 (II, 99).
18. Quoted in Pope-Hennessy, *Benvenuto Cellini*, p. 273.

Chapter Fifteen

1. Quoted in Pope-Hennessy, *Benvenuto Cellini*, p. 277.
2. Cellini: *Trattato dell' Oreficeria*, xii.
3. F. Tassi, *Vita di Benvenuto Cellini*, Florence, 1829, vol. iii, pp. 252–4.

Bibliography

Adams, N. and Nussdorgfer, L., *The Italian City, 1400–1600*, London, 1994

Argan, G.C., *The Renaissance City*, London, 1969

Ariès, P., *Centuries of Childhood*, New York, 1962

Armstrong, E., *Charles Very*, London, 1902

Ashbee, C.R., 'Cinque-Cento Jewellery, as illustrated by the Trattati of Benvenuto Cellini', London, *Art Journal*, 1894, 152–22

Astaria, T., *Village Justice: Community, Family and Popular Culture in Early Modern Italy*, Baltimore and London, 1999

Avery, C., *Benvenuto Cellini's Bust of Bindo Altoviti*, in 'The Connoisseur' 198, 795, 1978, 62–72, *Florentine Renaissance Sculpture*, London, 1970

—— and Barbaglia, S. (eds), *L'Opera completa del Cellini*, Milan, 1981

Avory, C., *Giambologna: the Complete Sculpture*, London, 1987

Bannister, F., *A History of Architecture*, 19th edn, ed. Musgrave, John, London, 1987

Bargaglia, S., *L'opera completa del Cellini*, Milan, 1981

Barocchi, P., ed., *Trattori d'arte del Cinquecento*, Bari, 1960–2

Bean, J. and Stampfle, C., *Drawings from New York Collections, I: The Italian Renaissance*, New York, 1965

Bell, R.M., *How to Do It: Guide for Living for Renaissance Italians*, Chicago and London, 1999

Berenson, B., *Italian Pictures of the Renaissance: A List of the Principal Artists and Their Works, with an Index of Places: Florentine School*, 2 vols, London, 1963

Bertolotti, A., 'L'Atelier de Benvenuto Cellini', *Gazette des Beaux Arts*, 13, 1876, 394–7

Black, C., *Early Modern Italy*, London and New York, 2001

Black, C.F., *Italian Confraternities in the Sixteenth Century*, Cambridge, 1989

Bode, W., *The Italian Bronze Statuettes of the Renaissance*, New York, 1980

Booth, C., *Cosimo I, Duke of Florence*, Cambridge, 1921

Borsellino, N., 'Benvenuto Cellini' in *Dizionario biografico degli Italiani*, vol. 23, 440–51, Rome, 1979

Boucher, B., 'Leone Leoni and Primaticcio's Moulds of Antique Sculpture', *Burlington Magazine*, 123, 1981, 23–6

Bibliography

Braudel, F., *Civilisation and Capitalism, 15th–18th Century; I: The Structures of Everyday Life; II: The Wheels of Commerce; III: The Perspective of the World*, trans. S. Reynolds, London, 1984

Brown, J.C., *In the Shadow of Florence*, Oxford, 1982

—— and Davis, R.C. (eds), *Gender and Society in Renaissance Italy*, London and New York, 1998

Browne, Sir A., *Le journal d'un bourgeois de Paris sous le regne de François Ier* (1515–36), ed. Bourrilly, Paris, 1910

Brucker, G., *Giovanni and Lusanna: Love and Marriage in Renaissance Florence*, London, 1986

Burckhardt, J., *The Civilisation of the Renaissance in Italy*, London, 1955

Burke, P., *The Italian Renaissance: Culture and Society in Italy*, London, 1987

——, *Popular Culture in Early Modern Europe*, London, 1978

Bush, V., *Colossal Sculpture of the Cinquecento*, New York, 1976

Byam Shaw, J., *Drawings by Old Masters at Christ Church, Oxford*, Oxford, 1976

Calamandrei, P., *Nascita e vucende del 'mio bel Cristo'*, in *Il Ponte*, 6, 1950, no. 4, 379–93, no. 5, 487–99

Campore, G. (ed), *La vita di Benvenuto Cellini scritta da lui medesimo ridotta . . . &c*, Milan, 1873

Castiglione, A., *A History of Medicine*, trans. Krumbhaar, E.B., New York, 1947

Cazeaux, I., *French Music in the 15th and 16th Centuries*, Oxford, 1975

Cellini, B., *My Life,** Italian text ed. B. Maier, Istituto Geografico de Agostini, Novara, 1962. English trans. by Nugent, T., London, 1771; Symonds, J.A., London, 1887, New York (2 vols, 1906); Cust, R., London, 1910; Bull, G., New York, 1983; Bondanella, P. and Conaway J., London, 2002

——, *The Treatises on Goldsmithing and Sculpture*, trans. Ashbee, C.R., London, 1888

Cervigni, D.S., *The 'Vita' of Benvenuto Cellini: Literary Tradition and Genre*, Ravenna, 1979

Chastel, A., *The Flowering of the Italian Renaissance*, London, 1965

——, *The Sack of Rome*, Princeton, 1983

Ciardi Duprè dal Poggetto, M.G., 'Nuove ipostesi sul Cellini', in *Essays presented to Myron P. Gilmore*, II, 95–106, Florence, 1978

Clark, K., *The Nude: a Study of Ideal Art*, London, 1956

Cohen, T.V. and Cohen, E.S., *Words and Deeds in Renaissance Rome: Trials before the Papal Magistrates*, Buffalo and London, 1993

Cole, A., *Virtue and Magnificence: Art and the Italian Renaissance Courts*, New York, 1995

* O. Bacci published a complete list of the printed editions of Cellini's autobiography in Florence in 1901: *Vita di Benvenuto Cellini: Testo critico con iontroduzione e note storiche.*

Bibliography

Cole, B., *Italian Art 1250–1550: the Relation of Italian Art to Life and Society*, New York, 1987

——, *The Renaissance Artist at Work*, New York, 1983

Cosson, Baron de, 'Cellini's Model for the Head of Ganymede', *Burlington Magazine*, 23, 353–4, London, 1913

Cox-Rearick, J., *The Collections of Francis I: Royal Treasures*, Antwerp, 1995

Cronin, V., *The Florentine Renaissance*, London, 1967

Dean, T. and Loew, K.J.P. (eds), *Crime, Society and the Law in Renaissance Italy*, Cambridge, 1998

De Beatis, A., *The Travel Journal of Antonio de Beatis, 1517–1518*, trans. Hale, J.R. and Lindon, J.M.A., ed. Hale, London, 1979

Della Casa, G., *Galateo: a Renaissance Treatise on Manners*, trans. and eds Eisenbickler, K. and Bartlett, K.R., Toronto, 1994

Dempsey, C., 'Some observations on the education of artists in Florence and Bologna during the later Sixteenth Century', *Art Bulletin*, 52, 552–69, London, 1980

Donati, V., *Pietre dure e medaglie del Rascimento, Giovanni da Castel Bolognese*, Ferrara, 1989

Fabriczy, C. von, *Italian Medals*, London, 1904

Ferrai, L.A., *Cosimo I de' Medici, Duca di Firenze*, Bologna, 1882

Ferrero, G.G., *Opere di Benvenuto Cellini*, Turin, 1972

Freedberg, S.J., *Painting of the High Renaissance in Rome and Florence*, London, 1985

—— and Gould, C., 'The Perseus and Andromeda', *Burlington Magazine*, 105, 112–17, London 1963

Gelli, J., 'Tra Benvenuto Cellini e Filippo Negroli', *Rassegna d'arte*, 2, 1902, 81–5

Goldthwaite, R.A., *Private Wealth in Renaissance Florence*, Princeton, 1980

Grendler, P.F., *Schooling in Renaissance Italy*, Baltimore and London, 1989

Haas, L., *The Renaissance Man and his Children: Childbirth and Early Childhood in Florence, 1300–1600*, London, 1998

Hackenbroch, J., *Renaissance Jewellery*, Munich and New York, 1979

Hall, E., *Henry VIII*, ed. Whibley, C., London, 1904

Hartt, F., *History of Renaissance Art: Painting, Sculpture, Architecture*, New York, 1969

Hayward, J., 'La Giunone in bronzo di Benvenuto Cellini', *Arte Illustrata*, 7, 1974, 157–63

——, *Virtuoso Goldsmith and the Triumph of Mannerism 1540–1620*, London, 1976

Heikamp, D., 'Nuovi documenti celliniani', *Rivista d'arte*, 33, 1858, 36–8

——, *Benvenuto Cellini*, Milan, 1966

Heiss, A., *Les Médailleurs de la Renaissance: Florence et les Florentins*, Paris 1891–92

Bibliography

Henderson, J., *Pity and Charity in Late Medieval Florence*, Oxford, 1994

Hibbert, C., *The House of the Medici: its Rise and Fall*, New York, 1975

Hill, G.F., *Medals of the Renaissance*, revised and enlarged by Pollard, J.G., London, 1978

Jacks, P. (ed.), *Vasari's Florence: Artists and Literati at the Medicean Court*, Cambridge, 1998

Jones, M., *The Art of the Medal*, London, 1977

Kempers, B., *Painting, Power and Patronage: the Rise of the Professional Artist in Renaissance Italy*, London, 1994

Kent, D.V. and Kent, F.W., *Neighbours and Neighbourhood in Renaissance Florence*, New York, 1982

Kent, F.W. and Simons, P., *Patronage, Art and Society in Renaissance Italy*, Canberra and Oxford, 1987

Knecht, R.J., *Francis I*, Cambridge, 1982

——, *Renaissance Warrior and Patron: the Reign of Francis I*, Cambridge, 1994

Kriegbaum, F., 'Marmi di Benvenuto Cellini ritrovati', *L'arte*, n.s., vol. ii, 1940, 3–25

Landucci, L., *A Florentine Diary from 1450 to 1516*, trans. de Rosen Jervis, A., New York, 1969

Letters and Papers, Foreign and Domestic, of the Reign of Henry VIII, ed. J.S. Brewer and others, 21 vols, London, 1862–1910

Liebert, R.S., *Michelangelo: a Psychoanalytical Study of his Life and Images*, New Haven and London, 1983

McCorquodale, C., *Bronzino*, New York, 1981

McHam, S.B. (ed.), *Looking at Italian Renaissance Sculpture*, Cambridge, 1998

Manilius, *Astronomica*, trans. Goode, G.P., Harvard and London, 1977

Martines, L. (ed.), *Violence and Civil Disorder in Italian Cities, 1200–1500*, Los Angeles and London, 1972

Massinelli, A.M., *Bronzi e anticaglie nella Guardaroba di Cosimo I*, Florence, 1991

Merrick, J. and Ragan, B.T. (eds), *Homosexuality in Early Modern France*, Oxford and New York, 2001

Miller, N., *French Renaissance Fountains*, New York, 1977

Morigi, Lorenzo, 'Cellini's Splendour: the Reversible Theory of Restoration', *Sculpture Review*, 43:3, 1999, 16–19

Morris, T.A., *Europe and England in the Sixteenth Century*, London and New York, 1998

Muir, E., *Mad Blood Stirring: Vendetta in Renaissance Italy*, Baltimore and London, 1993

Murray, L., *The High Renaissance and Mannerism*, London, 1995

Oakeshott, E., *European Weapons and Armour*, London, 1980

Paolozzi Strozzi, B., *Monete fiorentine dalla Repubblica ai Medici*, Florence, 1991

Parronchi, A., 'Il modello "de cera alba" del Cristo celliniano dell'Escuriale', *Studi Urbinati*, 41, 1967, 1123–32

Parsons, E.A., 'At the Funeral of Michelangelo', *Renaissance News*, 4, 17–19, London, 1951

Pevsner, N., *Academies of Art, Past and Present*, Cambridge, 1940

Planiscig, L., *Piccoli bronzi italiani di Rinascimento*, Milan, 1930

Plon, E., *Benvenuto Cellini, orfèvre, médalleur, sculpteur: Recherche sur la vie, sur son oeuvre, et sur les pièces qui lui sont attribuées*, Paris, 1883

Pollard, J.G., *Italian High Renaissance Medals*, Florence, 1983

Pope-Hennessy, J., *Cellini*, London, 1985

——, *Essays on Italian Sculpture*, London and New York, 1968

——, *An Introduction to Italian Sculpture*, London, 1985

——, 'A Bronze Satyr by Cellini', *Burlington Magazine*, 134, 1982, 406–12

Ptolemy, *Tetrabiblos*, trans. Robbins, F.E., Harvard and London, 1940

Quetel, C., *History of Syphilis*, Cambridge, 1990

Ramsden, E.H., trans. *The Letters of Michelangelo*, Stanford, California, 1963

Richelson, P.W., *Studies in the Personal Imagery of Cosimo de' Medici, Duke of Florence*, New York, 1978

Rocke, M., *Forbidden Friendships*, Oxford and New York, 1996

Rossi, P.L., 'Sprezzatura, patronage and fate: Benvenuto Cellini and the world of words', in *Vasari's Florence: Artists and Literati at the Medicean Court*, ed. Jacks, P., 55–69, Cambridge, 1998; 'The Writer and the Man: Real Crimes and Mitigating Circumstances: *Il casa Cellini*', in *Crime, Society and the Law in Renaissance Italy*, Cambridge, 1994

Rubin, P.L., *Giorgio Vasari: Art and History*, New Haven and London, 1995

Saslow, J.M. *Ganymede in the Renaissance: Homosexuality in Art and Society*, New Haven and London, 1886

——, *Pictures and Passions*, London, 1999

Scalini, M., *Benvenuto Cellini*, New York, 1995

Scher, S.K. (ed.), *The Currency of Fame: Portrait Medals of the Renaissance*, New York, 1994

Schevill, F., *The Medici, London*, 1950

——, *History of Florence from the Founding of the City through the Renaissance*, London, 1937

Shearman, J., *Mannerism*, London, 1967

Somigli, G., *Notizie storiche sulla fusione del Perseo con alcuni documenti inediti di Benvenuto Cellini*, Milan, 1958

Sotheby: auction catalogue, New York, 10–11/I 1995, exhibition at Palazzo Doria Pamphili, Rome, 7–8/XI 1994, no. 10

Spallanzani, M., 'Saluki alla corte dei Medini nei secoli VV–XVI', in *Mitteilungen des Kunsthistorischen Institutes in Florenz*, XXI, 3, 360–6

State Papers of Henry VIII, 11 vols, London, 1830–52, viii (pt v), 482–4

Bibliography

Stern, L.I., *The Criminal Law System of Medieval and Renaissance Florence*, Baltimore and London, 1994

Stevens, A., *Ariadne's Clue: a Guide to the Symbols of Humankind*, London, 1989

Strocchia, S.T., *Death and Ritual in Renaissance Florence*, Baltimore and London, 1992

Supino, I.B., *L'arte di Benvenuto Cellini*, Florence, 1901

Symons, J.A., *The Renaissance in Italy*, London, 1880

Thomas, A., *The Painter's Practice in Renaissance Tuscany*, Cambridge, 1999

Thorndike, L., *A History of Magic and Experimental Science*, vols i–iv, New York, 1932–5

Trento, D., *Benvenuto Cellini opere non esposte e documenti notarii*, Florence, 1984

Trexler, R.C., *Public Life in Renaissance Florence*, Ithaca and London, 1991

Turner, A.R., *Renaissance Florence: the Invention of a New Art*, New York, 1997

Valentiner, W.R., 'Cellini's Neptune Model', *Bulletin of the North Carolina Museum of Art*, I, 3, 1957, 5–10

Vasari, G., *Lives of the Most Eminent Painters, Sculptors and Architects*, trans. du C. de Vere, G., 10 vols, London, 1912–15

——, *Vasari on Technique*, Maclehose, L. and Baldwin Brown, G. (eds), London, 1907

Vermuele, C., Cahn and Hadley, R., *Sculpture in the Isabella Steward Gardner Museum*, Boston, 1977

Wackernagel, M., *The World of the Florentine Renaissance Artist: Projects and Patrons, Workshop and Art Market*, London, 1981

Walker, D.S., *A Geography of Italy*, London, 1967

Weissman, R.F.E., *Ritual Brotherhood in Renaissance Florence*, Princeton, 1970

Winner, M., 'Federskizzen von Benvenuto Cellini', *Zeitschrift für Kunstgeschichte*, 31, 1968, 293–304

Wittkower, R., *Sculpture: Processes and Principles*, London, 1977

Young, G.F., *The Medici*, Murray, 1909

Index